T0338929

Int|**AR**

Interventions | **Adaptive Reuse**

Editors In Chief:
Markus Berger
Liliane Wong

Special Editor:
Patricia C. Phillips

Graphic Design Editor:
Ernesto Aparicio

Int|AR is an annual publication by the editors in chief: Markus Berger + Liliane Wong, and the Department of Interior Architecture, Rhode Island School of Design.

Members of the Advisory Board:

-Heinrich Hermann, Adjunct Faculty, RISD; Head of the Advisory Board, Co-Founder of Int|AR

-Uta Hassler, Chair of Historic Building Research and Conservation, ETH Zurich.

-Brian Kernaghan, Professor Emeritus of Interior Architecture, RISD

-Niklaus Kohler, Professor Emeritus, Karlsruhe Institute of Technology.

-Dietrich Neumann, Royce Family Professor for the History of Modern Architecture and Urban Studies at Brown University.

-Theodore H M Prudon, Professor of Historic Preservation, Columbia University; President of Docomomo USA.

-August Sarnitz, Professor, Akademie der Bildenden Künste, Wien.

-Friedrich St. Florian, Professor Emeritus of Architecture, RISD.

-Wilfried Wang, O'Neil Ford Centennial Professor in Architecture, University of Texas, Austin; Hoidn Wang Partner, Berlin.

Layout + Design Coordination_Marianna Bender

Editorial + Communications Assistant_Lea Hershkowitz

Communications Assistant_Jenna Balute

Cover Design_Ernesto Aparicio, Marianna Bender

Cover Photo_ Copyright Do Ho Suh

Inner Cover Photos_Alaina Bernstein

Support Team_Francesca Krisli, Min Hee Kim

Copyediting_Clara Halston

Printed by SYL, Barcelona

Distributed by Birkauser Verlag GmbH, Basel P.O. Box 44, 4009 Basel, Switzerland, Part of Walter de Gruyter GmbH, Berlin/Boston

Int|AR Journal welcomes responses to articles in this issue and submissions of essays or projects for publication in future issues. All submitted materials are subject to editorial review. Please address feedback, inquiries, and other material to the Editors, Int|AR Journal, Department of Interior Architecture, Rhode Island School of Design, Two College Street, Providence, RI 02903 www.intar-journal.edu, email: INTARjournal@risd.edu

CONTENTS

AESTHETIC PRACTICES

ART AND ADAPTIVE REUSE

by PATRICIA C. PHILLIPS

[Aesthetics] is a delimitation of spaces and times, of the visible and the invisible, of speech and noise, that simultaneously determines the place and the stakes of politics as a form of experience . . . It is on this basis of this primary aesthetics that it is possible to raise the question of 'aesthetic practices', . . . that is forms of visibility that disclose artistic practices, the place they occupy, what they 'do' and 'make' from the standpoint of what is common to the community. Artistic practices are 'ways of doing and making' that intervene in the general disposition of ways of doing and making as well as in the relationships they maintain to modes of being and forms of visibility.

Jacques Ranciere
The Politics of Aesthetics[1]

Art in the built environment invites and releases, reveals and transforms. Frequently producing discourse and experience, art engages spaces and areas of the city that, in spite of often increasing restraint, economic tension, and social ambiguity, are in theory open to all. With its many different dispositions, because of where it is sited and, significantly, how its presence prompts or presents ideas of public space and local context, art fuels both urgency and resilience. When most dynamic and vigorous, art with(in) buildings and spaces activates experimental and trans-disciplinary probes to re-examine contemporary cultures, civic imaginings, new conceptual points of entry, and short and long-term consequences.

Art lives adaptively between the public and personal, the hard facts of buildings and infrastructure and the evanescent qualities of the ephemeral and ambient. Significant developments in many fields (urban studies, political theory, feminist theory, critical studies, performance studies, thing theory) have ignited important questions about context, co-production, and hybrid forms and methods. They touch on art and public space and direct attention to the role of performance and re-enactments, participation and relational aesthetics, collaborations and social practices, both sanctioned and "stealth" interventions, and assimilation and disruption.

Confrontations of art and architecture productively transform the materials evidence and meanings of both. In 1998, New York's Public Art Fund commissioned and installed Rachel Whiteread's *Water Tower* on the roof of a seven-story building on Grand Street in Soho. Cast in translucent resin from the interior of one of the city's "unique and ubiquitous water towers", the artist's phantom intervention fantastically reacted to changes of light and weather at the site, quixotically animating both the invisible (and insensible) and the apprehensible.[2] Eventually, Whiteread's restless site-responsive work was purchased and donated to the Museum of Modern Art. "When it entered the museum's collections its meanings were altered. Instead of being a discreet, ephemeral object that played on presence and absence, it became a permanent monument in the canon of modern art."[3] This is just one striking story of critical intermediation of art and existing conditions as *Water Tower* became enduringly quiescent within the museum.

'Threshold' is a resourceful metaphor (and invitation) for the many passages, comings and goings of art, existing conditions, and building re-use, as manifested in Do Ho Suh's *Staircase III*, featured on the cover of this issue. Thresholds frequently are transitions between public and private worlds. Constitutively transitory, thresholds possess our anticipation and trepidation. Neither in nor out, here nor there, they are bounded and unbounded, inhabited and empty psychological sites. The *Int/AR Journal's* call for papers, projects, and other submissions on transitional (and translational) relations of art and building re-use, offered inviting prompts, including: conditions of scale and duration; art's capacity to transform economies; how art is influenced by the built

environment; how materials from existing structures become catalysts for art; how art can generate function and program; and, with particular focus on adaptive re-use, how art becomes building and building becomes art. An intellectually and conceptually open invitation has produced a fruitfully eclectic and relevant convening of historical precedents, contemporary case studies, projects, and other speculations on intermediaries, collaborations, and collisions of art with existing buildings and sites.

Adaptive re-use summons liminal conditions between the "no longer" activities of past practices and the "not yet" visions of urban futures. [4] Often emancipating abandoned or condemned buildings and spaces from imminent demolition while refraining from more conventional ideas of preservation, adaptive re-use introduces new program and function through practical, and sometimes radical, recycling and re-purposing of the built environment. Through an alchemy of civic values and tactical processes, adaptive reuse creates opportunities for art and artists to resourcefully and collaterally intervene. The work of Gordon Matta-Clark (1943-78) is remembered or invoked in some essays in this volume. After studying architecture at Cornell University, he left without completing his professional degree and headed to New York City to activate his concept of "anarchitecture"—a beautiful and violent merger of architecture and anarchy. He immediately found opportunity within the city's volatile fiscal conditions, voracious dynamics of decay and development, de-industrialization and commercialization. He was drawn to condemned sites where he engaged in fugitive adaptive re-use to create short-lived expressions and experiences in doomed sites. (The remains of Matta-Clark's work include drawings, photographs, and "extractions" he took from fated buildings.)

Research and work represented in this issue often track themes of 'precarity' produced by the economic, social, and political forces that unsettle built environments and result in unexpected, exponential consequences through the vibrant coalitions of adaptive design with art and artists. The journal invites readers -- architects, artists, designers, historians, curators, and members of the public -- to actively consider the relation of art to a vision of architecture and the built environment that accepts a mission to maintain, care, repair, and re-imagine futures through transformations of "places with a past". [5] Art historians often consider the context from which an artist's work emerges including background, philosophy, notable historical, environmental, social, and economic influences, existing materials, and visual conventions. Yet here, and arguably always, there is a generative reciprocity – ins and outs, arrivals and departures -- of the possibilities that surround (inhabit) a work of art and its capacity to vividly influence (occupy) its context. A dialectical potential reveals that co-agency always exists – and continues to emerge -- with art and the built environment.

ENDNOTES

1 Ranciere, Jacques. *The Politics of Aesthetics.* London: Continuum, 2004. p. 13.

2 Malvern, Sue. "Antibodies: Rachel Whiteread's *Water Tower*." *Art History* 26.3 (2003): p. 402.

3 Malvern, p. 392.

4 Hannah Arendt explored the temporal spaces of the "no longer and not yet" in a number of essays and writings.

5 Curator Mary Jane Jacob organized a city-wide exhibition for the Spoleto Festival (1991) in Charleston, South Carolina entitled *Places with a Past* that 23 invited artists to create projects and interventions within buildings that were evocative of the city's complex history.

INTERSECTION OF ART, SCIENCE, AND ARCHITECTURE

STOCHASTIC ARCHITECTURAL COMPOSITIONS OF EVENTUALIST THEORY

by CLAUDIO GRECO

This paper illustrates the first architectural application of Stochastic Tiles based on paintings by Italian artist Sergio Lombardo. An active figure in art today, Lombardo was a leader of the Roman avant-garde in the Sixties and the creator of the innovative aesthetic theory of Eventualism[1] in the Eighties. Stochastic Architectural Composition[2] is an experimental research activity focusing on complex and random processes in architecture, according to the methods and procedures developed by Lombardo and the new ideas of creativity and artwork delineated by the Eventualist theory.

The theory of Eventualism

In the early Sixties, the young artists of the Italian avant-garde, in line with *Monochrome Malerei* and *Conceptual Art,* formulated several aesthetic principles based on a scientific and experimental approach connected to

Futurism, the foremost Italian avant-garde movement at the beginning of the century. The first of these principles was the rejection of the illusionistic and representative pretense of painting in favor of the purely technological and concrete aspects of the artwork as object. The second principle was the rejection of the expressive lyricist method (typical of the previous abstract and informal movements) in order to experimentally investigate programmable and reproducible structures with an intrinsic organizational process. The third principle was the elimination of the interior dimension of the artist in order to establish a provocative relationship with the viewer, with the desired outcomes of surpassing passive observation and invading the space of everyday reality.

Many Italian artists, including Piero Manzoni, Enrico Castellani, Giuseppe Uncini, *il gruppo N,* and *il gruppo T,* adhered to this movement. With artists such as Fran-

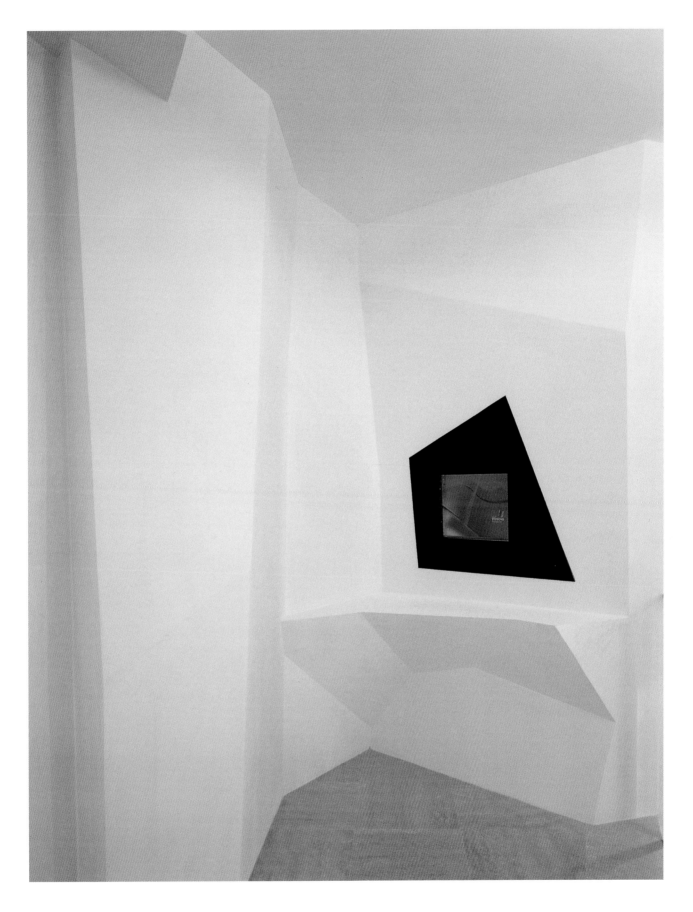

Stochastic wall in law firm, Rome

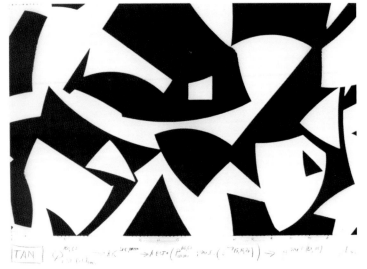

cesco Lo Savio, Mario Schifano, and Sergio Lombardo, Rome was one of the movement's focal points. However, by 1964, the year of Rauschenberg's success at the Venice *Biennale*, most of these artists had abandoned avant-garde scientific research and returned to the spontaneous intuitions that are typical of primitive art. The *Arte Povera* movement became very successful as of the late Sixties and was universally seen as representative of the entire Italian avant-garde art of those years.[3]

Meanwhile, Lombardo conducted his own original research as an artist and a psychologist. His first significant series of works was painted with black enamel on white canvases. The *Gesti tipici* (1961) consisted of oversized silhouettes of political leaders such as J. F. Kennedy, Mao Tse Tung, Nikita Khrushchev, and Charles de Gaulle. The subjects had very distinctive and authoritative poses, intended to disturb viewers and stimulate their oneiric activity.

The artist continued to develop the modalities of interaction with his audience in subsequent works: *Supercomponibili, 1967; Sfera con Sirena, 1970; Progetto di morte per avvelenamento, 1970; Concerti aleatori, 1971; Specchio tachistoscopico con stimolazione a sognare, 1979*. The public's reaction was considered an essential part of each and every one of these works. For example, "Sfera con Sirena" (Sphere with Siren), exhibited in 1970 at the Biennale di Venezia, consisted of six spheres, each a meter in diameter, randomly placed in a large hall. The spheres, made of a black, shining plastic material, possessed an enigmatic aspect that encouraged spectator interaction. The slightest touch, however, actually triggered an internal mechanism that set off a deafening siren that would stop only when the sphere was returned to its original position. This game produced the most varied and unexpected reactions in visitors, who in turn became the protagonists of the artwork.

In the 1980s, Lombardo began to investigate techniques and methods for randomly generating images. His investigation led to the idea of *Pittura Stocastica (stochastic painting)*, intended to generate absolutely arbitrary patterns so as to discover the most effective parameters and algorithms for obtaining the largest number of different viewer interpretations.[4] In the following years, he invented many different automatic stochastic drawing methods (TAN, in analogy with "tangram;" SAT, from plan "saturation"), intended to elaborate entirely new images far from our habitual visual experience.[5]

In 1987, these initial principles, applied and developed in a series of works, led to the formulation of the *Eventualist Theory* that can be summarized as follows:

- Definition of "event:" an event can be defined as anything regarding which there is no perceptive, interpretive, or evaluative agreement. An event never repeats itself in the same way, and it is not predictable. Reality is a macro-event. An event can be experienced subjectively as a loss of reality, an interruption in the flow of time, an identity crisis, a situation of emergency, or an oneiric atmosphere.

- Eventualist art aims to create a "stimulus" that can prompt the most heterogeneous interpretations (*evocative spectrum*) within a culturally representative group of people. Therefore, the stimuli that evoke the widest and most varied range of interpretations are true Eventualist works of art.

- The Eventualist process consists of three stages: the stimulus, the event, and the documentation of the interpretations of the stimulus.

- The event is measured by the "dispersion," or range of diversity, of the different interpretations (*interpretive spectrum*) of the stimulus.

- The "evocative spectrum" of a stimulus is unstable. It varies depending on whether it is shown to different people, or to the same person at different times. If the stimulus is shown repeatedly to the same people, it tends to elicit an increasingly restricted and narrow *evocative spectrum*, because some interpretations prevail over others, and some interpretations disappear. At this point, it can be said that the stimulus "decays."

- A completely decayed stimulus is "saturated," which means that it evokes very similar or identical interpretations in everyone. A saturated stimulus corresponds to that elicited by everyday objects.

- The aesthetic concepts of Eventualism are: minimality, expressive abstinence, structurality, spontaneity, interactivity, eventuality, and profundity.[6]

Sergio Lombardo's stochastic tiles

The stochastic paintings produced by Lombardo in the Eighties were conceived in a such a way that they could be positioned next to each other to cover a surface of any size. Therefore, they could also be seen as tessellations for walls or floors. In 1994, the artist began

Sergio Lombardo, Pittura stocastica TAN, (Stochastic Painting), 1983

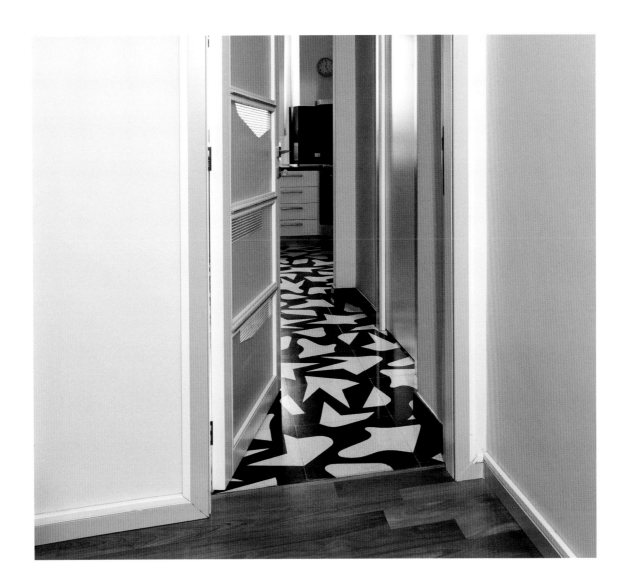

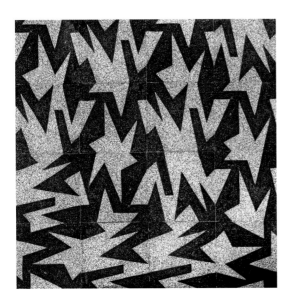

to consider his works as basic minimal modules and experimented with increasing the number of possible combinations. This led to his invention of a random shape-generative procedure that he called the RAN method. By using square tiles with black and white designs, he multiplied the number of possible combinations as the floor area increased.[7] The patterns produced by these tiles are always continuous, as the areas of black or white correspond on their edges no matter how they are positioned or rotated. The black shapes on each tile are altered or "deformed" according to the stochastic procedure to produce original patterns. Their levels of complexity vary, depending on the number of coordinates, or "points," chosen to produce the deformations (5, 10, 20, etc.).

The arrangement of the tiles can be planned either as a pre-established sequence or procedure or in a random manner. In the latter case, the result is an

TOP
Stochastic floor in apartment renovation, Rome.
BOTTOM
One of the 24 floors, Residential Complex in Tufello, Rome.

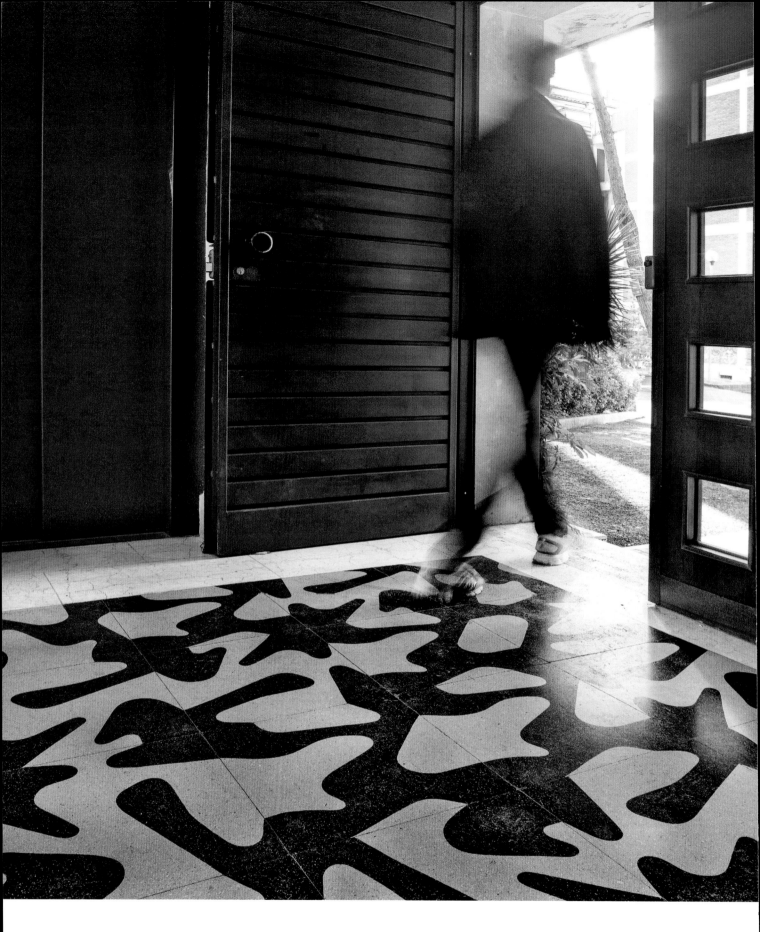

View of the new entrance hall and stochastic floor, Residential Complex in Tufello, Rome.

unpredictable composition covering the whole floor surface. According to the Eventualist aesthetic theory, the patterns obtained should constitute a stimulus for the viewer to engage in an active or even frenetic interpretative process, resulting in a wide range of interpretations, dependent on each viewer's individual experience. Stochastic tiles thus contributed new concepts to the history of modular tessellation in architecture, not only as innovative and attractive graphic images, but also in the relation between the perceiving agent and the object perceived. They also facilitate and simplify the creation of near-infinite numbers of original graphic patterns, as it is only necessary to manufacture a limited number of basic tile designs or modules for this purpose.[8]

Application in architecture

Planned by the author in 1998 and realized in 2002, the first large-scale installation of stochastic tiles within an architectural project was in the Sixties tenement blocks in the Tufello district of northeastern Rome. In response to an open call, a proposal was submitted for the restoration of the 24 residential apartment blocks, each one with 5 floors and without elevators. The plan consisted of the restoration of the façades, the enlargement of the 24 entrance lobbies, and the installation of 24 new elevator-towers.

These new elements were to be added to a complex of simple and sober architecture, to which the residents, most of whom had lived there for over thirty years, had a close emotional attachment. While the additions to the exterior responded to the context with shapes and patterns similar to the existing architecture (red brick and white vertical and horizontal structural elements), the proposal also included the addition of distinctive and original new elements to the plan.

A decorative element was inserted within the new entrance lobby, which, as an extension of the existing lobby, enhanced the prestige of the building. This element consisted of a pattern of square tiles framed by a marble floor. Following the logic for the elevator-towers, the floor design was identical in all of the buildings. A local material (*graniglia di cemento*: a cement mortar with inserted colored marble chips, in accordance with the consolidated tradition of social housing buildings in Rome) was used in order to encourage acceptance by the residents; however, its unusual and innovative contemporary design would subtly differentiate each building in order to encourage a form of effective identification.

The use of stochastic floor tiles was fully consistent with these principles, and its application here seemed a perfect opportunity to validate the Eventualist theory in a real architectural context. Two designs were chosen out of Lombardo's stochastic tile series; both were produced with a set of 10 randomly chosen points. These coordinates could be connected with either straight or curved lines, in order to obtain a total of four different designs or patterns on the tiles. The original black and white colors of the tile designs were altered to black with either blue, yellow, or green, in order to establish a visual link between the color of the new external ceramic mosaic cladding of the lift towers and the color of the internal floors (i.e. *yellow mosaic + yellow floor*) for each building.

A square panel with sides 1.6m long was designed from 16 tiles, each one with dimensions of 40x40cm. The

External view of one of the entrances, Residential Complex in Tufello, Rome.

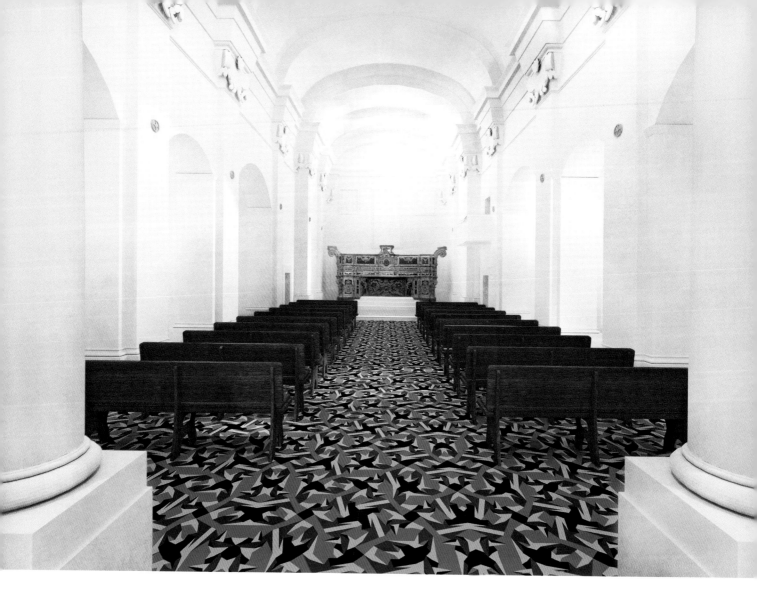

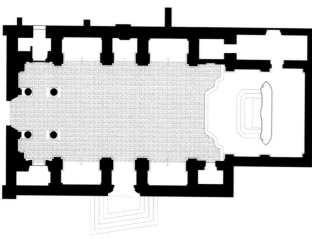

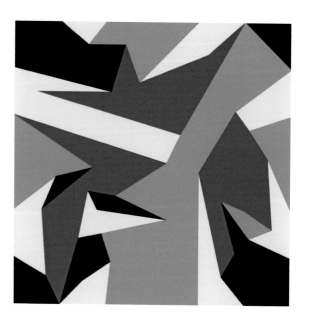

COUNTERCLOCKWISE FROM TOP

Internal view, S.Felice church, Avignonesi, Italy.
Floorplan, S.Felice church, Avignonesi, Italy.
A single tile, S.Felice church, Avignonesi, Italy.

fact that the tiles were handmade with traditional and familiar materials, rather than industrially manufactured using modern materials such as resins or marble-resins, made it less likely that the perceptions of the residents would be distracted from their interesting and unusual patterns. Specialized workers laid the floor tiles with instructions to do so randomly without following any system or plan.

The fact that the floors were much appreciated by the residents of the buildings even though they were highly abstract corroborates Lombardo's theory regarding the wide range of different personal interpretations (*interpretive spectrum*) of the stochastic artwork. The elderly and children, personally interviewed, were especially intrigued by these unfamiliar designs, and they engaged in a subjective and personal process of interaction and identification, which was repeated and re-elaborated every time they walked through the lobby of their building. The insertion of a work of art (not understood in the traditional sense as an "object to be observed," but as a stimulus with which one can relate) into the architectural space of the entrance lobby transforms the perceptual process into an "event," according to the Eventualist theory. After this initial application, stochastic tiles were used in a number of the author's other restoration projects of private apartments.

Recent application of stochastic colored tiles in the Church of San Felice

Following his series of two-color (*black and white*) stochastic patterns, Sergio Lombardo explored a wider range of colors, which produced some remarkable changes in the perceptual characteristics of his paintings.

The artist utilized the procedure called SAT, an extremely irregular stochastic tiling consisting of polygons that saturate the picture space, creating something that, in mathematical terms, is defined as a "map." Lombardo chose to enhance these patterns using the minimum number of colors possible, in accordance with the mathematical principle stating that at least four hues are necessary to color any complex design.[9] With this method, he produced numerous stochastic maps between 1984 and 1997. Lombardo's more recent experimentation and research have once again focused on stochastic tiles, but this time, they are complex polychrome creations.

The first application of these multicolored tiles in an architectural setting is now in progress within the floor of the church of San Felice, located in the town of Guglionesi in the southern Italian region of Molise. Following its construction in the 15th century, the church suffered numerous renovations and changes that altered the polychrome decorations of its walls. Some were only fragments of poor quality, and there are no surviving documents to aid in their reconstruction. In

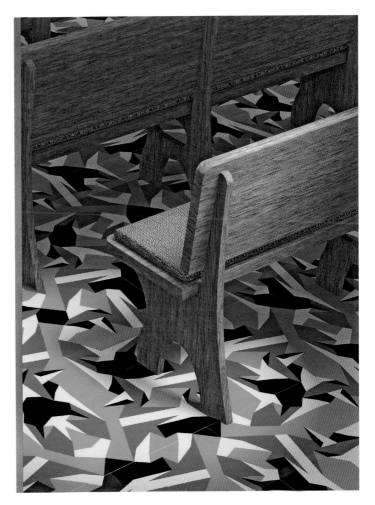

fact, most of them had been irretrievably deleted during various periods in which the church had been used as a working place. The artist decided to restore the walls and decorative elements (such as columns, capitals, and cornices) to their original white color, leaving only the new, brightly colored polychrome floor with the visual task of enlivening the architectural space.

The aim of this pioneering project, exceptional for a listed historical building in Italy,[10] was to achieve a contemporary renewal of ancient cultural traditions, instead of trying to establish a false impression of continuity with the past or accepting modernity in an indiscriminate way. A multi-colored modular tessellation in ceramic tiles was proposed for the floor, in continuation of the local tradition in the region of Molise, but with a new contemporary pattern. Whereas in the Tufello project, the square floor panels can still be seen as a quasi-painting, the new floor covering of the church occupies the entire central area of the nave and extends as far as the steps of the raised main altar and side chapels. Only one type of tile, selected from Lombardo's 2013 series, was used. This tile had 20 selected points and four

Internal detail, S.Felice church in Avignonesi, Italy.

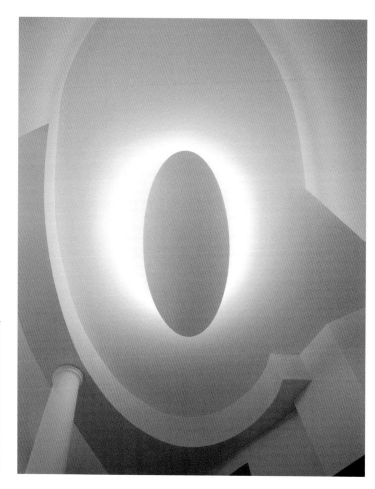

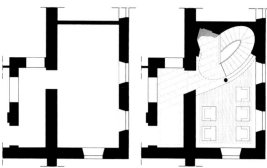

colors (black, light yellow, light green, and bluish violet) that are minor variations upon four of the most common colors in the Italian tiling tradition.

The monumental character of the church has made the insertion of the contemporary floor more problematic than in the previous Tufello project. The impact of the modern pattern of shapes and colors on the traditional architectural elements will most likely stimulate a wide range of reactions in worshippers and visitors to the church, as well as in art historians and art critics. Once the stochastic floor has been completed, it will be possible to further investigate the Eventualist theory by recording and analyzing the various impressions and interpretations of viewers by means of experimental tests.

The passage to the third dimension and to the architectural composition of spaces

The perception of three-dimensional figures in a two-dimensional pattern, with the addition of a third or fourth color or a different hue of the same color,[11] is a frequent element in the tradition of floor tiling (such as *trompe l'œil* cubes), as well as in avant-garde movements in modern art (such as cubism and futurism)

and in the subsequent Russian rationalist architectural avant-gardes.[12] Thus, the perceptual effect obtained by stochastic compositions on the plane can be made even more complex and ambiguous by opening up the plane into the third dimension and producing three-dimensional walls.

Since 2003, the author and his colleague Carlo Santoro conducted a series of experiments to create stochastic compositions and spaces in architecture, and they documented the most significant steps of their on-going research in several articles.[13] A first application of these principles was the creation of Eventualist architecture in the form of a stochastic wall, within the context of a renovation project for the office of a law firm in Rome. This intervention followed the same principles as the entrance lobby in Tufello; in both cases, an unfamiliar and unrecognizable element made with recognizable and familiar geometric shapes was added to a traditional architectural space.

The room involved was originally a regular, rectangular entrance hall with windows on two walls and a stairway leading to a lower floor. Transformed into a waiting room with seats, the room has a main axis of

LEFT
Before and after floor plans, Rome.
RIGHT
View of ceiling, law firm, Rome.

direction, from the entrance to the staircase, that now leads diagonally across the room and divides it into two separate areas. The original layout of the larger area, to the right as one enters the room, has essentially been conserved, while the walls on the other side have been modified into a new architectural space containing both the staircase and the new function of computer work station for clients. The staircase area, ideally extended in height, is a cylindrical volume with an elliptical cross-section. This architectural area and its static and dynamic perception are relatively familiar.

The other part of the space near the entrance has instead been modified according to processes of stochastic composition, i.e. by the "stochastic sponge" method developed by the authors.[14] The resulting architectural space has various new and unexpected elements. The space to the left of the waiting room thus consists of a *saturated* side and a *non-saturated* side according to the terminology of Eventualism. The static and dynamic perception of the space considered as *saturated* is presumably a more passive experience with a broad *evocative spectrum*, which tends to be interpreted in similar or convergent ways by different individuals, while the parts designed with *non-saturated* aspects should trigger dissimilar or divergent processes of subjective interpretation.

Conclusion

The relationship between a work of art and a work of architecture lies between the simple location of one within the other - as two distinct entities - as well as the attempt by the work of architecture to become a work of art. As in much architecture of the digital era, this attempt often leads to a complicated confusion of levels and meanings.

The interventions presented in this paper are not intended as an intermediate position between these two extremes. In fact, a completely different approach was explored, questioning the meaning of "work of art" and demonstrating the utmost importance of an aesthetic theory of reference.

On the basis of the Eventualist theory, the work of art and the work of architecture can be defined as the spectator's or user's interaction with them. As such, their value and significance should be measured within a real context in an objective and scientific way, rather than be subject to the personal judgment of specialists and critics. Moreover, the common goal should not consist of generically improving wellness and quality of life or assessing personal needs, but rather of stimulating a profound change in habits and beliefs.

Only when all these conditions are met will the gap between the two disciplines be filled, and entirely new relations become possible.

ENDNOTES:

1 Lombardo, S. "La teoria Eventualista," *RPA* Anno VIII 14/15. (1987). RPA (*Rivista di Psicologia dell'Arte*). This magazine was founded in 1979 by Sergio Lombardo and other avant-garde artists and it documents the research and experimentation of members of the Eventualist movement, with contributions from artists, scientists, musicians, art critics and historians.

2 Greco, C. "Verso un Architettura Eventualista," *RPA* Nuova Serie, Anno XXIV, 14. (2003).

3 Lombardo, S. "Primitivismo e avanguardia nell'arte degli anni '60 a Roma," *RPA* Nuova Serie, anno XI, 1. (1990).

4 Lombardo, S. "Approssimazione alla struttura casuale assoluta," *RPA* anno V, 8/9. (1983).

5 Lombardo, S. "Pittura stocastica, introduzione al metodo TAN e al metodo SAT," *RPA* anno VII, 12/13. (1985-1986).

6 See Note 1

7 Lombardo, S. "Pittura stocastica, tassellature modulari che creano disegni aperti," *RPA* Nuova Serie, Anno XV, 3/4/5. (1994).

8 Greco, C. "Modular Tessellation and architecture. Sergio Lombardo's stochastic tiles and their application in real architecture," *RPA* Nuova Serie, Anno XXXV, 25. (2014).

9 Lombardo, S. "Estetica della colorazione di mappe," *RPA* Nuova serie, XX, 10. (1999).

10 The project went ahead largely thanks to the commitment and open-minded attitude of the Superintendent of the Molise Region, the architect Carlo Birrozzi, who agreed to include a contemporary element inside a listed historic building. In Italy a public church of over 50 years of age is automatically classified as a listed building and there may also be further specific constraints concerning certain parts of the building or the objects within it. There are various different requirements for protecting such buildings, graded in a series of increasingly restrictive levels, but the local superintendents responsible for interventions of restoration are allowed a substantial degree of freedom in deciding how to implement them. Nevertheless the officials and experts involved in architectural restoration generally have a very conservative attitude towards such interventions

11 See note 9.

12 Greco C. "Le teorie dei razionalisti russi e il laboratorio di psicotecnica al Vuthemas (1919-1927) all'origine dell'approccio eventualista all'architettura," "*RPA*"anno XXXIII n.23. (2012)

13 Greco, C. - Santoro, C. "Metodi avanzati di composizione architettonica stocastica," *RPA* Nuova Serie, Anno XXV, 15. (2004); "Applicazioni di architettura Eventualista," *RPA* Nuova Serie, anno XXVI, 16. (2005).

14 See note 13.

A SACRED TRANSLATION

HOLY TRINITY CHURCH TO JESUS SON OF MARY MOSQUE

by DENNIS EARLE

The role of art in the psychic and social functioning of spaces or places devoted to the sacred can be critical. Perhaps the primary role of material, non-ephemeral art in such spatial contexts is to provide a sign of identity, both of the space as the proper realm for the experience of the sacred, and of the identity of the tradition, culture, or community of belief using the space. A second role, distinguishable from, but interrelated with that of identification, is 'mediation', wherein art modulates and generally creates conditions conducive to the particular kind of spiritual experience intended. Sacred art in sacred spaces often plays both roles, but understanding how or why it does so can reveal a great deal about visual culture, cultural space, and the sacred as it is conceived in various traditions. In this article, I examine a situation of the adaptive reuse of a sacred space for a similarly sacred function within a larger context of intercultural conflict. But as the new use supports a different spiritual and cultural tradition, it brought into pointed dialogue quite different approaches to, and readings of, sacred art in sacred spaces,

The project involves the translation of a sacred space with one particular cultural and religious identity – a German-American Roman Catholic church–into one that could embody and support quite another such identity, an Islamic-American one. The story of this translation involves an encounter between two very different notions of the role of art in sacred space or in the sacred in general – an encounter that reflects, but also illuminates, the nature of a much larger conflict unfold-

ing across our society and the wider world between (one strand of) a substantially Judeo-Christian culture, and Islam. The implications of this wider conflict have created a unique context for the transformation sought by the Muslim community – the 'client' for the design of the *Masjid Isa Ibn Mariam* ("the Mosque of Jesus Son of Mary") at the site of the former Holy Trinity Church at 501 Park Street, in Syracuse, New York. The project began as an undergraduate interior design studio assignment at Syracuse University's School of Design in January of 2014, and it provided the opportunity for relevant research and exploration of issues and solutions, with substantial community input, before design actually began. I created the new design, which is still being implemented, in the summer of 2014.

The story of this transformation began with the closing, decommissioning, and sale of the church building to a local non-profit community development organization, which in turn leased the building on a long-term basis to an Islamic community group for use as a place of worship. The non-profit, according to its mission, had been devoting an ever-larger portion of its work to serve the struggling immigrant community on the north side of the city that has in recent years become predominantly Muslim. At 501 Park Street, societal trend lines crossed: attendance at the city's Catholic churches has been declining for several years as Islam became the city's, and the nation's, fastest growing faith. Many members of the local community around upper Park Street grew up with the church as an active neighborhood institution

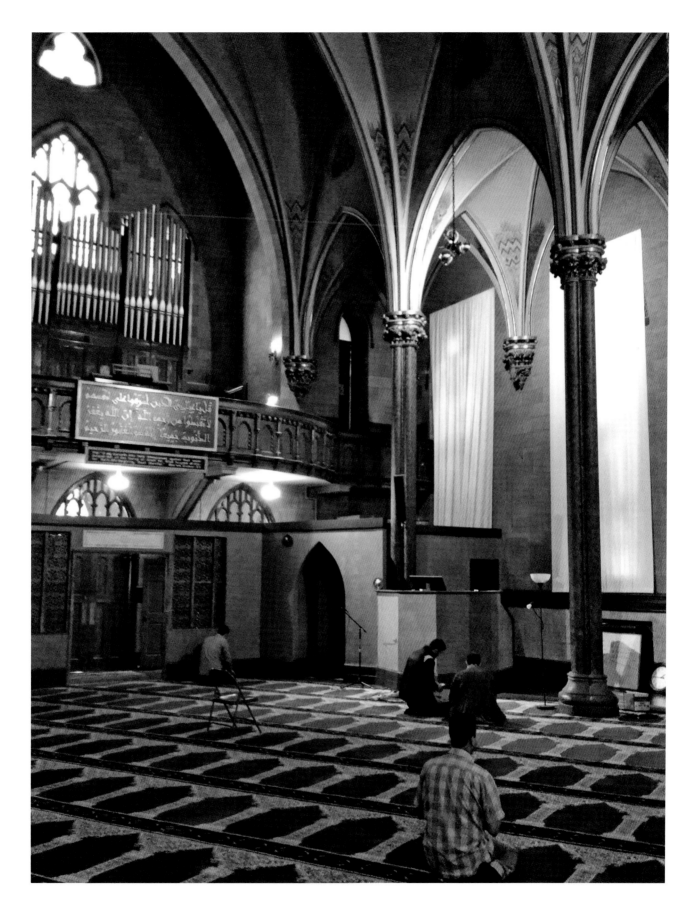

Prayer hall, Masjid Isa Ibn Maryam, Syracuse, NY.

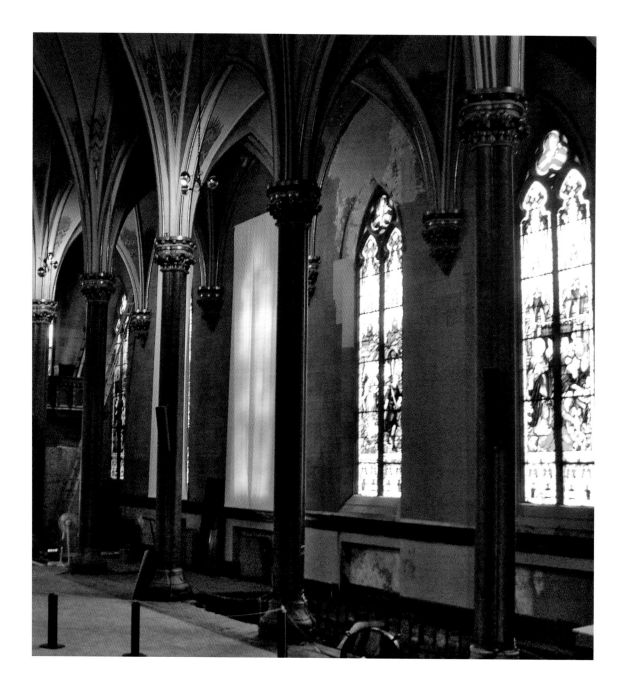

and symbol of faith, community, and heritage. More than a few mourned and even complained about its closure and, with the sale and lease of the building, real anger became apparent at the prospect of turning over the building to a Muslim immigrant community. At one point in the process of preparing for renovation, it became necessary to hold a neighborhood meeting, sponsored, mediated, and staffed with security personnel by the city, to air complaints, quell rumors, and promote tolerance and understanding between the building's new occupants and some of their non-Muslim neighbors.

As the architect for the renovation project, I was charged with the implementation of the adaptation ac-cording to a certain few key principles beyond building codes and permit criteria. The Muslim faith community (*ummah*) wanted to observe specific traditions in the design, but not too strictly nor ostentatiously – in part out of a sense that the powerful ideological and ethical underpinnings of American civic life should in some way color this 21st century and unusually situated *masjid* (mosque). (A minimal budget played a constraining role as well.) The fundamental architectural operation to be achieved was the reorientation of the main space to face toward the holy city of Mecca – meaning that the key fo-cal elements of sacred niche (*mihrab*) and sermon plat-form (*minbar*), presumably supported and tied together

Original nave windows in the early stages of renovation.

by an enveloping screen wall, would need to be designed so that the focal axis of the space was rotated some 240 degrees. As part of this reorientation, the location of the twin focal points (*mihrab* and *minbar*) and identifying components needed to be conceived, scaled, and placed for their primary functions, but in accord with the main conceit suggested by the unusual circumstances: that the intervention as a whole should be designed to seem at home with the still-visible features and overall character of the existing interior environment. The third design imperative, after re-orientation and appropriate design of main new components, was to either remove or cover all of the a) figurative and b) explicitly or emphatically Christian art or iconography. This practice was in keeping with Islam's traditional strictures against figurative art and related iconography, and for rectifying the inappropriateness of the most sacred iconography of another faith in one's own sacred space. Here is where the challenge, the conflict, and the need for both creativity and tolerance were greatest. Since the City of Syracuse's Landmarks Preservation Board deemed the stained glass windows to be of significant cultural value to the neighborhood and wider community, they mandated that they not be removed in any renovation of the building. The leadership of the Muslim *ummah* decided to take the notion of preserving existing features for the benefit of the wider community and broaden it to include almost all of the art found there. So, much of the Christian art was to remain a part of the building – but masked, ultimately in a permanent way, though in a manner that allowed for periodic viewing. This circumstance created a design and budgetary challenge that has not yet been fully met. Beyond the technical and aesthetic challenge, the continued presence of the windows also brought into sharp relief the contrast of approaches taken within the two traditions – Christian and Muslim – toward sacred art.

In the *masjid* design, the reorientation of the main space was accomplished with the imposition of a screen wall not unlike examples to be found, in various forms, in traditional Islamic interiors – but detailed in certain ways to match the existing church interior. The design of the decorative screen-panels comprising much of the main screen wall is based on a motif which appears in the Al-Aqsa *masjid* in Jerusalem, albeit much simplified to satisfy the budget and to effect a more contemporary, restrained interpretation of the original. This motif is repeated in a simple, regular way to form the perforated portion of the main partitions separating key spaces. The motif as executed – the decorative module, laser-cut into wood – would in itself hardly seem to suggest an autonomous work of art, but it became both a signal of a heritage and an aid to a mode of spiritual experience in its repeated form as the typically 'Islamic' screen. Its environmental or perceptual effect is to articulate light and shadow in a way both familiar ('Islamic') and

appropriate to the spiritual focus and self-submersion demanded by Muslim worship. In this important dual role and in its visual appeal, the screens could arguably be deemed Islamic-inspired art.

Taken together, the screens seem in some ways the opposite of the stained glass windows in nature and effect; they are composed of an abstract, uniformly repeated and geometrically ordered device for modulating light and view, that facilitates a meditative surrender to the will of the divine. The stained glass windows, each a unique composition and scene that is illustrative and didactic, figurative and narrative, teach and remind, as they convert white light into colors to stimulate exultation and wonder at the divine. While the windows are additive and more autonomously contribute to a Christian notion of the sacred, the decorative screen walls are spatially integral and tend to disappear into the setting. The screens are what Islamic art scholar Oleg Grabar called "intermediary" ornament; they are neither focal objects/images – perhaps presenting spiritual axioms or entities – nor are they mute architectural planes merely defining the limits of sacred space. They are in between foreground subject matter and background boundary, ambiguous and multivalent. They are subordinate and adorn rather than create, but they adorn *space* more than mass or surface, and they qualify the delimitations of space that they impose.

In the former church, the forms and images that could be understood as sacred art were either figural images, as in the crucifix, saint, and angel images, or body-related symbols, such as crosses and bleeding hearts. This body-focused 'iconism' has historically dominated the Christian ideal of sacred art and its function. In most Christian settings, spaces are made sacred most obviously and importantly by the presence of such art, which signals the identity and function of the space. Islam does not permit the presence of images of living beings or figural iconography. For Islam, the creation of an image of a being is an imitation of the divine creator and therefore an act of arrogance. The absence of the Christian concept of the divine incarnated in humankind, combined with the emphasis on the incomprehensibly infinite nature of Allah, means that the attempt to capture divine essence in an image or icon would contradict the Prophet's teachings. So, in the creation of Islamic sacred space, the relationship between art and space or place is basically reversed; art or potential art is made sacred, and made art more clearly by its deployment in a space, which is understood as sacred by its explicit orientation, organization for sacred function, and environmental conditioning in a perceptual sense. The paradigm for imagery – so often what we think of as art – becomes one more of absence, of representation, or of figuration, rather than its presence in rendering the space sacred. Empty space, architectural surface, or detail uninhabited by all but the most purely decora-

tive and stylized representational images, if any, are meaningful, even representational in an abstract way, and conducive to a meditative spirituality.

For the city, represented in this project by the Landmarks Preservation Board, the important art in this situation was first, the building itself as a sculptural whole and iconic landmark, and second, the stained glass windows, not fully visible from the outside of the building. The Board adopted the stance that although the windows could only be properly viewed and appreciated from the main space of the building's interior – the only space suitable for a new Muslim worship space, these locally familiar, admired, and 'historic' works of art are cultural resources worth preserving and keeping available to the community. This reflects a civic perspective

according to which art is, in effect, a secular community resource of presumed cultural value to the citizenry. The generally understood philosophy underlying the preservation of historic and cultural resources formed the justifications for imposing this art on the new occupants, and insisting that while the stone crosses mounted on the church exterior could be removed, they must be stored inside the building and made available to the public, or for some future display or use.

Some in the local neighborhood (according to their own informal testimony) had once sensed that the neighborhood had something of special value and meaning in its midst in the building and its grand windows. Now they saw in quick glimpses, and heard about in descriptive rumors, the supposed stripping of

LEFT
Temporary coverings for cherub heads.

RIGHT
Plaster cherub head ornament before covering.

the once beautiful interior as a kind of assault on that value and meaning by a largely Islamic immigrant population. For the most upset among them, the need to cover or remove iconography with which they could culturally identify seemed more an act of negation than one of faith. The very grace and nobility they saw in the saintly personages, rendered with a skill and a richness now too expensive to be employed, invoked a lost, hallowed past. The feeling of loss and negation was only heightened by the visual drama of the removal of stone crosses from steeples and gables – even though those crosses were eventually replaced with non-iconographic ornaments.

On the other hand, for the Islamic *ummah*, there was some frustration and resentment expressed over the mandate to retain the windows (and the ongoing delays in covering them). In contrast to the perspective of the Landmarks Preservation Board, the belief of many in the *ummah* was that the presence of the stained glass windows was an indication that the powers could not accept their full possession of this hallowed ground and a reminder that they must deal with being Muslim (and 'immigrant') in a not entirely Muslim-friendly or immigrant-friendly society. Meanwhile, according to deeply felt tradition, any viewing of the image of the Virgin Mary holding the Christ child, to cite one example, quite apart from historic or present-day social or cultural relations between faiths, will strike the devout Muslim as an inappropriate display of human beauty and importance, or of human artistic skill and illusionistic 'powers' before Allah. While the devout Christian willingly suspends disbelief and finds herself in the presence of a personified transcendence, the traditional Muslim sees a celebration of humans and their capacities as being at the expense of praise for and submission to God.

Ultimately, the modest but adaptable ornamental screen form, based on a type and motif from a rich ornamental tradition, proved to be the "art" essential to solving the challenges of the project – essential as a mediator of aesthetic and cultural roles, as part of the major partitions in the main space, and as part of the permanent solution to masking the windows in an operable way. While these screens are not comparable in some ways to the evocative and magical windows, they are representative, in a modest way, of something especially Islamic: in their conceptual purity and adaptability, their aniconic abstraction, their reliance on multiplicity for a sense of richness, and the way they blend together their part in supporting a focused, sacred experience with their more generic appeal as a simple, almost homely decoration. This was the key to this sacred translation: to create an intermediary and modulating, rather than overly assertive or exclusive, sort of design. It is this aspect of much of Islamic art and architecture that will serve the faith well in its attempt to negotiate its place in the American cultural landscape.

Decorative screen at rear of main prayer area.

SAMPLING SECULARIZATION

TRANSFORMING RELIGIOUS SPACE

by KIRBY BENJAMIN AND KATHERINE PORTER

With the decline of religious practices in North America, many of the religious structures that once occupied places of architectural and socio-cultural importance have become increasingly underutilized, under-maintained, and underappreciated. This is not surprising, given the statistics: between 1930 and 1960, the percentage of American individuals who identified as 'non-religious' increased from less than 5% to over 21%.[1] Christianity has incurred proportionally large rates of decline, more so than other religions in North America. This decline is most visible in small states such as Massachusetts. Prior to 1990, 54% of the Massachusetts population identified as Catholic. After 2002, that figure dropped to 36%.[2]

The waning of religious practices in North America has put sacred religious structures under both fiscal and physical stress. Furthermore, efforts to diversify assets while remaining financially viable are causing underutilized religious spaces to succumb to either demolition or privatization of their once public spaces. Fortunately, the architectural infrastructure of North America is young, and designers can always look to churches of older countries for precedents. Of church adaptation typologies, the Church of St. Pere (Spain), Fontevraud L'abbaye Royal (France), and the Oude Kerk (Netherlands) demonstrated that the most successful examples of adaptive reuse in church structures possess three common elements: a prioritization of public over private space, a strong alignment to the arts, and architectural interventions that open up structures for the shared enjoyment of their communities.

ENDNOTES:
1 Bindley, Katherine. "Religion Among Americans Hits Low Point." *The Huffington Post*. March 13, 2013. Accessed February 1, 2015.
2 Ibid.

Conceptual models of additive and subtractive operations for the church typology.

FONTEVRAUD L'ABBAYE ROYALE, GENERAL

Inaccessible to the public for almost 900 years, the Royal Abbey of Fontevraud in western France re-opened its gates to all in 1975. Founded as a 'mixed' abbey in 1101 by Robert d'Arbrissel, an iconic preacher and visionary, the Royal Abbey of Fontevraud welcomed worshippers from all social backgrounds. Over the subsequent seven centuries, Fontevraud became a royal necropolis and was the largest abbey in Europe until 1792, when the last abbess was evicted as a result of the French Revolution. Twelve years later, Napoleon Bonaparte ordered that the Abbey be transformed into a high-security prison, which eventually became the most stringent prison in France. After operating as such for 150 years, the historic site opened again to the public with dynamic programming such as award-winning restaurants, a boutique hotel, and art installations.

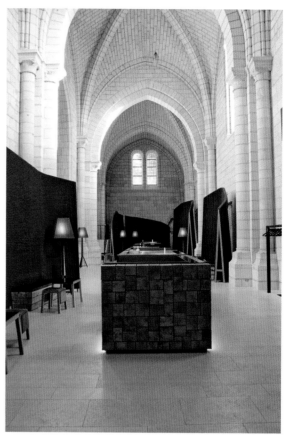

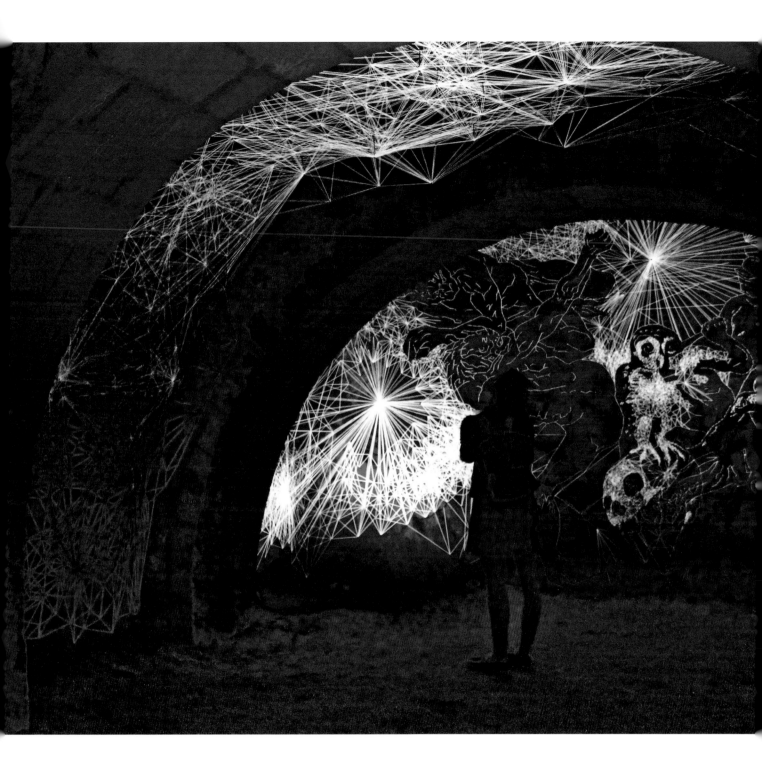

FONTEVRAUD L'ABBAYE ROYALE, JULIEN SALAUD

In the cellars of the Maison Ackerman at Fontevraud, artist Julien Salaud installed an original work, titled "The Crypt of Owls." In the underground stone vaults, Salaud constructed ephemeral 3D illustrations with white thread and nails to narrate the central themes of The Passion of Christ, as portrayed on the walls of the chapter room of the Royal Abbey.

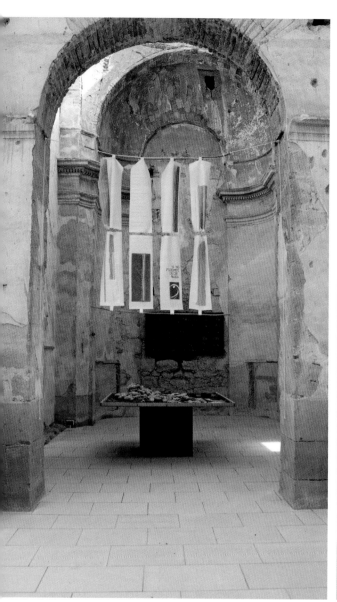

CHURCH OF SANT PERE

The Church of Sant Pere sits on top of Montera Mountain and overlooks the village of Corbera D'Ebre, Spain- a witness to one of the most intense and brutal combats in the Spanish Civil War. The ruins of this violent 1938 battle remain virtually untouched and serve as a silent reminder of the devastating effects of war. In the 1990s, the Catalonian Parliament declared Corbera D'Ebre a place of historical interest. The village was transformed into a cultural center and universal monument to peace to which artists are invited to exhibit their work. As visitors ascend to the church, they walk through "The Alphabet of Freedom." A collective work of 25 different

pieces based in semiotics, "The Alphabet of Freedom" explores the symbiotic relationship between cooperation and mutual understanding in a peaceful and just society. The Romanesque Church of Sant Pere, consecrated in 1022, is located at the top of the walk and hosts temporary art collections. Architect Ferran Vizoso's intervention strategy of "embracing" sealed the interior of the ruins with a transparent roof, which simultaneously prevents further deterioration and allows the blurring of the exterior with the interior. The building and the artwork invite reflections on peace in the memory of war.

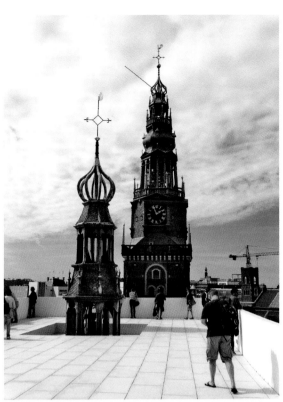

OUDE KERK

An 800-year-old church located in the heart of Amsterdam's main red light district, Oude Kerk serves as a unique host for religious and cultural activities alike. The transformed church invites a constantly changing schedule of artists, designers, musicians, writers, and architects to display their work. In the summer of 2015, Japanese artist Taturo Atzu, whose contemporary work transforms viewers' experiences of statues and monuments, installed "The Garden Which is Nearest to God." By providing new circulation to a temporary platform on the church roof through the addition of temporary scaffolding, Atzu facilitated close access to elements of church architecture that are typically restricted to the public. This radical transformation of Amsterdam's oldest building speaks of the gradual shift from religious spaces to cultural spaces; the furnishing of the top terrace as a contemporary Dutch living room references the classical notion of church as meeting place.

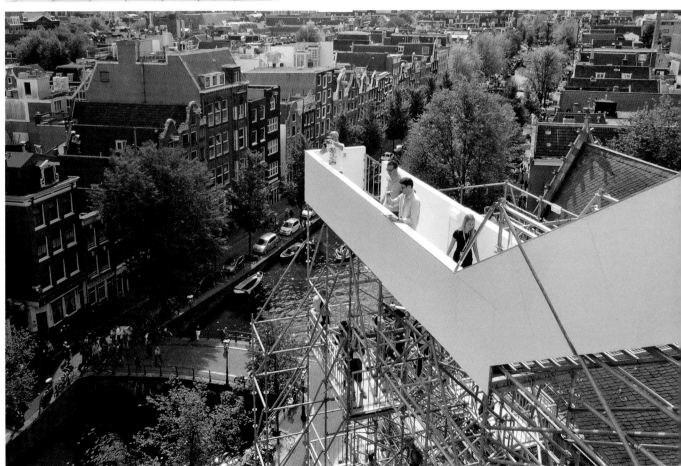

CONSTRUCTING
"documenta"

by MARIEL VILLERÉ

A lightweight temporary structure formed by taut, irregularly shaped, heavy cotton fabric provided shade for the music performances programmed at the 1955 *Bundesgartenschau* (Federal Garden Show) in Kassel, Germany. Not yet widely recognized for its remarkable form, the music pavilion was Frei Otto's *first* tensile structure experiment, a textile "two-up, two-down"[1] tent typology that made the architect-engineer famous. With only a few points of contact on the ground, the structure expressed the new modern lightness and mobility of a cultural momentum towards integration with the democratic west. Though interrupted by World War II, the biannual *Bundesgartenschau* continued a long German horticultural tradition and traveled throughout East and West Germany in the years following the war as a catalyst for regenerating ruined cities from the gardens and parks outwards.[2] In 1955, landscape architect Hermann Mattern designed the gardens and show for Kassel.[3] Although ultimately sited at the city's historic and rebuilt Karlsaue Gardens, Otto's pavilion was originally proposed for the city's central plaza, Friedrichsplatz, to house a show of modern art being organized by painter, exhibition designer, and local art school professor, Arnold Bode. Bode saw an opportunity in the anticipated garden show and global attention on Kassel for a built-in audience, something advantageous for the art exhibition. Rather than in Otto's innovative shelter, Bode would install the art exhibition in an established–but ruined–building with legible history that would tangibly interweave with the exhibit design and artwork in what he called *Inszenierung* (mise-en-scène). The exhibition-event would be called *documenta: Art of the Twentieth Century* and would be a museum for one hundred days.

In the liminal time between a violent, nationalist history and a hopeful, democratic future, the 1779 Fridericianum building, unlike the nomadic tent, provided the space and necessary cultural grounding for the art that had been banned as "degenerate" and stolen by the Nazi party in the decades prior.[4] A former library and Enlightenment-era cabinet of curiosities, the neoclassical Fridericianum had been damaged after successive bombings, but by 1954, it had been provisionally

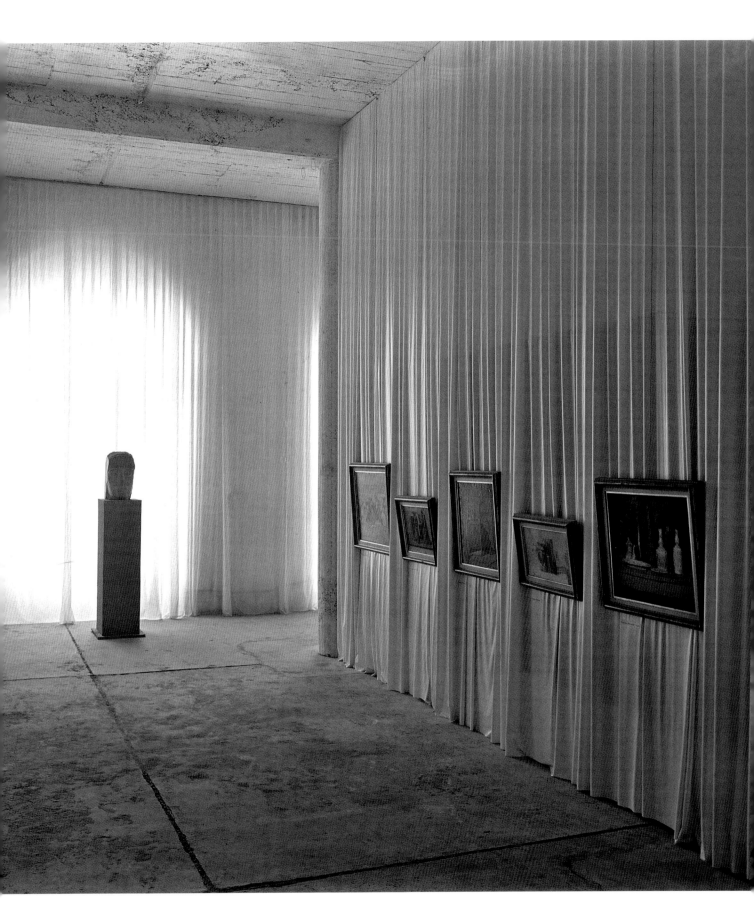

Milky white galleries on the first floor of the Museum Fridericianum where
Göppinger plastics and homasote boards shape the gallery space and blur interior/exterior.
Photograph: Gunther Becker © documenta Archive.

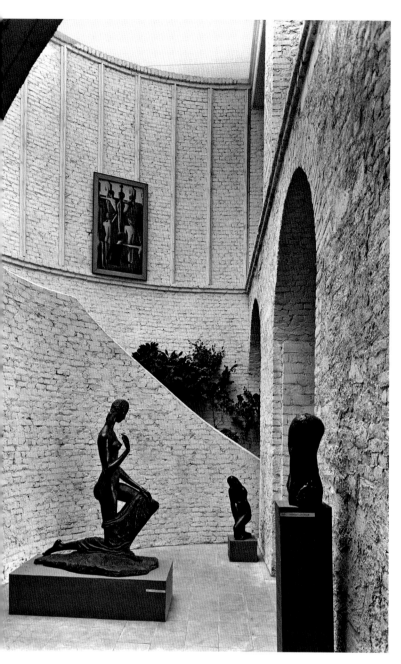

additions, sometimes precariously balancing concepts and sensibilities assigned to the particular temporal realities. The first *documenta* recombined parts of the original building's exhibition design elements and installed painting and sculpture in an alchemic formula for the reinterpretation of modernity through architecture and art in postwar Europe. This paper explores the spatial conditions of the building's galleries, specifically the typology and variation on the wall, as a rich territory for conditioning a new type of exhibition viewer.

As the city of Kassel, a microcosm of a continent in reconstruction, sought to clean up the rubble and rebuild its war-torn city center, the *Hessische/ Niedersächsische Allgemeine* (HNA) regional newspaper solicited ideas for the damaged Fridericianum. A 1954 article expressed a universal sentiment, "What surfaces! What space! In terms of floor space, it comprises almost two acres (5,000 square meters); the rooms and halls are so unusually high, and the reconfigured space is so enormous that one can hardly imagine what a building of this size would cost today."[5] In fact, Kassel *could not* imagine building a new structure of the same size in the midst of reconstructing the city with housing for its displaced citizens as a priority. However, Arnold Bode *could* imagine using the façade that was still available to make a statement of cultural progress and subvert ideas of permanence and obsolescence. In the same stroke, the city of Kassel found a new tenant for its most impressive and historically symbolic piece of architecture. A two story[6] neoclassical structure, the Fridericianum is flanked by six ionic columns along a central porch and topped with a pediment declaring its Latin name. Seven pilasters rise on each side of the pediment, alternating with arched Palladian windows on the first level and square windows on the second. Located in the center of the city, the Fridericianum represented Enlightenment ideals in its form and program over nearly two centuries prior to *documenta*. Therefore, the staging of the exhibition in the Fridericianum represented Kassel's aspirations of returning to tolerant politics and a humanist society, a sentiment emphasized by the building's scale. Within a flattened urban landscape, the Fridericianum's impressive structure was significant as a beacon of hope for civilization and thus, for housing art once again.

In supporting the display of modern abstract art, Kassel asserted its liberal democratic governance against the former National Socialists, as well as against the German Democratic Republic's single-party communism and its dominant artistic style, Soviet Realism. As Kassel transformed into a hub of abstract and expressionist art in 1955, the exhibition "softly" conditioned the viewing public to accept modernist thought and ideals. Furthermore, content shown at *documenta*, although 'mainstream modernist' for most of Western Europe, yet still 'new' for Germans, championed the European hybrid as an alternative to the polar Sovietiza-

rebuilt by the city. Reduced to a shell of its former self, the building could offer flexibility to the interior design and liberation to the modern viewer. Bode's 1955 precise architectural intervention for a temporary exhibit dissolved a tense rebuilding dilemma and presented an early form of adaptive reuse, emphasizing the shared internationality of neoclassical and modern styles. At the time that Bode conceived of this aesthetic and economic solution, reconstruction precedents sat firmly in either demolition or preservation, that is, building facsimiles of former structures. As we know it to be defined today, the practice of "adaptive reuse" reanimates salvageable pieces of buildings with contemporary

Wilhelm Lehmbruck's *Kneeler* (1911) in the Museum Fridericianum Rotunda. Paintings by Oskar Schlemmer were hung along the stairway. Photograph: Gunther Becker / © documenta Archive.

tion in East Germany and Americanization in the West. As a display of modern art and also an event, the exhibition sought to cross-fertilize artists and ideas across Europe, despite the impediment of cultural flows across the metaphorical iron curtain, just thirty kilometers northeast of Kassel.

Arnold Bode started scheming an art exhibition at a similarly ambitious scale as early as 1946 with his colleagues at the Kassel Werkakademie when he cautiously wrote a letter to Teo Otto asking how one would *go about* executing an international exhibition.[7] Once the *Bundesgartenschau* was confirmed to come to Kassel in 1955, city and state governments made the necessary financial undergirding available, and Bode began to harness the ingenuity of his colleagues, including Hermann Mattern, to develop a design. A collection of exhibition ephemera from the early 50s held in the *documenta* Archiv points to a range of inspirations, most notably the 1953 Picasso exhibition in the shell of the Palazzo Reale, Milan, to which Bode traveled on a visit.[8] After this visit, Bode would accept ruins as an aesthetic, putting the architecture on display, neither enclosed in a display case, nor rebuilt in the tradition of Romantic artificial ruins, nor through ersatz reconstruction–but rather with historical fidelity and tangibly "as is." Although preservation had its advocates, Bode being one of them, concepts of preservation in postwar West Germany were generally vague and undirected, wavering between historical amnesia and intentional forgetting of the recent violent past. In a state of rebuilding urgency, few took on the challenge of "enhancement" as an early and imprecise form of adaptive reuse or bricolage, but Bode led that effort for the Fridericianum. The state made provisional improvements after the war[9]: the plank and slate roof was raised, interior and exterior walls were reinforced with a cement mixture, and replacement windows were installed.[10] The original brick structure was left exposed, the sandstone base showed signs of damage, the marble façade was unevenly patched, and Bode was left with two floors to install artwork.[11]

On a later trip to Italy, Bode visited the 1954 Venice Biennale and introduced himself to art historian Werner Haftmann in one of the city's cafés. After long and inspired discussions, Haftmann was officially brought on board and offered an incisive editorial perspective to the selection of works included in the exhibition. Artwork that was sought after for temporary loans followed his recently published authoritative textbook, *Malerei im 20er Jahrhunderts* (Painting in the 20th Century) written between 1950 and 1953[12] and published in Munich in 1954 by Prestel-Verlag, the same publisher of the *documenta* catalogue in 1955.[13] Haftmann's book organized the material based on "the problems with which the artists were concerned"[14] rather than chronologically or by nationality, so as not to impede the organic development of modern art with an imposed order.

Similarly organic, the exhibition would translate the textbook's content and historical approach into an immersive environment without linear or strictly dictated paths.[15] Separating discourse from content, Bode was interested in creating a visual understanding of architecture and art, or as I argue, art *through* architecture.[16] Critics at the time wrote of the exhibition's architecture and design as having captured the *Zeitgeist* more powerfully than the work put on display.[17] The two were seen as codependent; design contributed a model of art as experience, away from the traditional setting of an edifying Museum. Rather than imposing interpretive wall text onto the artworks, each piece was accompanied by only the artist's name and a reference number. The art could speak for itself. For an affordable price of five marks, however, viewers were offered a 240-page exhibition catalog, complete with 156 illustrations in black and white and 12 in color, to take home the art historical content of the exhibition, effectively a smaller version of Haftmann's textbook.[18] What couldn't be transported from the site of *documenta*, however, was the Fridericianum and Bode's interpretive exhibition design.

With his art students as assistants, Bode reconfigured the interior structure of the Fridericianum as a modernist gallery behind the building's conserved façade. The gutted Fridericianum afforded flexibility within the regular framework, large volume, altered mass, and resonant history. Concepts of "time" were inscribed in the exhibition design on multiple metaphorical registers as the decay seemingly continued, was paused, or partially reconstructed through the Fridericianum's walls. Rubble and dust from the most immediate history lurked behind the swept spaces, the material liberated from the previously confined axial symmetry and gravity of the neoclassical interior. A new open floor plan reflected the open political boundaries sought after by democratic West Germans.

Architectural variety in linear details–including the canopied grid sub-architecture that pushed through and beyond thresholds, variety in wall treatment and texture, and attention to light–all suggest deliberate design decisions, even if improvisational in a repurposed structure. A painter and exhibition designer, Bode's interest in architecture is arguably concentrated in the elemental wall and its many material iterations and effects that complicate the line between art and architecture, architecture and product. Original walls had been reinforced with applied concrete, left rough, and painted white without replacing the interior ornament.

From the "unfinished" and "provisionally" restructured building, the exhibition brochure reads, "the show is organized in spaces of unusual dimension." That is, small cabinet-sized rooms meant for intimate viewing experiences offset the unusually large rooms. Before handing over the building to Bode, the state installed

roughly fluted columns in the footprint of the former Ionic columns. Stripped down ghosts of a previous architecture and program and evocative of the Brutalist *pilotis*, the columns connected the building to the land and place while allowing a freed floor plan and sense of lightness or floating in the architecture. Between the columns, Bode installed thin planes of lightweight materials to further divide the space, transforming the rigid neoclassical museum grid to a playful zigzag maze and engaging the architectural frame of the exhibition house with a unique fluidity. Homasote panels and the sheer plastic sheeting alike were conceived as partitions between inner and outer space. Even some of the solid walls hovered, disrupting any traditionally clear connection between load and support. Screens fashioned from different materials distinguished sections of the gallery from one another while maintaining a fluid continuity of the whole in a unified rhythm, "different from walking through the clearly circumscribed spaces of traditional museum architecture, or the tedious line-up of booths at trade fairs," like those at the garden show across the ring road.[19] In the modern interior, the viewer could create her own experience, and the flexible floor plan reciprocally shaped a new postwar subject.

Having visited the ruined Palazzo Reale, Bode realized that an entire exhibition space could be constructed from planks, drapes, and plastic wall cladding, and he absorbed these techniques for *documenta* and sought donations from local material companies. He fashioned the exhibition on-site from three primary materials: partitions made from Heraklith-manufactured panels of compressed straw and concrete—commonly known as homasote; concrete blocks to form walls; and plastic sheeting as a transparent and soft boundary that elegantly appropriated the modernist architectural language of his time to alter the interior proportions. Unlike a white cube,[20] Bode's Fridericianum was porous and in motion; it brought both the art and the architecture into spatial dialogue with their context; the gallery space was kept sacred but not isolated. Material treatment linked past and present, tradition and innovation, space and object, senses and memory. The "near brutal" design was sensorial beyond touch and appearance—the combination of new plastic curtains and the concrete, still wet on opening day, gave the space a particular scent. As one visitor (and volunteer seamstress of the plastic curtains) remembered in a personal interview, the exhibition would not have been the same without the immersive scent and dampness of the materials that created a living, breathing environment of art and architecture.[21]

Revealing the haphazard "as found," or "as donated" necessity of the show, the floor surfaces varied dramatically from room to room, lending themselves to interpretation and thus further blurring the lines of materiality. Provisional concrete reads in the exhibition photographs as dirt in some views, and as carpet in others—referencing the garden and the trade fair in one move. A designer for trade fair booths himself, Bode developed decorative forms and a modular stand system for the Göppinger Plastics Company in 1951 at the Constructa building exhibition in Hannover. It is here that we see that plastic sheeting, the most representative "exhibition technology"[22] in the 1955 *documenta,* may also have informed the exhibition's name. Scholar Christoph Lange has placed the *documenta* title in the lexicon of interior design, or a "spin-off of the '1950s advertising neologisms'" including the *Constructa* exhibition, the German furniture manufacturer *Korrekta,* and the synthetic fabric line *Abstracta*, a material that Bode used in several design series for the Kaliko- and Kunstleder-Werke GmbH in Göpping, Germany.[23] Göppinger Plastics donated their signature sheeting (later to be reused by the company in a reciprocal adaptive reuse strategy) to *documenta* in 1955.

In the Fridericianum, Bode used black and white Göppinger plastic sheeting in three distinct manners: as window coverings, as skins over the rough brick walls, and as sheathing for the homasote walls to create yet another texture to the vocabulary. More than displaying the material properties of the plastic, the wall treatment enhanced or shifted the reading of the art hanging on it, playing with color, black, and white. The exterior environment was suggested by transferred movement, light filtered through the diaphanous white plastic, and shadows of the windowpanes were projected, adding another dimension to the wall. Whether they fluttered at the edge of the windows or stretched nine meters from the ceiling to floor, the plastic sheets revealed stresses through folds and wrinkles, suggesting new possibilities in the materiality, or dematerialization, of architecture. Furthermore, at the points of adjacency or intersection between neoclassical and modernist, where arched doorways were rectilinearly bisected, or axes were closed off by curtains, the larger implications of adaptive reuse in shifting historical provenance are illustrated.

Along the length of the central hallway to the main galleries, white plastic sheets brushed the coarse concrete floor and softened the brick in the structure's impressive arched doorways. Horizontal beams across thresholds recalculated the interior proportions for a modernist sereneness and brought the architecture to human scale with simple lines, particularly in the double height of the second floor. In the Grand Hall, a black wooden trim traces the outline of the former floor plate, encircling the void and floating an implied ceiling. Painted black to look like welded steel, the aesthetic of these stock wooden beams likens itself to modernist architecture and the style's allegiance to industrial materials. To create more wall space for paintings, Bode installed temporary walls covering the windows on the

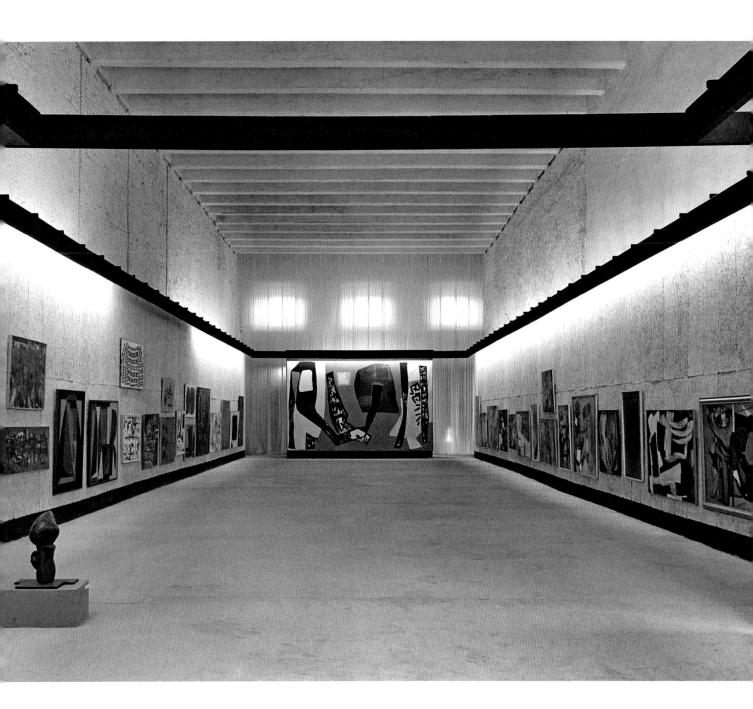

façade, shearing planes of old and new and adjusting the architectural proportions for the visitor, treated for the act of viewing art. This technique was carried through with independent pergolas in each room, self-referencing fragments that carried the viewer throughout the exhibition's entirety in the architectural language of the garden. The pergola frame also served to disguise necessary artificial lighting to supplement natural light muted by the curtains. Using the same inexpensive and modular trade fair construction for an exhibition of "high art," *documenta* elevated modular units to autonomous design elements.[24] Material choices and their installations rhetorically question the clarity of boundaries between neoclassical and modern; the trade fair and the garden; art, design and architecture.

More than just a simplified white wall for hanging pictures, the gallery materialized as a medium for making art from architecture, an opportunity that Bode would take advantage of in the Fridericianum by framing the spaces *between* the frames. Paintings were set out from the wall, drawing attention to the "primitive quality" of the bricks, and leveling architecture with art, unfold-

Museum Fridericianum Große Halle, 1955
With Fritz Winter's Composition on the far wall.
Photograph: Gunther Becker / © documenta Archive.

ing in real time and space. Mondrian's grids pressed out into the gallery, continuing from the canvases into the geometries of the concrete building blocks. In the rotunda, the white bricks were reciprocally framed with lumber painted white, alternating with paintings by Oskar Schlemmer that mimetically evoked climbing or traced motion up the stairs, making the viewer part of the picture in a new, alternative, and shared space. On the second floor, the height of the Grand Hall signaled a lightness and transcendence that was capped by the mezzanine gallery on the third floor.

Bode intended to "display each work in a dignified, meaningful and interesting way, and to create lively interaction with the viewer."[25] Borrowing the "key experience" of interaction from the Palazzo Reale and the lightweight modular construction of trade fair installations, paintings were hung on vertical rods set off from the brick walls and balanced on short poles with a light touch on the rough floors, echoing the ≪d-o-c-u-m-e-n-t-a≫ signage panels in the plaza and linking the gallery space with the urban space. Combined with the walls that seemed to float over the floor, the lightness of the poles suggested the possibility of taking flight and the autonomy of the art from a "home," that is, from the Museum.

As if a stage, the exhibition moved bodies with surprising turns and vantage points, reminiscent of the possibilities in a garden, specifically that outside of the walls of the Fridericianum. Though the liberated architectural plan suggests diversified pathways, the second exhibition brochure depicts on a mathematically gridded sheet, one of the only architectural plans of documenta, complete with measurements of the improvisational building, imposing order on the otherwise intuitive architecture and design, transforming the architecture itself into a graphic. As a total environment, the plastic altered and dignified the atmosphere over the course of a viewer's movement through the exhibition. Thresholds played with negative and positive space—in one view, a narrow passage to the Chagall "cabinet" traces the silhouette of a column with stepped bricks toward the ceiling. On one end of the long central hallway, white plastic curtains weave and bundle behind the black arms of Toni Stadler's sculpture, *Standing Woman*, at the threshold of room 15, pointing first to the wall's temporary and nebulous character, and second, to its perambulatory function.

Viewers scrutinizing archival photographs are left with the question: were visitors free to create their own paths, even if they disrupted the designer's carefully placed plastic sheeting? Bode's design nods to the flexible floor plan of modern architecture within the original neoclassical framework. While the temporary walls may not have strictly regulated movement through space or defined private from public, they suggested spatial configurations, created a modern environment

as an extension from the artwork, and blurred the lines between art, exhibition design, and architecture. Installed in the warmer months over spring and summer, the 100-day museum did not need to be hermetic. The ruined exterior walls and unrestricted interiors created new fluidity between indoor and outdoor, between the gallery and the garden, between art and life. Furthermore, as an intercessor between architecture and art, the exhibition design performed as a provocation for visual understanding, and for what John Dewey would call "re-aggregating the social sphere" through "full bodied freedom and self determination."[26] The charged and restituted degenerate art on display at documenta especially provoked the viewer to imagine new political possibilities in a post-isolationist Germany and across Europe. This translated to the impact of art on both the universal human experience and individuals as sentient beings, ultimately elevating the quality of life.

In a tense mediation of the recent past with hope for a peaceful future, the postwar West German subject simultaneously reached outwards—outside of herself, outside of Germany's borders—and inwards, to understand her own nature as an individual. The documenta exhibition participated in this fold, a cross-directional search from the Museum to the urban context, to the reconstituted German identity and the international arena. Using the symbolism of the building's neoclassical façade and its metaphorical foundations, documenta absorbed historical relevance and legitimacy in order to reintroduce modern art for the spiritual health of Germans. Emerging from isolation could not happen at a specific point in time or place, but would be continually defined by shifting external circumstances. documenta in 1955 would not be the end, but rather one point in a process of political and cultural transcendence from the Third Reich, arguably superseding the traveling *Bundesgartenschau* as an internationally recognized cultural fixture. documenta continued in Kassel in 1959, 1963, and then every 5 years thereafter; its next installment will open in 2017. It has become an influential transnational index of the world's most highly regarded contemporary art. The five-year schedule, flexibility, and autonomy from the constraints of the traditional museum format create possibility for responsiveness, which has kept the show relevant as an episodic institution. In 1955, external circumstances and organizational structures tethered and stabilized the contours of the event and resisted an "escape" from the past as suggested by simply placing modern art within Frei Otto's ephemeral tensile pavilion. documenta did more than insert Germany back into the global modern art world with historic pieces that had been barred. Through pioneering adaptive reuse, the exhibition-event demonstrated forward movement, transitioning the space of the museum from a historicizing institution to a flexible, contemporary, urban, and international force.

ENDNOTES:

1 "Frei Otto," The Pritzker Architecture Prize/Hyatt Foundation, last modified September 8, 2015, http://www.pritzkerprize.com/sites/default/files/file_fields/field_files_inline/2015-PP-Photo-Booklet.pdf: 28-30.

2 The *Bundesgartenschau* was presented for the first time after World War II in Hannover in 1951 and then in Hamburg in 1953 before Kassel in 1955.

3 Frei Otto would continue to iterate his pavilion structures for the *Bundesgartenschau* after 1955. He installed the Entrance Arch and the Dance Pavilion at Cologne in 1957, and then expanded the form to house the entire Hall at Hamburg in 1963. "Frei Otto," The Pritzker Architecture Prize/Hyatt Foundation, last modified September 8, 2015, http://www.pritzkerprize.com/sites/default/files/file_fields/field_files_inline/2015-PP-Photo-Booklet.pdf.

4 Having assembled 670 pieces of sculpture and painting from galleries and collections in Western Europe and America, *documenta* was the first exhibition that endeavored to enthusiastically introduce modern "art of the twentieth century" to the general public since the encyclopedic Dresden Exhibition in 1927, as referenced by Haftmann in his introduction to the exhibition catalog. More poignantly, it was the first exhibition of its kind since the Third Reich forbade the production and display of modern art, culminating in the *Entartete Kunst* exhibition of "degenerate art" in Munich, 1937.

5 "Museum Fridericianum als Ausstellungsbau," *Kasseler Lokalausgabe*, HN Nummer 31, 6. Februar 1954. Retrieved from the Stadt Archiv, Kassel.

6 Prior to the damage from the war, the Fridericianum was three stories, the uppermost an attic.

7 Arnold Bode and Heiner Georgsdorf, *Arnold Bode: Schriften Und Gespräche* (Berlin: D & S Siebenhaar, 2007), 304.

8 In a 1977 interview in Kunstforum, Bode cites the Picasso exhibition at the Palazzo Reale, also in ruins, as inspiration for inserting modern art within a war-torn, "primitive" structure. Georg Jappe interview with Arnold Bode, "War wieder eine großartige Ruine da...," *Kunstforum International* 21 (1977): 212.

9 It wasn't until 1962 that the façades were dealt with, which required 100 different processes, and cost 600,000 DM. "Kunststeinwerk arbeitet Tag für Tag" *Kasseler Stadtausgabe*, August 21, 1963.

10 "Kunststeinwerk arbeitet Tag für Tag" *Kasseler Stadtausgabe*, August 21, 1963.

11 Photographs of the Fridericianum after the fire in 1941 show that both floor plates had collapsed, but by 1954, that which separated the first and second floors was rebuilt. Bode would occupy the two floors with *documenta* as well as the partial floor just bordering the rotunda on the third floor.

12 As the back cover of the English version boasts, the textbook "was originally published in English in 1961 as a boxed set of two volumes at 12 guineas. It was immediately acclaimed as a new standard work on modern art, brilliantly analytical and breathtakingly comprehensive."

13 Ian Wallace, *The First Documenta, 1955 = Die Erste Documenta, 1955* (Ostfilern: Hatje Cantz, 2011), 1

14 Werner Haftmann, *Malerei im 20. Jahrhundert* (English: *Paining in the Twentieth Century*) (Munich: Prestel-Verlag, 1954), 9.

15 Haftmann's book served as a theoretical "script" for *documenta*, so much so that the book has been referred to as the "imaginary documenta" by Eduard Trier, paralleling the title of Malraux's "imaginary museum," which was in Bode's personal library and has surfaced through loose references as an important informant in the conceptualization of *documenta*. See Annette Tietenberg's essay, "An Imaginary *Documenta* or The Art Historian Werner Haftmann as an Image Producer" for further reading, *Archive in Motion: 50 Jahre documenta 1995-2005*, edited by Michael Glasmeier and Karin Stengel (Göttingen: Steidl, 2005), 35-45.

16 Players involved with *documenta* naturally had different opinions about the role of the exhibition, the first of its kind. While Bode stressed the sensorial aspects of the exhibition's design and Haftmann, the content of the artwork, Bode's assistant is reported to have said that the "chief aim of the venture was to instruct people's minds." Christoph Lange, "The Spirit of *Documenta*," in *Archive in Motion: 50 Jahre documenta 1995-2005*, edited by Michael Glasmeier and Karin Stengel (Göttingen: Steidl, 2005), 14.

17 Charlotte Klonk, *Spaces of Experience: Art Gallery Interiors from 1800 to 2000* (New Haven: Yale University Press, 2009), 175 (fn 12).

18 This token of the exhibition was popular, and necessitated a second print run. By the end of the show in 1955, 14,000 copies were sold.

19 Hans Haacke, "Lessons Learned," *Tate Papers: Landmark Exhibitions Issue* 12 (2009): http://www.tate.org.uk/research/publications/tate-papers/12/lessons-learned.

20 Bode's Fridericianum sits just outside of the lineage of the "white cube," of which only a short history precedes *documenta* in 1955, and after which the term developed the fuller and more readily accepted definition in the 1960s. We can take Brian O'Doherty's tenets as the prevailing definition of the "White Cube" gallery space: "The outside world must not come in, so windows are usually sealed off. Walls are painted white. The ceiling becomes the source of light... The art is free, as the saying used to go, 'to take on its own life'...untouched by time and its vicissitudes." Brian O'Doherty, *Inside the White Cube: The Ideology of the Gallery Space* (Berkeley: University of California Press, 1999), 15.

21 Enne Lux, in discussion with the author in Kassel, January 15, 2013.

22 This term comes from the undated second draft of the *documenta* committee's "Sales letter to the industry," *documenta* Archiv, Mappe 6a. Commercial sponsors also included Rasch Tapetenfabrik (wall coverings), Eternit AG (fiber and cement products) and Siemens AG (which donated light bulbs). *documenta* Archiv, Box 1, Folder 6a, *documenta* 1 Collection, Kassel.

23 Ernst Schuh, Bode's assistant at the first *documenta* in 1955, quoted in Christoph Lange, "The Spirit of *Documenta*," in *Archive in Motion: 50 Jahre documenta 1995-2005*, edited by Michael Glasmeier and Karin Stengel (Göttingen: Steidl, 2005), 14.

24 Roger M. Buergel, "The Origins" in *50 Jahre Documenta: 1955-2005*, edited by Michael Glasmeier and Karin Stengel (Göttingen: Steidl, 2005), 177.

25 Arnold Bode, *documenta* Archiv, *documenta* 1 Collection, Kassel.

26 John Dewey, *Art as Experience* (New York: Minton, Balch, 1934).

"WORN HALF AN INCH DOWN"

AUTHENTICITY OF DIGITAL REPLICAS

by CHRISTOPHER WILLIAM BROWN

This paper documents the design and making processes involved in the author's production of a sculptural intervention within the walls of a 'controlled ruin' in Newcastle Upon Tyne, England, U.K. The proposed installation is part of a practice-based research project that is exploring, recording, and representing techniques for the material aesthetics of ruination in architecture. These processes are contextualised within an archaeological framework of traditional and contemporary theory regarding the 'authenticity' of architectural restoration, preservation, and adaptation. Ultimately, this paper is a reflection on installation and intervention in a ruin, by means of 3D laser scanning and digital fabrication processes. Furthermore, this paper is an analysis of the potential for challenging traditional notions of authenticity in architectural reuse. A number of pertinent questions relating to these fields are raised as a result of the ongoing sculptural practice.

West Alcove Mk.2 (A WORK IN PROGRESS)

The installation project was initially conceived in response to a passage in John Ruskin's *Seven Lamps of Architecture*. In this text, Ruskin's argument for the inappropriateness of restoration through replication was based on the idea that such restoration was impossible at the time when he was writing. Ruskin wrote, *"And as for direct and simple copying, it is palpably impossible. What copying can there be of surfaces that have been worn half an inch down? The whole finish of the work was in the half an inch that is gone; if you attempt to restore that finish you do it conjecturally; if you copy what is left, granting fidelity to be possible, how is the new work better than the old? There was yet some life, some mysterious suggestion of what it had been, of what it had lost."*[1] In the 150 years since the publication of this text, surveying and manufacturing technology has advanced to a point at which the replication that Ruskin declared impossible is now entirely possible. Today, the possibility of replication and reconstruction of weathered architecture presents a chance to explore and challenge Ruskin's questions and statements regarding the appropriateness of this practice to the adaptation of architecture. The proposed installation, entitled *West Alcove Mk.2*, consists of a 1:1 physical replica of a section of the existing ruin of Lord Armstrong's Banqueting Hall that is placed within the physical context of the ruin. The work is formed through processes of 3D laser scanning, digital fabrication, and rapid prototyping, in order to produce a replica form from a low density modelling board.

What copying can there be of surfaces that have been worn half an inch down?

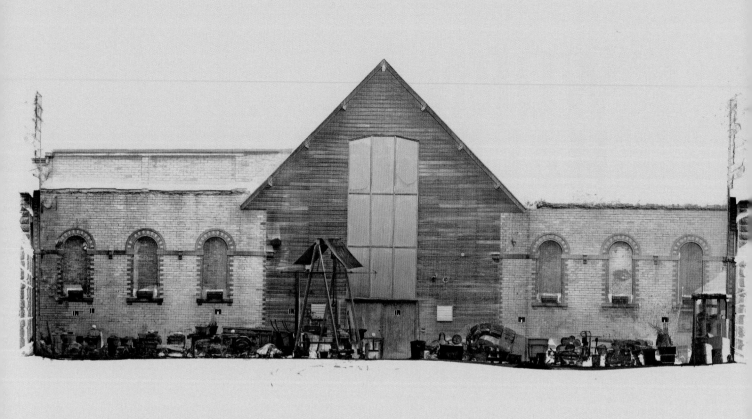

By using examples from the author's practice, this section of the paper demonstrates that it is possible to produce a 'physical replica' of the surface of an architectural ruin, i.e. an object that shares the morphology of the original object, through digital surveying and rapid prototyping techniques. Over the last 15-20 years, 3D laser scanning systems have been used with increasing frequency for building surveying, forensics, and engineering purposes. The technology uses a laser to measure distances from the position of the scanner to the nearest physical boundary and represents the information as a 'point cloud,' a series of points organized on a three-dimensional coordinate system. In combination with these measurements, high resolution photography determines the approximate real life color of each point in the form of a RGB value in order to generate full colour scan data.

This type of three-dimensional information can then be used to produce accurate 3D models of existing architecture. A point cloud has no 'surface;' it is merely a collection of points in space. Therefore, a 'solid' computer model must be formed to allow the manufacturing of the sections of scan data. This process could be analogized as throwing a blanket over the points in space.

The capturing of high resolution scans for specific areas allows for the formation of a point cloud in which the vertices are very close together. This density of points allows for the formation of a complex mesh, which accurately represents the original object. As the computer program triangulates the points closest together to form a face, lower resolution point clouds translate into a faceted surface. From these meshes, physical replicas or moulds for replicas can be manufactured through digital fabrication processes such as 3D printing and CNC milling.

A Berlin-based 3D scanning company, 'TrigonArt,' has successfully completed this digital fabrication process by creating a high-resolution model of the Liebknecht Arch in Berlin that is suitable for 3D printing. Using this model as a basis, 1:1 sand based 3D prints were produced by the large-format 3D print manufacturer Voxeljet. Interestingly, these 1:1 models were involved in the production of a set of guides for the conventional stone sculptors to reference in the production of a replica of the original Liebknecht Arch. This example demonstrates the accuracy and viability of the digital replication of architectural objects based on 3D scan data.

The whole finish of the work was in the half an inch that is gone...

3D scanning captures surface and records the physical information about the outermost external envelope of an object; however, it is equally significant that the negative space is recorded. To one side of the point cloud is a solid mass, and to the other side is a void. This solid and void information allows for the revelation of an accurate cross section of an object. In the context of a ruin, this cross section often reveals the parts of a building that once existed but have now become detached, removed, or crumbled to dust. The processes of 3D scanning and digital manufacturing enable the reproduction of the "finish" of a work, including the "half an inch that is gone."[2] However, these processes also offer opportunities for the revelation of new information about a weathered object through the presentation of its cross section. The Banqueting Hall installation proposes the presentation of a cross section of the west alcove, and it is hoped that the presentation of this alternative perspective will offer the viewer a new opportunity to interpret the condition of the Hall.

If you copy what is left, granting fidelity to be possible, how is the new work better than the old?

I have established that it is possible to produce a copy of a ruin; however, Ruskin's final question in the passage is perhaps the most challenging. This is a question about authenticity; it queries the theoretical implications of the replica by challenging the motivations for producing a replica and questioning the essential purpose of the replica. I would agree with Ruskin that the production of a replica is a fruitless task if the replica is intended to replace an existing object. However, by side stepping the direct comparison between the original and the replica in this question, we may reveal more engaging questions about the authenticity of a replica. What if the replica is not intended to be better than the original? West Alcove Mk.2 intends to reveal something new about the original object and the immediate context in which it exists.

The processes involved in the production of "West Alcove Mk.2" are, in many ways, an attempt to generate objects that possess 'authenticity' through replication.

More recent literature on the subject of the authenticity of objects documents a movement from traditional 'materialist' approaches to a constructivist approach. In a recent review of this observation, Sian Jones[3] argues that authenticity is not directly linked to the material form and origin of an object, as characterised by a materialist approach. Jones believes that the authenticity of an object is attached to its social and cultural context. Thus, he appears to suggest that authenticity is generated by a sense of contact with past experiences and relationships. For the purpose of this investigation, I am interested in the following question: if an authentic object is simply able to communicate something of the

Milling Experiments In Low Density Modeling Board
Point Cloud Extract and Meshed 3D Print At 1–20 Scale

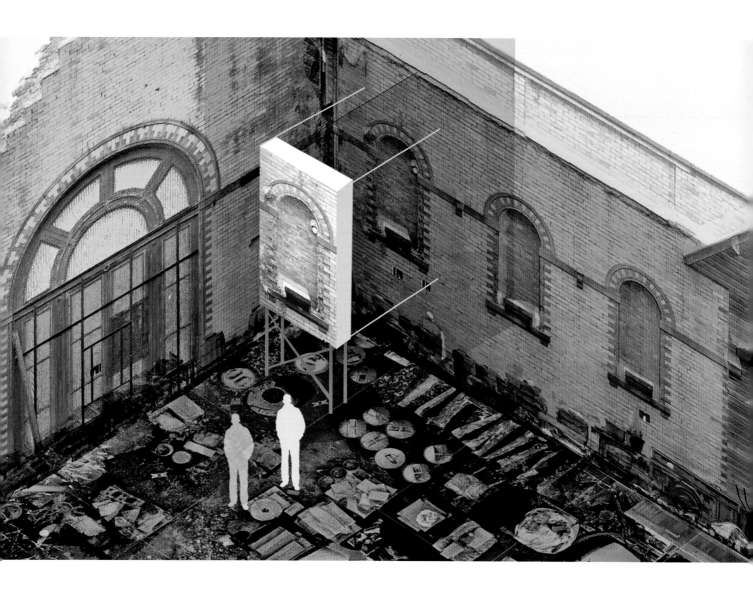

past, then by creating an object (using 3D scanning and manufacturing processes) that communicates something of past events, can this object possess its own authenticity?

It may be possible to generate a level of authenticity by considering the qualities identified by the constructivist approach to authenticity. Cornelius Holtorf [4] refers to a useful term, "pastness," which describes the ability of an object to communicate past events without necessarily being from the past. This idea challenges the traditional notions of authenticity in archaeology. According to this theory, it is no longer a requirement that an object be old in order for it to be authentic; on the contrary, it may be enough for the object to only possess 'pastness'.

What is "pastness," and how do we achieve it?

If an object appears old or is presented as old, does it possess 'pastness' and, by association, its own level of authenticity? This approach to authenticity is based on the perceived aesthetics of an object, rather than the knowledge of an object's origin. The notion of authenticity possessing 'pastness' shares the distinction that the perception of a place or object's history is based on its presentation. Holtorf identifies some material characteristics of objects that generate 'pastness,' and in turn authenticity. These characteristics attempt to define the conditions under which the materiality of an object generates 'pastness'. First, "*Pastness Requires Material Clues…An object's materiality speaks to its age through obvious traces of wear and tear, decay, and disintegration. Patina, cracks, and missing bits are hallmarks of an object possessing the quality of being of the past.*"[5] To summarize, objects must appear old in order to possess 'pastness'. Holtorf's second point is that "*Pastness Requires Correspondence with the Expectations of the Audience.*"[6] Here, he explains that an audience only perceives an object as being of the past if it adheres to

their preconceived ideas of 'pastness.' In other words, if something deviates from the audience's expectations, its element of 'pastness' is lost. The final condition that Holtorf identifies is that *"Pastness Requires a Plausible and Meaningful Narrative Relating Then with Now."*[7] This argument is based on the idea that people only perceive an object as being 'of the past' if they believe the historical narrative into which the object is presented. If the audience does not believe the historical narrative of the object, then the object can lose the authenticity of its 'material clues' or 'correspondence with viewers' expectations.' My question is this: if a replicated object holds all of the physical characteristics of the original, then why shouldn't it possess the 'pastness of the original object,' albeit indirectly? An object that is a replica in every way except in its construction satisfies the first two conditions for possessing 'pastness' and may have the potential to challenge the basis of Ruskin's arguments. The new object does not intrinsically hold the narratives of time through weathering, yet the qualities of the original may be copied in the accuracy of the replica.

This article has two primary intentions. First, it identifies the potential of using 3D laser scanning and digital manufacturing processes to reproduce accurate replicas of ruins. Secondly, it reflects upon theoretical questions regarding the authenticity of objects that arise from these new opportunities in 3D laser scanning and digital manufacturing. The production of an accurate 1:1 replica of a section of an existing ruin would be an opportunity that challenges traditional theory regarding the conservation, restoration, and general adaptation of ruins and heritage architecture. Ruskin's challenge of copying a surface that is "worn half an inch down"[8] has been satisfied. This fact stands to generate further questions, not addressed in this paper, pertaining to the 'appropriateness' of a recreation. It is argued here that laser scanning and digital manufacturing processes have the potential to reveal new interpretations of places of ruination. One specific example is their ability to capture and present a 3D surface abstracted from its original context; this allows viewers to see the cross section of a ruin object and reveals the existing fabric and the trace of the non-existent or *"the half an inch that is gone."*[9] It is suggested that the use of laser scanning and digital manufacturing for intervention in architectural ruin may have the potential to produce copies of original objects that 'inherit' the quality of 'pastness' and in turn may possess authenticity, providing that the narrative of their introduction is honest and legible. This paper is part of an ongoing installation project, West Alcove Mk.2. Hopefully, the sculptural work of West Alcove Mk.2 will reveal the potential of laser scanning and digital manufacturing processes for intervention within sites of architectural ruin and heritage, while simultaneously generating theory and reflections regarding the appropriateness and authenticity of working in this way.

ENDNOTES:

1 John Ruskin, *The Seven Lamps of Architecture* Chapter 6, "The Lamp of Memory" (Reprint edition New York: Dover Publications 1989, originally published 1849). p.194-195

2 Ibid

3 Siân Jones, "Experiencing Authenticity at Heritage Sites: Some Implications for Heritage Management and Conservation." *Conservation and Management of Archaeological Sites* 11(2), (2009) 133-147.

4 Cornelius Holtorf, "On Pastness: A Reconsideration of Materiality in Archaeological Object Authenticity" *Anthropological Quarterly*. 86 (2) (2013), 427–443

5 Ibid

6 Ibid

7 Ibid

8 Ruskin, p. 194-195

9 Ibid

WHAT ONCE WAS

by JENNA BALUTE

Existing structures serve as host buildings to architectural interventions that transform them into spaces with forms and functions. Art, in its various forms, has demonstrated an ability to intervene on the surfaces and spaces of such structures, deriving new forms of interaction and use for what already exists. Different artists have used existing architectural forms to produce artwork that not only serves as a remembrance of the architecture, but also capitalizes on the latent qualities of host buildings to create sculptures, thereby extending the relation between art and adaptive reuse. Artist Rachel Whiteread, best known for sculptures cast from ordinary objects and spaces,[1] evokes memory and questions monumentality through her use of existing objects and spaces. These objects and spaces host her explorations, which share some of the same questions architects ask themselves in adaptive reuse projects: What is the nature of the host building? What is its value prior to intervention? What is the relation between the host building and the new intervention? What is the impact of the new intervention on the host building and the site? Whiteread's architectural castings as sculpture provide a unique form of intervention strategy in adaptive reuse.

The Hosts: From Mundane Objects to Architectural Ruins

Whiteread's early works solidify spaces around, over, under, and in-between ordinary and familiar objects. Inspired from daily life, her sculptures explore domestic spaces and household objects such as beds, closets, mattresses, and bathtubs. Whiteread's interest in mundane objects is rooted in her quest to capture the human experience through the objects that we use, hold, and inhabit in everyday life.[2] These mundane objects become the hosts, from which Whiteread was able to

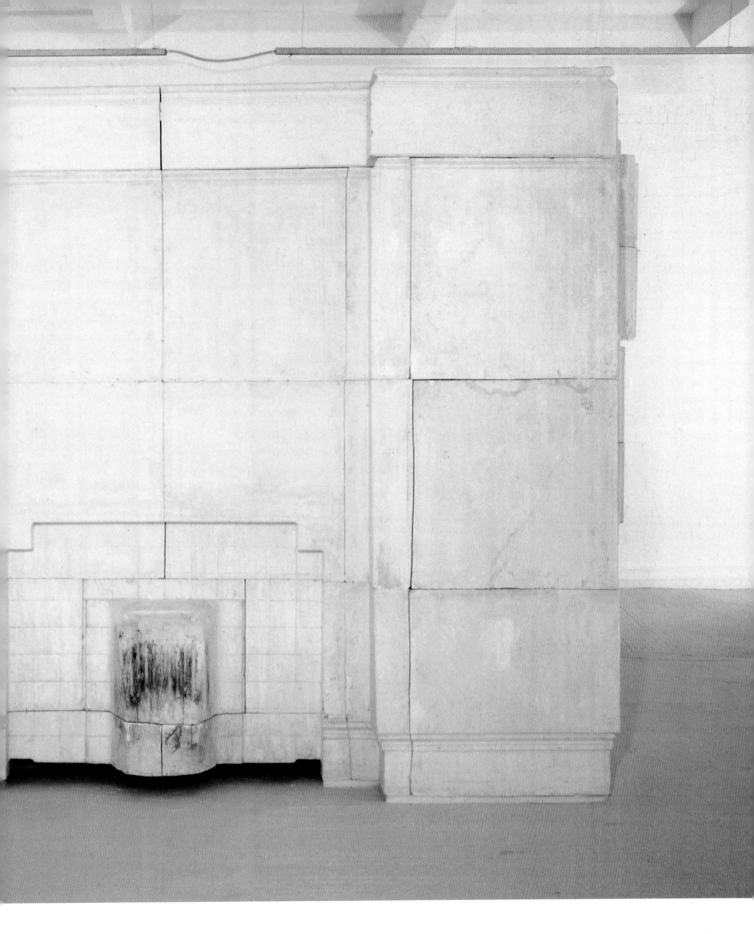

Rachel Whiteread, *Ghost*, 1990
Plaster on steel frame
106 x 140 x 125 inches (269 x 356 x 318 cm)
©Rachel Whiteread; Courtesy of the artist, Luhring Augustine, New York, Lorcan O'Neill, Rome, and Gagosian Gallery

create an array of sculptures that evoke stillness and contemplation.

Whiteread moved from casting household objects to casting entire rooms and buildings. *Ghost*, completed in 1990, is the artist's first piece that captures the interiority of an entire room. Using casting as her mode of production, Whiteread "mummifies the air" in a room of a Victorian house at 486 Archway Road, slated for renovation. After the success of *Ghost,*[3] Rachel Whiteread was awarded the Turner Prize in 1993 for her first public commission, *House. House,* a short-lived installation, is a cast of the interior of a condemned Victorian house on 193 Grove Road, in London's East End. It was demolished in January 1994, only 11 weeks after the project was conceived. Once a part of a neighborhood of Victorian terraced houses, the Grove Road area witnessed severe destruction during WWII. Following the war, the damaged terraced houses were replaced with prefabricated ones as part of urban transformations during the 1980s. By 1990, most of the prefabricated houses were substituted with new tower blocks, leaving 193 Grove Road the only terraced house remaining on the street. The model of the Victorian terraced house was replaced by social housing that manifested itself in concrete highrises. In such a changing urban context, 193 Grove Road could not stand the test of time, and it was eventually scheduled for demolition.[4] Both *Ghost* and *House* are the byproducts of architectural ruins (here defined as abandoned structures) that were struggling to cope with the transformation of their time.

Adaptive Strategy: Cast, Destroy, Reveal

In adaptive reuse, the lives of buildings are extended through interventions that seek to suspend these buildings in time or provide them with an afterlife. For Whiteread, casting is an adaptive strategy to temporarily extend the life span of condemned architectural ruins. In *Ghost*, the artist divided the internal elevations of the room into sections, which she casted in plaster. These sections became the building blocks of the installation and were assembled on a metal frame.[5] The casting technique adopted for producing *House* differs slightly. In *House*, the interior walls of 193 Grove Road were sprayed with a layer of concrete and then reinforced with a steel mesh. In both works, however, Whiteread successfully brings to life the illusion of solidifying space by casting the internal facades of the host structures.

The power of Whiteread's installations lies in their unique relation to the host structure; one that is characterized by absence. After the process of casting, the intervention and the host are separated, either as a result of relocating and reconstructing the intervention (*Ghost*), or as a result of demolishing the host (*House*). Both 486 Archway Road and 193 Grove Road served as molds for Whitread's sculptures. Here, the absence of the host structure is crucial to Whiteread's work; only by removing the host could her sculptures come to life.

Whiteread's interventions are inversions; they reveal the guts of the host building through negative casting and the absence of the host. In both *Ghost* and *House,* the interior of the building is turned inside out. The host building is transformed into a sublime mass with recessed friezes, indented cornices, and solidified keyholes and fireplaces. By reversing the perception of interior and exterior, one begins to understand the space by its interiority; this understanding cannot be gained by entering the space itself.

In her quest to intervene on threatened architectural ruins, Whiteread has adopted a specific strategy of adaptive reuse, which can be seen as a combination of restoration, conservation, and protection. According to Viollet-le-Duc, "to restore a building is not to maintain it, repair it or refurbish it, it means to reestablish it to a state of completeness that may have never existed, at any given moment."[6] In other words, one must return a building to a state of "completeness" by bringing it back to its essence. Whiteread literally portrays the essence of the host building by casting the inside of a house. She solidifies the spaces where domestic and everyday practices take place. As a result, she transforms the building from a shell that houses these practices to an installation that speaks of domestic life.

Contrary to le-Duc's restorative approach, John Ruskin believed that one should not intervene on the host building because "our duty is to preserve what the past has had to say for itself, and to say for ourselves what shall be true for the future."[7] *Ghost* and *House* adhere to Ruskin's philosophy of conservation as well.

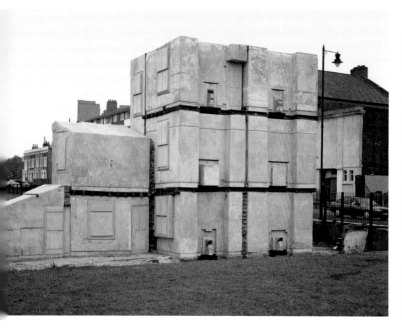

Rachel Whiteread, *House,* 1993
Concrete
Commissioned by Artangel Photo credit: Sue Omerod
©Rachel Whiteread; Courtesy of the artist, Luhring Augustine, New York, Lorcan O'Neill, Rome, and Gagosian Gallery

Whiteread acknowledges the fact that she cannot stop 486 Archway Road from being renovated or 193 Grove Road from being demolished. Her interventions do not tamper with the buildings' lifespans, but pause them for a short period of time.

Another way of reading Whiteread's installations is through William Morris' SPAB Manifesto.[8] The manifesto states that any intervention on an existing building must preserve the building by protecting it. In *House*, Whiteread temporarily preserves, and thus protects, 193 Grove Road from demolition and the accelerated globalization that is transforming the eclectic nature of East London.

Whiteread's casting technique posits her work as a unique combination of multiple and, at times, contradictory theories, namely, le-Duc's restoration, Ruskin's conservation, and Morris' preservation, theories that are precursors to those of adaptive reuse.

Impact: A Monument Commemorating Death

Adaptive reuse provides a way to preserve memory and maintain our connections to the past. Whiteread's sculptures, in particular *House*, become sites of memory that reference a past. In her article "Space-time and the Politics of Location,"[9] Doreen Massey contrasts the ways a classic 'heritage site' and *House* evoke memory. According to Massey, both the buildings and social practices in and around a heritage site are retained so that they provide "ready-made" and "pre-given understandings of the past." On the contrary, *House* does not provide the viewer with a pre-defined understanding of the past. The installation certainly provokes nostalgia, as do classic heritage sites; however, in reversing the interior and exterior, the nature of this nostalgia is left for interpretation. *House* is a site that speaks of "the right to have a home", "control of property and gentrification,"[10] and British heritage and identity.[11] By providing the viewer with room for interpretation and imagination, *House* succeeds at questioning memory and disturbing the notion of nostalgia.

House emerges as the return of the repressed, the familiar scene of a terraced house, but estranged twice, once in the gentrified environment, and another time through Whiteread's process of mummification. Thus, *House* can be said to evoke a sense of uncanny.[12] When experiencing the installation, the viewer is confronted with an architecture that resonates domesticity and familiarity. However, this familiarity is also an estrangement through the negative casting and monochrome appearance of *House*.

Whiteread's sculptures do not immortalize the host, but they instead capture the instance of its death and dilate its temporality through the process of casting. Whiteread's interventions are similar to photography. Fiona Bradley finds a parallelism between photography and Whiteread's casting technique, saying:

"Photography, like casting, combines that which is present with that which is other-the residue of the original which advances and retreats in the mind of the viewer. In order to begin to understand the shapes of Whiteread's sculpture, a viewer might first relate them to the object from which they were cast."[13]

While an image indexes buildings that are no longer there, Whiteread's work similarly indexes these buildings by providing us with an image of what no longer exists.

Alois Riegl defined a monument as " a work of man erected for the specific purpose of keeping particular human deeds or destinies (or a complex accumulation thereof) alive and present in the consciousness of future generation."[14] Even though it is not clear what kind of memory Whiteread is trying to keep alive, her sculptures are monuments that mourn the demise of the host structures. By transforming the host structure into a ghost, Whiteread completely removes the host from the viewer's experience and provides only traces of what once was.

ENDNOTES:

1 Mullins, Charlotte, and Rachel Whiteread. *RW: Rachel Whiteread*, 7. London: Tate Pub., 2004. p.7.

2 ibid., p. 5-16

3 *Ghost* was exhibited at Chisenhale Gallery, Bethnal Green, in 1990, and was bought by Charles Saatchi (ibid., p. 23)

4 Whiteread, Rachel, James Lingwood, and John Bird. *House*. London: Phaidon, 1995. p. 7-11.

5 Mullins, Charlotte, and Rachel Whiteread. *RW: Rachel Whiteread*, 7. London: Tate Pub., 2004. p. 23.

6 Viollet-le-duc, Eugene, and Charles Wethered. *On Restoration*. London: Sampson Low, Marston Low, and Searle, 1875. [translated from an article in his *Dictionnaire raisonée de l'architecture française*]

7 Ruskin, John. "Book 6: The Lamp of Memory" in *The Seven Lamps of Architecture*. New York: J. Wiley, 1849.

8 Morris, William & Founding Members. *Manifesto*. The Society for the Protection of Ancient Building, 1877.

9 Massey, Doreen. "Space-time and the Politics of Location" in *House*. London: Phaidon, 1995. p. 43.

10 Mari, Bartomeu. "The Art of the Intangible". In *Shedding Life*. New York, N.Y.: Thames and Hudson, 1996. p. 66.

11 Massey, Doreen. "Space-time and the Politics of Location" in *House*. London: Phaidon, 1995. p. 36-46.

12 Myzelev, Alla. "The Uncanny Memories of Architecture: Architectural Works by Rebecca Horn and Rachel Whiteread." *Athanor* 19 (May 2001): 59-65.

13 Bradley, Fiona. "Introduction" in *Rachel Whiteread: Shedding Life*. New York, N.Y.: Thames and Hudson, 1997. p.11.

14 Riegl, Alois. "The Modern Cult of Monuments: Its Essence and Its Development" in *Historical and Philosophical Issues in the Conservation of Cultural Heritage*. Getty Publications, 1996.

COMING HOME

A CONVERSATION WITH DO HO SUH

by LEA HERSHKOWITZ

Named Wall Street Journal Magazine's *2013 Innovator of the Year in Art, Do Ho Suh received a BFA in painting from the Rhode Island School of Design and an MFA in sculpture from Yale University. As a Korean man living abroad, Suh describes his feelings of "cultural displacement"* [1] *when first arriving in the United States as a student at the Rhode Island School of Design; these feelings became the springboard for his Home series, which comprises some of his most coveted works today. The "so called transitional spaces"* [2], *such as staircases and doorways, represent the physical space separating the United States and Korea, as well as the space that we all create within different cultures.*

Interested in the malleability of space in both its physical and metaphorical manifestations, Do Ho Suh constructs site-specific installations that question the boundaries of identity. [3] *Through full-scale fabric installations, Suh recreates specific domestic spaces informed by his experiences. These spaces include his childhood home, a traditional hanok-style Korean house; a house in Rhode Island, where he lived as a student; and his apartment in New York City. Dreamlike and captivating, Suh's work is one that meticulously encapsulates memory by replicating such interiors that address some of our most vulnerable feelings.*

Do Ho Suh's works are housed in several globally prestigious collections such as: the Guggenheim Museum, New York's Museum of Modern Art, The Whitney Museum, LACMA, and Tate, London [4]. *Suh shares with Int|AR author and RISD graduate student of Interior Architecture, Lea Hershkowitz, his experiences of the city of Providence and of RISD, while discussing the impact of place on artists and designers as they strive to*

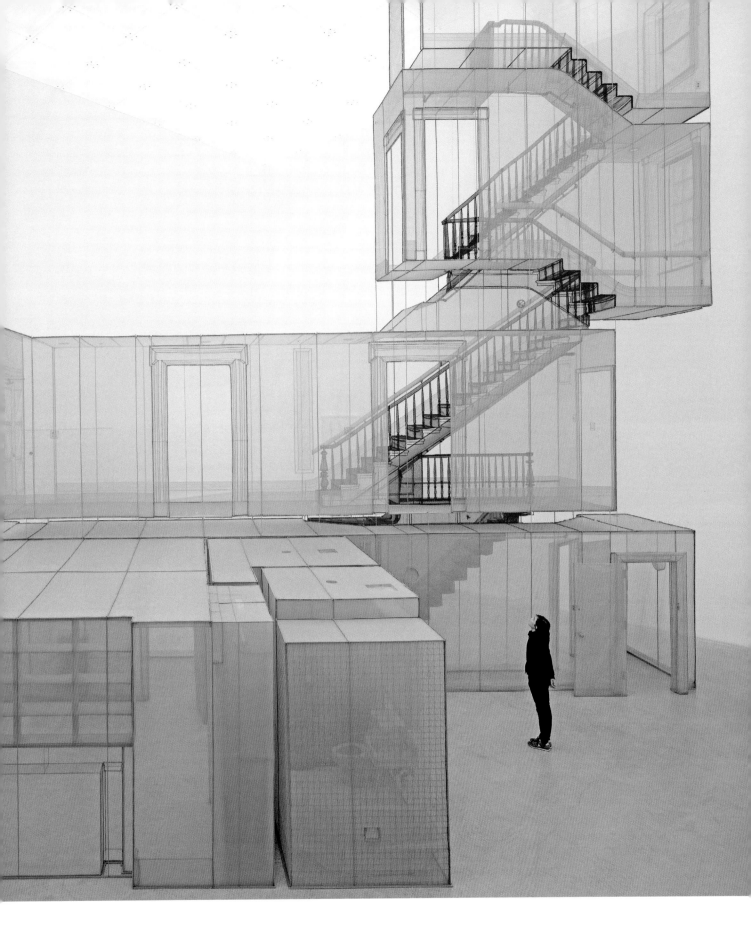

348 West 22nd Street, New York, NY 10011, USA - Apartment A, Corridors and Staircases (Kanazawa version)
2011-2012
Polyester fabric, stainless steel
Apartment A:690 x 430 x 245 cm / Corridors and Staircases: 1328 x 179 x 1175 cm
© Do Ho Suh

allow their personal questions and longings to manifest while maintaining the logic and ethos of a universally relatable work.

Do Ho Suh: The first place that I ever lived outside of Korea was Providence, to go to RISD. The experience of leaving home and going somewhere to study without knowing what was going to happen in my life was something to chew on for many years. I'm still fascinated by it. It was a physical and spiritual experience, rather than an inspirational one.

Lea Hershkowitz: You've mentioned the idea of transitional space[5] as the focal point for much of your work. I imagine this stems from the feelings of cultural displacement that you just alluded to. These ideas are literally represented in your *Home* series and mirrored by your placing of your homes in Korea and Providence within the walls of a gallery. In this sense, does the gallery become your new home, rather than the work itself?

DHS: Each time I show my work in a different space I know the piece will somehow contain the memory or the experience of that particular space. That trace of movement from one space to the other has always been in my mind from the very beginning of the project. It's hard to see it in an obvious way, since the physical change might be subtle.

My fabric pieces are very ephemeral. The museum people probably hate to hear this, but the color of the fabric fades once it has shown for several months in the museum context. Simple wear and tear as well as aging

Each replicated space is precisely measured, wrapped in paper, and then rubbed to generate an imprint of every scratch, notch, or smooth surface within the space.

Rubbing/Loving Project: Kitchen, Apartment A, 348 West 22nd Street, New York, NY 10011, USA
2014
Colored pencil on vellum pinned on board
363.9 x 843.6cm (143.25 x 332.125 inches)
© Do Ho Suh

accumulate the more you show the work and the more the work travels to different places. That is what happens to the physical piece.

For me, it is how I remember the space; it is the memory associated with that particular space and that particular piece. These intangible elements become visible layers that my pieces start to possess. It is a very complex experience. In a way, the piece itself is a catalyst. You bring your work to show somewhere, but ironically, the final product is less about the piece being shown somewhere than it is about the process of organizing, traveling, and communicating to get the piece

there. Each particular process of showing the work gets added onto the piece.

LH: That is what is most fascinating. You scrupulously replicate the space through your papering process, creating volumes rather than objects in the space. You've mentioned that the intention behind building your childhood home out of fabric was to be able to carry it everywhere with you. You once said, "I want to carry my house, my home, with me all the time, like a snail."[6]

Typically, when people travel and want to be reminded of home, they bring memorabilia with them, maybe

Specimen Series: Stove, Apartment A,348 West 22nd Street, New York, NY 10011, USA
2013
Polyester fabric, stainless steel wire, and display case with LED lighting
741/8 x 361/8 x 35 inches
© Do Ho Suh

a book or a photograph, maybe a stool. You've done the opposite and found a way to take the space with you, rather than the objects. Was your reasoning that the space holds memory in a way that objects cannot?

DHS: I think so. Don't get me wrong - I have obsessions with or attachments to certain objects as well. What struck me since first moving to the United States was how different cultures construct space and environments, which is directly related to how different cultures see the universe and understand the world. There were many stimuli all at once; it was not just a single object, it was the space that I responded to.

I think I moved nine times over the course of my three years at RISD, and your first impression is always the space without anything in it. I didn't like the process at the time, but it gave me a lot to think about. Then, when I moved to New York, I lived in one place for 18 years, which was a little different. I started traveling a lot, and my New York home became my home base. I have been traveling like crazy for the last decade, and I have started

to develop certain attachments to objects within the building. It has been an interesting development.

From the beginning, it was always about the space. I was a painting major at RISD, so I didn't have the means to realize my ideas in a three dimensional way, but I really wanted to make something spatial. I wanted to make something at a 1:1 scale. I didn't want to make anything smaller scale because, for me, everything that I experienced was really physical.

LH: You wanted something you could be in.

DHS: Right. So the very first series of works and experiments that I did at RISD, which still resonate with me, dealt with measuring my studio. Measuring the corridors in the Met Café and measuring my apartment without really knowing what I was going to do. I really spent time with those particular measurements and came up with something. While I was developing an understanding of my environment, I was learning the techniques that I needed to realize my ideas in a three dimensional way.

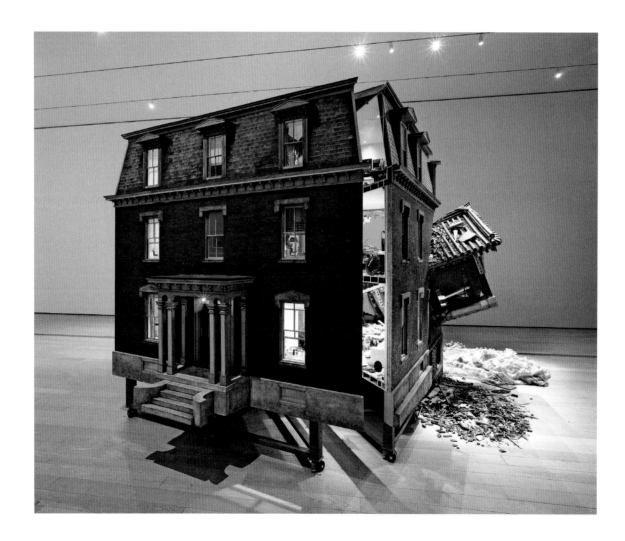

Fallen Star 1/5
2008 - 2009
ABS, basswood, beech, ceramic, enamel paint, glass, honeycomb board, lacquer paint, latex paint, LED lights, pinewood, plywood, resin, spruce, styrene, polycarbonate sheets, and PVC sheets
Approximately 332.7 x 368.3 x 762cm (131 x 145 x 300 inches)
© Do Ho Suh

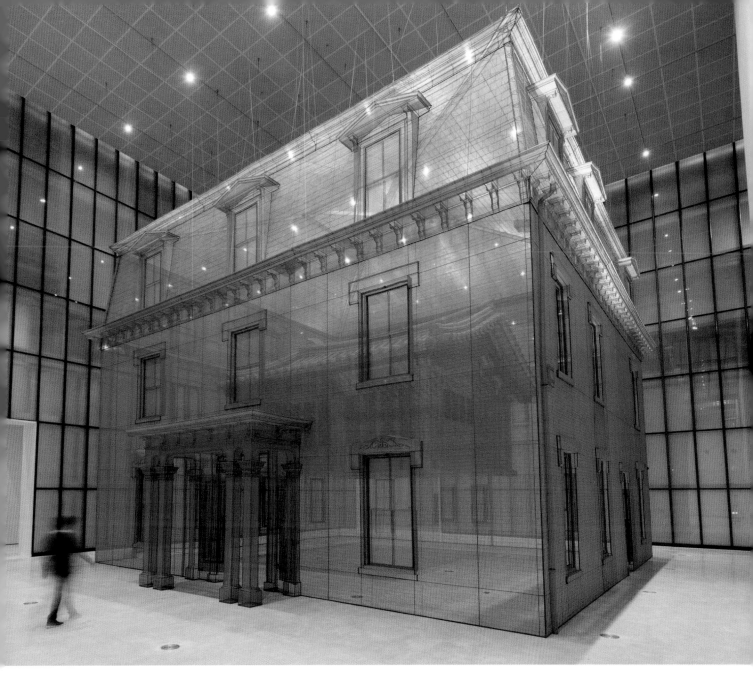

The rubbings are transposed onto silk or polyester, rung on metal wire, and hung to represent, in a 1:1 scale, the documented space that a viewer can occupy.

Home within Home within Home within Home within Home
2013
Polyester fabric, metal frame 1530 x 1283 x 1297 cm
© Do Ho Suh

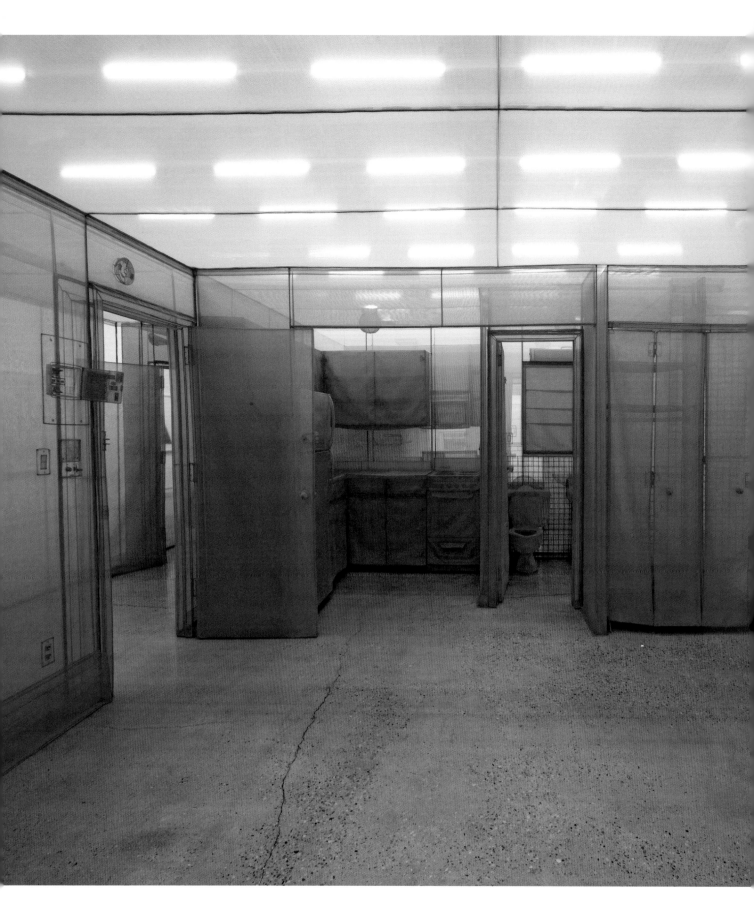

Apartment A, 348 West 22nd Street, New York, NY 10011, USA
2011-2014
Polyester fabric, stainless steel tubes 271.65 x 169.29 x 96.49 inches / 690 x 430 x 245cm
© Do Ho Suh

Maybe because I did not come from architecture or sculpture I had the flexibility to approach the problems I saw in a more naïve way. Making something in fabric is almost impossible in construction: A whole house, a three story building at a 1:1 scale, in fabric?

LH: From the outside, your work is a precious object, which is typically not occupied by people. You've mentioned that your inspiration came from the way you interacted with people in different cultures and the way that people interact with the spaces within which they exist. I'm wondering if you have an opinion regarding what happens in the spaces that you create once people interact, touch, or engage them, because those interstitial spaces are then dissolved.

DHS: It is interesting that you mention the absence of people. With any work of art, there is no one there when you are creating something; you are alone. Once you put your work out, and it starts to interact with people, my presence as an author and theirs as the user is always there.

LH: As if in the absence of a person, you know that there is the presence—

DHS: — presence of the person, yes. It is related to the things that I mentioned at the very beginning: that you only see the sheer fabric, and it seems like there is nothing attached to it. But, for me, there is this invisible memory with many layers attached to it. It's an interesting question, because I hardly ever see my favorite architecture without any people in it.

LH: It's impossible, yet that is typical of how the completed space is displayed within a firm's portfolio.

DHS: When it's being documented, there's no human presence. I think that's a really interesting thing. It's kind of a modernist tradition.

LH: Once you add a user, the nature of the space changes: it potentially implies a new author and, with her or him, the possibility of a change of function to the form, maybe different from what the architect intended.

DHS: Exactly. I've been trying to fight against that tradition in many ways. First of all, the use of ephemeral fabric is against this modernist attempt to preserve and monumentalize. My works, my pieces, are about the anti-monument. The monument is immobile.

LH: It's a dead thing.

DHS: It's on a pedestal. It doesn't really matter where you show that piece - as long as it is on the pedestal, it

is the same piece. That's how the modernists see their work. For me, each and every time I show work in a different place, it becomes a different work, because it's in a different context.

LH: When I first began to think about you and your work, meticulously measuring, documenting, and papering each aspect of the building or room, it seemed almost a preservationist technique. But it sounds like you would not consider yourself a preservationist.

DHS: I don't think so! My work is not about being an immobile static sculpture. The work is about the beholder's movement throughout the different spaces. Lately, when I've shown my work, I have used video. The interaction of my work within different contexts, and with different viewers, is important, and that makes the experience of the work differ from one place to the other. It is about the subtle changes of light and movement of the people. In different cultures, people behave differently at the museum, and that also makes the work a different piece—a completely different piece. I think the ironic thing is that the original space is an extremely private place. As art, it becomes a highly public space with a transformation of both the space and its functionality.

LH: What *is* the function of the space? It was meant to be your home, but what is it now?

DHS: Once I occupied the space, my old apartment became my own intimate space. The audience has never lived in or even seen my old apartment. If the audience includes people from New York or the West Coast, the apartment might be a different spatial configuration and have different hardware.

LH: The objects you've chosen to feature—the stove, for example—are very utilitarian, but they also create an emotional connection, because everyone experiences those objects. This is why at the beginning of the interview, I asked about objects in space rather than just space. Your idea that the space you've transposed is unique while also being universal comes through in

these typical appliances; they hold your memories but can also hold mine.

DHS: At the moment, I'm in London, renovating my old apartment. It's quite interesting; this is the first time I've had the opportunity to make a lot of decisions based on my own taste.

The structure of the building is already given; it's really limited for the architect. There are many unforeseen discoveries that force us to change the design as we take the walls down, for example. It's almost a karmic experience. How many people can afford to create their own space from scratch? Most of us cannot. But the original appliances in the apartment were not my choices; they were already given and are probably the most generic things.

LH: They look like mine in Providence, which probably look like yours did when you were in Providence.

DHS: And somehow we created this collective memory based on these sorts of mass produced products, which is fascinating.

LH: Going back to this idea of being able to create or design your own space being something of a luxury: On one end of the spectrum, I think of your work in relation to primitive man or nomadic architecture. On the other end, and more relevant in today's context, I think of refugees. Though you've elevated this idea, your work references what is currently happening throughout the world, as people are being forced to carry their homes with them.

DHS: Let's put it this way: I think that going to the United States was probably the most important experience in my life, and a lot of my work comes out of that experience. Interestingly enough, no one really asks me about my work prior to what I did in the United States. It's very strange.

LH: Well, what was your work like prior to coming to the United States?

Heavy in process, the work reflects how the pieces are experienced by the artist and how the pieces are constructed.

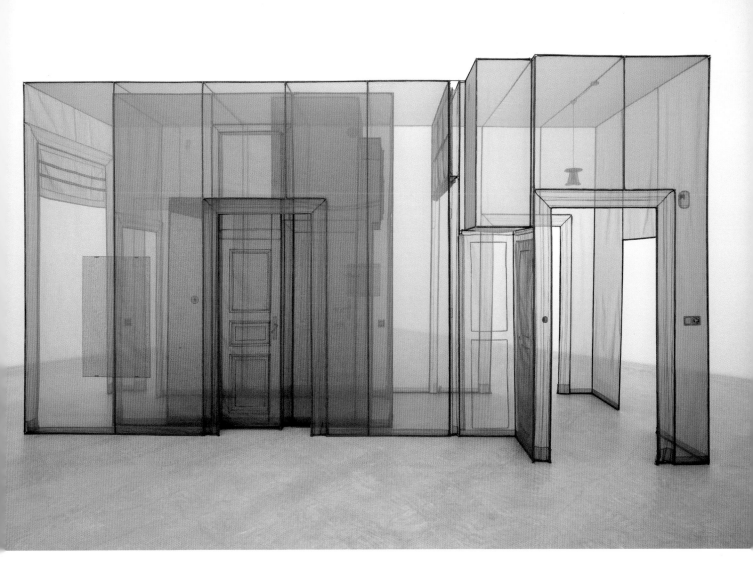

DHS: I was a painting student.

LH: Because your father was a painter?

DHS: Yes. I studied the more traditional medium of ink and brush on paper. However, the pieces that I was making were installations that dealt with the idea of transporting space from one place to another. My point is that, before I left, the seed was planted in Korea but it was nurtured by my education at RISD. That's how all of this work started.

In Korea, I was making a piece using a balloon, blowing it up in my studio. The idea was that the air inside the balloon was representative of the space in my studio. I put the balloon in a very large plastic bag and then transported it to the gallery space, but it was not just sitting in the gallery. The balloon traveled from one gallery space to the other. It wrapped around the partitions from one gallery space to the next, so that at first glance within the gallery spaces, the piece was difficult to see in its entirety. In this sense, I was transporting the air from one particular space to the other. This was one example of how the ideas I'm working with now first developed in Korea.

When I went to the US, I started again as a painting student. It didn't occur to me to continue to work three dimensionally, and maybe the reason was that I just wanted to learn something completely new. The strange thing was that when I look back at my old sketchbooks in Korea, there are some old sketches that are very relevant to what I'm doing now. I didn't even realize that connection until recently.

Wielandstr. 18, 12159 Berlin, Germany - 3 Corridors
2011
Polyester fabric, stainless steel tubes
655 x 209 x 351cm
© Do Ho Suh

LH: The connections our brains make before we are consciously aware of them are fascinating. It sounds like that's what you're describing.

DHS: It was great to discover these old sketches. Did I really think about this back then? At the same time it's scary; you're kind of trapped with this one idea for a long time, and you have to wonder, how did it happen?

LH: As if we choose these paths or topics based on our experiences, something innate.

DHS: Yes. However, I'm pretty sure someone would have done this work if I hadn't done it. But I happen to be the person, and I've only just barely scratched the surface. In this way, I know that it didn't happen without any reason, because these ideas are a consistent thread throughout my life. I completely forgot about my old sketches, and I came up with some great ideas. I'm happy about them, only to look back at my sketchbook, and the drawing is already there. I know that I didn't intentionally look back in my studio just to create this piece ten years later. Maybe that idea or that sketch has been in me on a subconscious level for ten years, and then reemerged. I'm not sure how those things work.

I also think there are particular spaces that I'm more drawn into, and I'm trying to understand why and what triggers that. You probably have experienced this sense of déjà vu? Whenever I remember my dreams, the spatial background or the places and spaces are always the same. For example, my childhood home in Korea is different than the real house or home. Some part of the house is similar to the real home, but it is otherwise different.

LH: But it has the same feeling, is that what you mean?

DHS: The sensation in my dream tells me that the space is my home, but there is a very strange, different feeling. It feels completely new. I'm almost lost within my own home, but that particular space, as a home, comes often in my dreams. Somehow my brain or my consciousness puts this information together, and it creates this...

LH: Whole new space?

DHS: Yes. So when I have a dream, I think, 'oh not again, that's the same space that's not home'. I know that 100%, but in my dream setting, that is my home. In real life, sometimes I go somewhere and feel the same way. I strongly believe that I've lived there in my previous life because there is no way I would know it otherwise. But in the dream, my studio is always in the same place looking down to the sea; the experience is just so vivid and real. The more I think about it, the more I think it is probably un-erased memory from many different past lives.

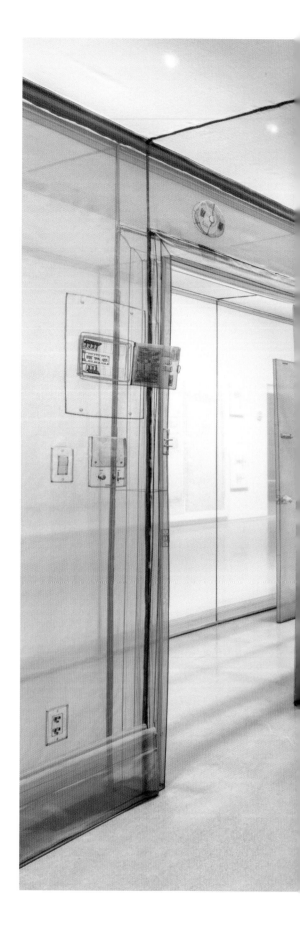

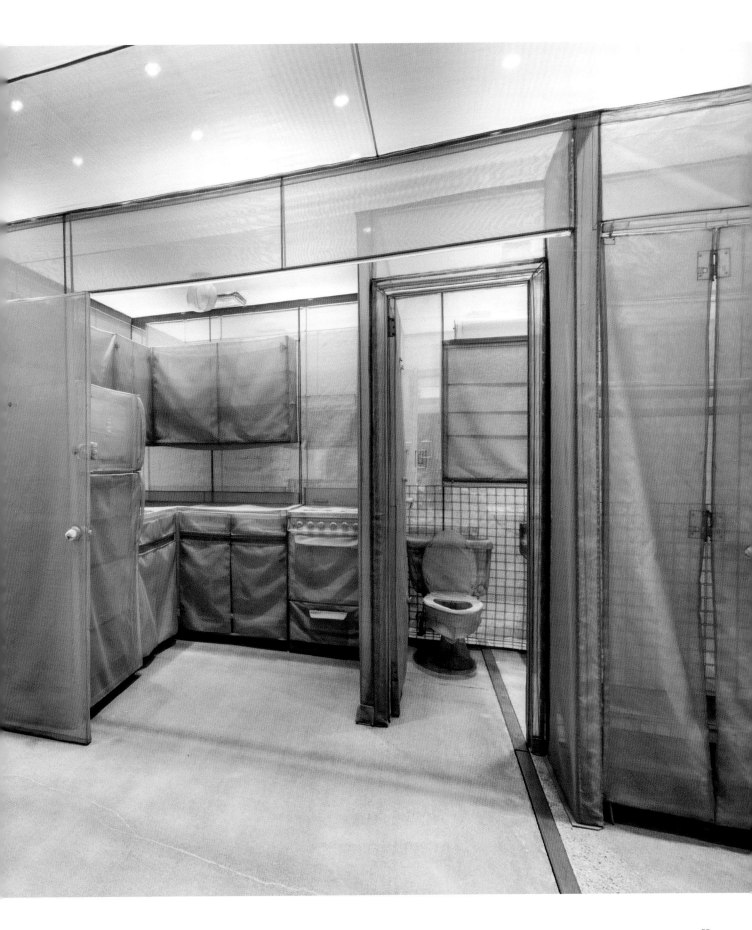

Apartment A,348 West 22nd Street, New York, NY 10011, USA
2011-2014
Polyester fabric, stainless steel tubes
271.65 x 169.29 x 96.49 inches / 690 x 430 x 245 cm
© Do Ho Suh

LH: I once read that individuals with impaired facial perception do not dream of faces.[7] Maybe it's possible that individuals with heightened spatial perception dream only of space, or create new spaces within their dreams. Yet, what you're saying is that maybe the spaces we create come from our past lives and our past experiences.

DHS: I think the mechanism of dreaming is very interesting. I'm not in a position to completely understand how it works, but what I find fascinating is that I remember this space within the dream over and over again. This space exists in me, and in a way, that makes it more real.

LH: Have you ever built it?

DHS: I've made some sketches about it, but I think in a way the work I'm doing now might be a quest to find that space that I've been dreaming of. I don't know whether I will find it. I think the conceptual gesture of working with the spaces I live in is itself an accumulation of the fragments that make up the space that appears in my dream.

LH: What I hear you saying is that you cannot create that space because you have not found it yet, and your whole conceptual method is: existing within these spaces first, developing memories, and then transposing those spaces. Rather than saying, 'I dreamt of this space and I want to construct it', which is very much more of an architectural practice!

DHS: There is probably a long history and tradition if you're an architect that becomes a limitation.

LH: To draw a conceptual link here, you are adaptively reusing your memories rather than developing a new construction of your dreams. And that is *The Architect's Dream*[8]: this perfect, complete world built of tradition that was dreamt and then created.

DHS: Right, and I don't have that, so I can do whatever I want to do! Art and architecture have their own limitations. I was traveling in Tokyo, and I saw the Frank Gehry and Norman Foster exhibition. From Tokyo, I went to Los Angeles, and I saw the other Frank Gehry exhibition at LACMA. The Tokyo show of Frank Gehry had a lot of models, but it was more focused on the technology that he created to design his buildings. The LACMA show was more traditional. I was thinking that I would like to have an exhibition like that. I really like architecture exhibitions. It was perfect for me to see how the models were made, and I would love to have an exhibition of just models and drawings.

LH: Your recent show at MOCA Cleveland included a lot of your sketches, the paper you used for imprinting, as well as video. The idea of documenting and displaying your process seems particularly interesting for your work because the final form, as well as the process, makes up the total memory that is on display.

DHS: The process is becoming more and more important to me. The process has always been there, but I just didn't want to share it, or I just didn't think that it was something that people might be interested in.

LH: But now that you've found that sketch, you know that it's probably really important.

DHS: I think you're absolutely right, because the chain of thoughts, the threads in my old sketchbook, have always been there. I'm still making manageable pieces, even though the scale is large. There are pieces that are completely impossible to make in real life due to the scale, so I've been thinking of making models and drawings and bringing all of those things together to have an exhibition like those of architects.

LH: Something that is important in making models is how to get the viewer to really experience the space when it's very small, or when it's just a model, and the materials are not exactly what you imagine them to be. The model becomes a completely new and unique challenge, rather than being able to make the space the way that it really should be at a 1:1 scale.

DHS: I think that's a unique kind of challenge. For me, people have been experiencing my installation versions of the spaces, so I think people could make a connection from my model to the other full-scale versions. It's kind of a retrofit too. I just recently opened an exhibition at the Contemporary Arts Center in Cincinnati, and for that show, I made a few models, very intricate models, of the piece that was being made but then destroyed. Not many people were able to see it and experience it as a permanent piece. So, I made a model. It's not a study model to realize that project; it was more a replica of the actual piece that no longer existed.

LH: Talking about Modernism, Le Corbusier used to say that the model is the ideal form of the architecture. You can't touch it, and nothing happens to it. You are flipping that statement on its head and saying, 'well, I created the actual thing, but I destroyed it, and now I only have the model to show you.'

DHS: Right! So, I've been documenting the pieces through film. In Cincinnati, I showed a documentary of the making of the piece with a model and that's probably the closest experience one could have of the work without actually being there. It's a challenge for me when my work is really site specific. I think that my work, as well

as that of many architects, deal with three dimensional space, yet everything is becoming virtual.

LH: Do you know Oculus Rift? You put these goggles on and in à couple of seconds you can be anywhere, including home. I was wondering too what you thought about that because you spend enormous time doing these amazing, almost historic processes, and there are people on the other end of the spectrum that are using technology to try to replicate a similar experience. I wonder if you see the potential for that kind of thing in your work, or if integrating these kinds of technology is something that you'd like to stay away from?

DHS: I'm actually looking into it. Those technologies have been evolving so rapidly. I remember when I was at RISD we got a tour at some kind of media lab at Brown University. They were experimenting with virtual reality and it was so primitive. Now, we have 3D filming as well as virtual reality. Before 3D filming had the chance to pick up, virtual reality has really taken off. In my work, I would pass by the 3D filming and just go directly into virtual reality. It is really affordable now and I think it is perfect for documenting space. However, I still think that it cannot replace the physical experience. I have a collaborator who has been helping me to document my work and almost make video art so we've been talking about it.

LH: Which is really interesting as an architectural practice to create space without actually having to make space.
Being in Providence, I'm wondering if there are certain spaces at RISD that you found to be particularly inspirational?

DHS: Providence is a really beautiful place. I went back maybe 5 or 6 years ago, and I scanned the whole building I used to live in on Benefit Street. The landlord is actually an architect from RISD Architecture, practicing in Providence. He knew my brother, who also went to RISD, and he helped me access the building to do the documentation. There's a hidden staircase that goes up to the top of the building. I don't know how they did it. They just probably chopped the space into 6 or 7 units but originally it was meant for one very rich family. There are two different staircases; probably one was for the family, and the other was for the servants, but they closed it off and that staircase was behind the refrigerator in my flat.

LH: Did you know it was there?

DHS: I had no idea. I knew there was a space, but I had no access to it.

LH: The architecture in Providence has such amazing history, for reasons you've mentioned; it was a colonial town, lots of really wealthy families. Some of the most amazing structures have been converted into the craziest units.

DHS: There are a lot of details, half buried in the plaster. It's fascinating when you're measuring those spaces. It was a total coincidence, but the building I used to live in was also where my brother used to live when he was at RISD before me. When I first moved to the US, I lived in one of the school dormitories, but it was too small. So, I was looking for an apartment, and someone called me to show it, and it happened to be my brother's building.

LH: Talk about building Karma?

DHS: I think there is something that is not just superstition. I really like Providence because it is associated with good memories. I really worked hard, learned so much, made good friends. You know, you see RISD graduates everywhere, and we still keep in touch.

LH: It's really nice to hear about your experience, as I am about to leave RISD and Providence.

DHS: Did you drink the water from that fountain on Benefit Street, the one outside of the court building?

LH: I have not, but maybe I should?

DHS: If you drink the water from that fountain, you will never leave Providence.

And maybe Do Ho Suh never has, as he continues to take 388 Benefit Street with him wherever he goes.

ENDNOTES:
1 http://www.pbs.org/art21/artists/do-ho-suh, accessed February 03, 2016

2 https://www.youtube.com/watch?v=xYEF_GXilu8, accessed February 01, 2016

3 Do Ho Suh Biography from the Lehmann Maupin Gallery website, http://www.lehmannmaupin.com/artists/do-ho-suh, accessed April 05, 2016

4 http://www.lehmannmaupin.com/artists/do-ho-suh#13, accessed February 03, 2016

5 https://www.youtube.com/watch?v=xYEF_GXilu8, accessed February 01, 2016

6 http://www.sothebys.com/de/auctions/ecatalogue/2010/fusion-contemporary-art-and-design-n08748/lot.63.html, accessed February 03, 2016

7 http://www.ncbi.nlm.nih.gov/pmc/articles/PMC2814941/, accessed March 08, 2016

8 http://www.explorethomascole.org/tour/items/91/about, April 04, 2016

DESIGN, SUBJECTIVITY, AND CULTURE

NOTES ON PRODUCTIONS

by CLAY ODOM

Given contemporary contexts of instability, growth, and change, are design practices becoming more ephemeral and transient in their engagement with questions of inhabitation and intervention? Contemporary Architecture, which focuses primarily on the project of constructing new buildings, is growing slower as land-use and building costs escalate due to the urban(izing) conditions that emerge from globalization. Michael K. Jensen argues in his book *Mapping the Global Architect of Alterity* that: "though globalization is defined in many ways, none of its definitions capture the magnitude of its influence on modern society more than its definition as de-territorialization, where cultural spaces are developing with no tangible connection to physical geography."[1] This type of distribution and '*deterritorialization*' that emerges from globalization and urbanization produces an effect in which interventions seem to be increasingly temporal, distributed and aligned with questions of interiority and adaptation. Andrea Branzi described this transformation, writing that "the quality of an urban place is no longer therefore formed by the effectiveness of its architectural setting, but rather by the sophistication of its various interior designs... It is a city of interior spaces, immaterial experiences,

and pulverous systems of micro-projects."[2] As a result, interventions into existing conditions become more prevalent and important; however, they also become more ephemeral and transient. This temporal shift is the effective "deterritorialization" to which Jensen referred. However, this shift could be seen as generating new, optimistic territories from which one can consider spatial-practices relative to questions of reuse, adaptation, and intervention. Here, we may begin to see the development and expansion of global, de-territorialized processes into the built environment through local, territorial projections.[3] In this context, the way that contemporary spatial practices generate, disseminate, and transfer projects within this temporal field becomes increasingly more important. Ultimately, these considerations lead one to explore and expand understandings relative to the processes, objects, spaces, and experiences that contemporary practices generate, or produce. It is this notion of productions that is the core of this essay.

01

When the word "production" is used, one's imagination moves almost immediately to fields of art, film, or theater. These fields are important within this context

Installation 'Tesseract 4.0' at Salvage Vanguard Theater, Austin, Texas.

for two primary reasons: their speed relative to forms of interior design and architecture and their focus on experience and effects. The types of work that these fields generate are focused on producing new conditions that might best be described as temporal, atmospheric, or ephemeral. However, many critics might pejoratively characterize these types of work with terms such as 'superficial', 'fake,' and 'scenographic'. However, as Gernot Bohme stated in his seminal work, "Atmosphere can only become a concept…accounting for the particular intermediary status of atmospheres between subject and object."[4] This intermediary status can be described as the territory in which the effects, the material, the experience, and the contextual conditions are complexly entangled. These entanglements are primarily associated with interior space and its fields of interior design, interior architecture, and art, which consider the implications of form and surface as generators of spatial, contextual, and experiential effects. Installation work is particularly relevant for its relationship to the generation of effects and its engagement with context. A simple example of atmospheric, subjective intervention is found in a current exhibit at the Cooper Hewitt National Design Museum.[5] People visiting the exhibit, titled 'Immersion Room,' can interactively view the museum's large collection of wall coverings by selecting different digitized versions with accompanying audio descriptions. However, viewers are also immersed in the range of patterns, colors, and textures that they "…[see] projected on the walls from floor to ceiling—for a vibrant,

impactful, immersive experience."[6] This experience engulfs the entirety of the historic space and remakes it with each new viewer.

Today, "the goal of architectural practice is still highly predictable, especially in the way that representations remain focused on the production of buildings, and in the way that they remain static and lack the immersive qualities of phenomenal space."[7] However, this condition has changed for practices engaged in questions of production. In an interview with Charlie Rose in which he described Milstein Hall at Cornell University, Rem Koolhaas stated, "performance is not function. What role does the building play, and what kinds of scenes does it trigger? … What does it create? What does it sponsor? And what does it stimulate?"[8] The notion of questioning what design 'triggers', 'creates', 'sponsors', and 'stimulates' is now essential to understanding productions as the focus of both design processes, the results that are generated by these processes, and the way that work is distributed in a global context. Although Koolhaas referred to a specific architectural project in his interview, the general understanding that he elucidated does give a glimpse into issues -namely ephemerality and effects such as those described in 'Immersion Room.' These issues have emerged from a trend toward the development of complex form and surface in consort with investigations into systematized design processes.

In addition to the complex entanglements of form, material, and effects, works associated with productions engage questions regarding authenticity that

Rendering of proposal for installation at Boston Society of Architects.

differ from traditional notions of authenticity in art, as well as questions regarding the dissemination of work. Here, they are more aligned with aspects of popular culture such as film or music, in which one could assert that authenticity is produced as an effect of experience by individuals. The concerns surrounding questions of 'productions' are also evidenced by engagement with concepts of repetition and seriality as aspects of strategic design processes and the tactical realization of work in particular locations.

Within production-oriented practices and their referents, space and atmospheres are driven by collaborations between form and surface that reflect and transmit light. At the same time, these collaborations also create moments and passages for people to move through or experientially pause within. A dialectical attitude toward the relationship(s) between the producer and produced, between the objective and subjective, and between contexts and interventions may be useful in the development of serial diagrams of potentiality. However, contemporary approaches seem to be on an interactive, oscillating continuum.

02

"…various software packages for building information modeling are quickly becoming global and almost inevitable industry standards…the potentials for these new tools go well beyond the mostly bureaucratic purposes to which they are presently confined."[9]

It is easy to see negative effects of the globalized serial transmission of projects in the built-environment. From local mom-and-pop shops that open second locations to the large multi-national roll-outs of corporations such as *Starbucks* or *McDonalds*, the idea that projects can be distributed is certainly applicable to us today.

"In these scenarios, rigor is used to generate precise known and measurable conditions and to project brand identity. These types of known conditions are key to typologies developed and aligned with global brands in fashion, food and other consumer-oriented businesses. They have traditionally been applied with disregard if not disdain for the production of difference. In his book *Pattern Recognition*, William Gibson laments this effect, 'My God, don't they know? This stuff is simulacra of simulacra of simulacra. A diluted tincture of Ralph Lauren, who had himself diluted the glory days of Brooks Brothers, who themselves had stepped on the product of Jermyn Street and Savile Row, flavoring their ready-to-wear with liberal lashings of polo kit and regimental stripes. But Tommy is surely the null point, the black hole.'[10] Instead, a contemporary approach to ID/IA (Interior Design and Interior Architecture) becomes a mode of transmitting and projecting knowledge while also maximizing the potential for localized idiosyncrasy and emergent effects."[11]

In addition, the role of repeatability has been notable since the Industrial Revolution, and the implications of industrial repetition for art and aesthetic productions are almost always associated with 'The Work of Art in the Age of Mechanical Reproduction.'[12] However, evidence of the role of serial reproductions dates much farther back. This idea is even the subject of the current exhibition 'Serial Classic' at the Prada Foundation in Milan, the online catalog of which states, "We tend to associate the idea of classical to that of uniqueness, but in no other period of western art history the creation of copies from great masterpieces of the past has been as important as in late Republican Rome and throughout the Imperial age."[13]

One key aspect of contemporary production-oriented work is that it is repetitive, but not identical. Production practices, understood across a range of contextual scenarios through processes of design and material intervention, are developing "a typology of design process rather than a typology of form… the redefinition of typology from formal classification to generative device."[14] This typology is described as serialized, as a set of instances that are similar nonetheless. Better still, the similarities are not the same project, but rather resultant productions that emerge from the same process. Additionally, these similarities are locally differentiated by their response to contextual conditions. The contextual conditions are given by the varying 'sites' of the work, which range from gallery spaces to abandoned warehouses, while the overall strategies are developed external to these local constraints. Finally, they are consistently re-worked as iterative developments between instantiations. As productive enterprises, works by designers and artists such as Olafur Eliasson, Anish Kapoor, Christo, and Tomas Saraceno tend to optimistically embrace the potentiality of contemporary forms of distribution. Although these forms of distribution are somewhat driven by the commodification of experiences, they are more focused on generating serialized yet differentiated (re: parametric) interventions as ongoing actions.

03

Traditionally, art has been understood to consist of single objects, such as paintings or sculptures, that were physically transmitted from artist to museum to museum or from artist to collector to collector and so on. Today, however, objects can be translocated through code transfers, resulting in local instantiations in which differences are produced based on engagement with context. Today, codes are transfered at the speed of light using the Internet and may consist of computer programs or other forms of instruction for making. In the last 10-15 years, much of contemporary design practice has moved through a preoccupation with parametricism as a project-specific logic focused primarily on material

'Intricacy.[15]' Today, we see practices that leverage these more localized, project-specific engagements to move to larger understandings of parametricism.[16] The spatial, perceptual, and qualitative effects that have designed conditions produce both objects and effects. Even if these productions are fundamentally temporal and ephemeral, these realities are of equal (if not greater) importance to their poetic or philosophical meanings, which one might argue are cultural effects that they produce as well.

Examples of parametricism can be found in works generated by the installation art practices mentioned earlier. Here, we see works such as Tomas Saraceno's 'On Space Time Foam,' installed in Milan's repurposed Hangar Bicocca, that exhibit properties aligned with one-off site-specific installations. These works are also instantiations of installation systems that emerge and reconfigure across a range of sites and times. In her review of Saraceno's work, Allison Furuto touches on this aspect of transmission. "On Space Time Foam" is part of the research that has involved Saraceno for years on the creation of airborne systems, such as platforms that can change shape and be transformed thanks to public interaction. In his works, the structural context, environmental forms, and innovative materials come together to create projects with a powerful ideal impetus that can break down all disciplinary barriers and focus on the language of space and social dynamics. "Cloudy City" and "Air-Port City" are works in progress, systems and works that, as a whole, constitute a complex reflection on the major themes of the present..."[17]

04

"Atmosphere is the common reality of the perceiver and the perceived."[18]

The notion of form as emerging through a set of contingent, contextual conditions is not new; it has been espoused throughout the history of architecture and interior design. However, during the first digital revolution, Gregg Lynn espoused it through notions of seriality and proto-parametricism. In 'Animate Form,' "form is therefore shaped by collaboration between the envelope and the active context in which it is situated."[19] Later in the exhibition that he curated, entitled "Intricacy," Lynn further examines the question of context in terms of the distribution of methods and conceptual frameworks across a range of disciplines. "Intricacy aspires to disassociate a number of common formal and structural techniques from the milieu of any particular field."[20] Today, we see this intricacy manifest in form and atmosphere. However, it is also evident in the way that work is globally disseminated and in its ability to produce cultural effects. The production of cultural space emerges from interventions into existing conditions. The generation of individual, subjective experience becomes an ever-changing yet objective potential that may be produced through contemporary practices. Culture can be understood here simply as an inherently emergent condition of shared perceptions that results from interactions between people over time.

How does the notion of culture -Bohme's 'common reality'- as a shared set of perceptions, understandings, or values apply relative to notions of subjectivity? As with any anamorphic projection system, the understanding of the whole does not come into focus immediately or simply. Instead, individuals are required and even provoked to move through the system in order to discover moments in which things—figures, in the case of graphic anamorphosis—come into focus most clearly. Here, we can see the production of culture in a similar way. Individual subjective experiences are only shared ex-post-facto, and then they are developed into shared experiences. This mode of formation, which emerges from certain types of ID/IA projects over time as both a subjective and collective whole, is the way that the production of culture may be generated.

In inherently atmospheric works such as Olafur Eliasson's 'Feelings are Facts' or Antony Gormley's 'Blind Light,' the cultural, collective body is literally displaced within atmospheric effects of light, color, and fog. The effect is simultaneously visceral, visual, and completely subjective. The experience is manifest through means that take away one's ability to visually apprehend others; however, these means simultaneously disembody the subject, making one's self-awareness also more visceral than visual. "Rather than heightening awareness of our perceiving body and its physical boundaries, these dark installations suggest our dissolution; they seem to dislodge...-albeit temporarily- by plunging us into darkness, saturated colour, or refracting our image into an infinity of mirror reflections...the possibility of locating ourselves in relation to the space is diminished, because the space is obscured...or in some way intangible."[21]

05

In his seminal work, "Realist Magic," Timothy Morton argues for the fundamental aesthetic condition of objects. He states, "One of the many intriguing things about graffiti is that it straddles decorating and causing or affecting." He follows this by asking, "How can one aesthetic effect be more real than another?"[22] Following Morton's lead, we can interrogate the role of materiality and surface as the conditions necessary for productions to occur. The definition of productions can then extend to encapsulate notions of form and surface, as well as the generation of effects. In addition, this definition also implicates issues that surround making, fabrication, and design processes themselves.

The particular type of project that is generated by means of this type of interventionist modality exhibits fluid, temporary, and fundamentally ephemeral qualities. Works such as Tomas Saraceno's 'On Space Time

Foam' offer insights of the particularities of existing conditions. However, these works also develop design systems and approaches that allow for work to be disseminated and re-installed in order to generate particularity to both location and connection. Questions of authenticity now emerge from subjective and interactive experiences within these temporal interventions. Furthermore, the totality of the work is now distributed and remade through experiences that are shared between geographic sites and across a-synchronous instances through social media.

The contextual engagement of works, such as those in the installation genre, continually remakes contextual conditions. The specificity of the interventions is important to this work, but it is neither the locus for its concept nor the end point for its distribution. In general, contemporary design and art practices engaged in installations either test grounds for ideas or instantiate iterations of projects. However, interventions as active, insurgent conditions are one way that we can begin to understand the radical potential underlying the current work of interior designers, artists, and architects who develop work through installation. Context, and by

extension, preservation and adaptive reuse, is at the core of the questions suggested by these works. If works are now considered part of a process that is only tested at the local level, then how might one now understand the role of context, not as instigator of work, but as part of a larger, contingent system in which works are developed iteratively? Through logics of shared information, the logics of the work are further disseminated as the work influences other designers and theorists to test and expand concepts through new, localized projects.

Projects associated most closely with productions are those with qualities of form, materiality, effects, and experience. These projects simultaneously engage and remake existing conditions and remake the process of design. The work is primarily defined by its ability to directly interact with local criteria, such as existing building context and spatial conditioning, and by its ability to globally transmit the modes of production and codes of design. These concepts and practices are inherently contemporary and hold vast potentials for consideration by Interior Designers and Interior Architects interested in the ability of design processes.

ENDNOTES:

1 Michael K. Jensen, *Mapping the Global Architect of Alterity* (New York: Routledge, 2014), 2.

2 Andrea Branzi, "The Visceral Revolution," *Domus* 897 (Nov 2006): 43.

3 Clay Odom, "Mobile Processes Transient Productions: Nomadic Spatial Practices", (these concepts were originally laid out relative to questions of contemporary transience in a paper presented at the IFW Nomadic Interiors, Politecnico di Milano, May 2015).

4 Gernot Bohme, "Atmosphere as the Fundamental Concept of a New Aesthetics," *Thesis 11* 36 (1993): 115.

5 The Cooper-Hewitt National Design Museum is housed in a re-purposed residence, formerly the Carnegie Mansion, New York City.

6 Cooper Hewitt National Design Museum, *Immersion Room*. http://www.cooperhewitt.org/events/current-exhibitions/immersion-room/.

7 Nic Clear, "Drawing Time," *Architectural Design* 83 Issue 3 (2013): 74.

8 Rem Koolhaas, interview with Charlie Rose, October 19, 2011, http://www.archdaily.com/182642/rem-koolhaas-on-charlie-rose/.

9 Mario Carpo, *The Alphabet and The Algorithm* (Cambridge: The MIT Press, 2011), 124.

10 William Gibson, *Pattern Recognition* (New York: Berkley Books, 2003), 17-18.

11 Odom, "Mobile Processes Transient Productions."

12 Walter Benjamin, *The Work of Art in the Age of Mechanical Reproduction* (London: Penguin, 2008). Benjamin's work is referenced broadly here in regard to concepts of transmitting work through technologies.

13 *Serial Classic,* Prada Foundation Milan, curated by Salvatore Settis and Anna Anguissola, , (9 May – 24 August 2015), http://www.fondazioneprada.org/exibition/serial-classic/?lang=en .

14 Roland Snooks, "Observations on the Algorithmic Emergence of Character," in *Models: 306090 Books*, Vol 11. Ed Emily Abruzzo, Eric Ellingsen, and Jonathan D. Solomon, (New York, 306090 Inc., 2007), 96. (Snooks develops this statement in reference to the work of Jesse Reiser and Nanako Umemoto)

15 Gregg Lynn, "Intricacy,", in *Intricacy: Exhibition* catalog (Philadelphia: University of Pennsylvania / Institute of Contemporary Art, 2003). Intricacy as espoused by Gregg Lynn for example in this essay and exhibition.

16 Patrik Schumacher, "Parametricism as Style," http://www.patrikschumacher.com/Texts/Parametricism%20as%20Style.htm . Parametrcism has been espoused as a 'style' by Patrik Schumacher for example.

17 Allison Furuto, "'On Space Time Foam' Exhibition / Studio Tomas Saraceno," *ArchDaily* (November, 2012). http://www.archdaily.com/292447/on-space-time-foam-exhibition-studio-tomas-saraceno

18 Bohme, "Atmosphere", 122.

19 Gregg Lynn, *Animate Form* (New York: Princeton Architectural Press, 1999), 10.

20 Lynn, "Intricacy", *Intricacy: Exhibition catalog*. (Philadelphia: University of Pennsylvania / Institute of Contemporary Art, 2003).

21 Claire Bishop, *Installation Art: A Critical History* (London: Tate Publishing, 2005,2008), 82.

22 Timothy Morton, *Realist Magic: Objects, Ontology, Causality* (Ann Arbor : Open Humanities Press, an imprint of MPublishing - University of Michigan Library, 2013), 40-41.

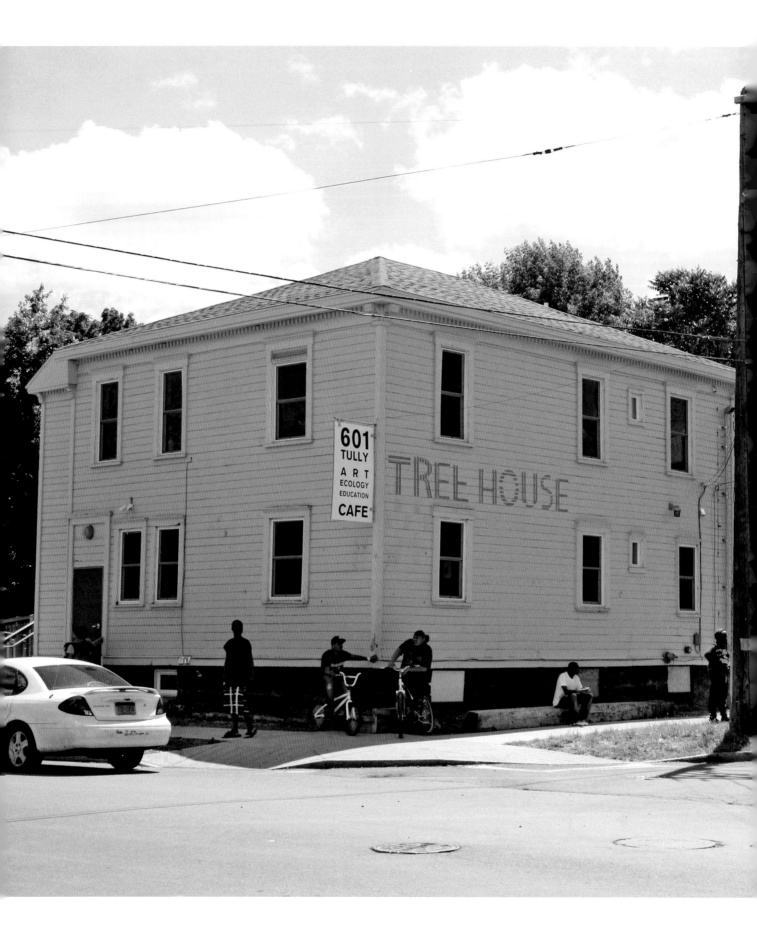

THE BUTTERFLY EFFECT
ARTIST ITINERANCY AND ADAPTIVE REUSE

by MARION WILSON

The following is a recent conversation between Marion Wilson, artist and Professor of Practice at Syracuse University; Anda French, an architect and principal of French 2D; and Jonathan Massey, Dean of Architecture at CCA, reflecting on their work and collaboration in Syracuse, NY. The projects discussed are *601 Tully Center for Engaged Art and Research* and *MLAB, the Mobile Literacy Arts Bus*, in which students and faculty at Syracuse University partnered with agencies, organizations, and neighbors to design and build facilities for community development.

Jonathan Massey: With the proliferation of Social Practice degree programs developing in universities and art schools across the world, I find it compelling to re-visit an early curricular model that was developed by artist Marion Wilson while I was the Chair at Syracuse University in the School of Architecture in 2007. Wilson was then joined by Anda French from the School of Architecture in 2010. Now that I am Dean of Architecture at CCA, and CCA recently created an M.A in Social Practice and Public Forms, I am reflecting back on what Wilson and French did. What were the ingredients for their success - budgetary resources, administrative support, or civic partners? And what *was* the curriculum that built these two facilities (I am thinking specifically about MLAB and 601 Tully)? Can other university social practice programs learn from this "best practice" model you began at Syracuse University? Marion, tell us about MLAB—the Mobile Literacy Arts Bus—and 601 Tully and the New Directions in Social Sculpture curriculum you began in 2007 at Syracuse University.

Marion Wilson: Yes, to begin, I would like to frame my discussion of these two projects in relationship to the Miwon Kwon article "One Place After Another" – which in its book form was the textbook for my college classes that built 601 Tully. And then, if we can extend the definition of *reuse*, which is the theme of this journal (reuse referring to objects), to include the word itinerancy (the artist as a performer), – I think this conversation would become very rich. I would like Kwon's article about *site* and the idea of the itinerant artist/performer to be the arc that writes the narrative of the two projects - MLAB and 601 Tully. And by thinking about reuse as itinerancy, we begin to understand how the artist (in this case, myself) can move her practice from Syracuse to Philadelphia, Charlotte, the Bronx, and Miami.

In addition, it is prescient to visit this curriculum now, as I will be leaving Syracuse University in a year, and the new leadership of Syracuse University has steered the ship back towards campus life and more traditional forms of research and scholarship.

So while Syracuse University may have been a forerunner of a Social Practice curriculum, its lifespan was just seven years. As social practice programs develop, they might think about their expected lifespan and put into place what would be necessary to keep them alive. Or is it relevant to embrace the possibility that there is a limited life cycle inherent to this kind of work? And again to think that the assessment of this curriculum is not in the objects themselves, but rather in the lives of the students and the neighbors who experienced them – which we will talk about later in the conversation.

The first thing to note is that I did not develop the

Pre-Renovation Exterior 601 Tully, Syracuse, NY, 2010

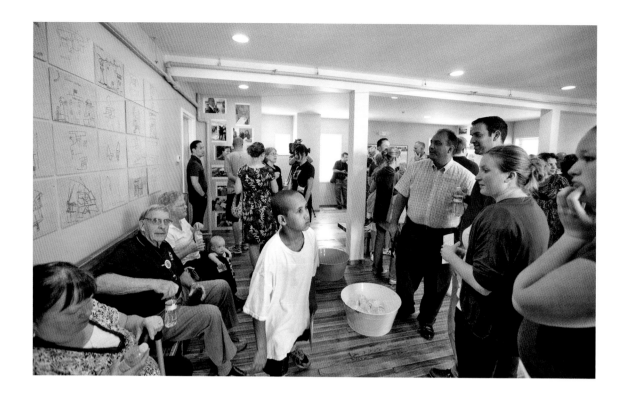

"New Directions in Social Sculpture" *from within* the hallowed halls of academia or in the comfortable niche of a departmental home, in fact, traditional department structures, faculty, and colleges were never quite sure what to do with my curriculum. The classes thrived because they were championed by a few key people, such as Jonathan, who was a tenured faculty member with administrative power. In his early days as Academic Advisor, he was able to send me some of the very best and brightest architecture students. Jonathan was able to massage the nuances of scheduling, credits, and course cross-listing. After that, it was really students who recommended my class to other students. Something was happening in my classes that wasn't happening elsewhere on campus in 2007-8, and students were attracted to that and drove its potential.

Professionally, I had just completed a well-publicized public project called "This Store Too", commissioned by the New Museum of Contemporary Art, NYC, for an exhibit called "Counter Culture," curated by Melanie Cohn. I linked the Bowery Mission (a homeless residency and soup kitchen) with the museum through a mobile pushcart street store. The pushcart, with images of me selling for eight hours a day for the length of the exhibit, was reviewed in the *New York Times*, *Art in America*, *Time Out*, and the *Syracuse Post Standard*. I think the project got attention because of the intimacy that developed between myself and the three homeless men I worked with, and, in turn, the public. Miwon Kwon says:

"the radical restructuring of the subject from an old Cartesian model to a phenomenon- logical one of lived bodily experience; and the self-conscious desire to resist the forces of the capitalist market economy, which circulates art works as transportable and exchangeable commodity goods-all these imperatives came together in art's new attachment to the actuality of the site."[1]

In 2007, I was hired by then Syracuse University Chancellor Nancy Cantor (2004-2013) to create a bridge between the campus and the Syracuse City school district. "Cantor is widely recognized for helping forge a new understanding of the role of universities in society that re-emphasizes their public mission."[2] Joseph Beuys, a German conceptualist from the 1970s, said "sculpture is not an object or a thing – but is how we as artists can mold and shape the world in which we live."[3] The Sculpture department embraced a new curriculum that I developed and named after this concept: "New Directions in Social Sculpture" (MLAB Builds), which took on the task of addressing the lack of space in the crumbling city schools with their lack of arts education.

MLAB Builds began with the purchase of a 1984 American Eagle RV. With a total of $30,000 from two grants, my class of nine students gutted, renovated, and then programmed this used RV into a mobile digital lab, poetry library, and community gallery. With one set of cameras and books and two student teachers (and another grant from the Verizon Foundation), MLAB then

Renovated First Floor, 601 Tully, 2013

travelled to 12 schools a year, offering art and creative writing programs for three years after its completion.

601 Tully, the second project to be discussed here, began with the purchase and renovation of an abandoned residence on the near westside of Syracuse, New York, that had become a local drug haven. Again, with a college class that took place over the course of seven semesters, we designed, built, and programmed the house into a contemporary arts space that links university, neighbor, and artist in the production of new culture. Whereas MLAB was about creating a liminal or threshold space that could always shift, 601 Tully was about being present, being a neighbor, and staying in place. As Kwon says, "the space of art was no longer perceived as a blank slate, a tabula rasa, but a real place."[4]

Anda French: In 2008, I met with Marion to ask for advice on a current project I was working on as a new Architecture faculty member at Syracuse University. Somehow, 601 Tully folded seamlessly into the conversation. Shortly after, Marion invited me to become the architect and an academic "consultant" for 601 Tully. We then set to work inventing a process to completely gut renovate the 2000 square foot 1890s structure, inventing our own client/architect-artist/architect and practitioner/consultant relationships all along the way.

JM: Marion, you're an artist; Anda, you work primarily as an architect. What does it mean for each of you to engage the other's field of activity? How does architecture enrich, conflict with, stymie, or provoke art-making, and vice versa?

AF: For this engagement to work, we had to reevaluate many of the standing relationships prevalent in art/architecture collaborations. In her discussion of what Philosophy and Architecture can offer to each other, Elizabeth Grosz examines a relationship that could be understood between Art and Architecture, asking similarly:

> *"What are some of the pertinent points of overlap or mutual investment that may implicate each other in mutually productive ways? Perhaps more pertinently, what are the blind spots within the self-understanding of each? And how can each be used by the other, not just to affirm itself and receive external approval, but also to question and thus expand itself, to become otherwise, without assuming any privilege or primacy of the one over the other and without assuming that the relationship between them must be one of direct utility or translation"? (Grosz 109)[5]*

Grosz's discussion then moves to virtuality (of time) and 'becoming' to bring the disciplines together, something that definitely plays out in 601 Tully's process. The collaboration on 601 Tully certainly works through these questions, and, I think, successfully navigates issues of primacy and privilege.

MW: I think the way an artist "grows" a project is very different from the way an architect might "map" a project. The students from architecture, interior design, and sculpture had distinctly different approaches. This can be seen in the example of creating the ceiling of MLAB (a collage of disparate white Plexiglas scraps). The architects measured, numbered, and mapped each piece in a CAD drawing to fit into the lopsided 1984 bus. This is not a criticism, but they didn't touch a piece of the material in their planning. The artists, on the other hand, schlepped the pieces of plastic into the bus with a drill and began a process of install-as-you-go with actual materials in real time and space. This was very messy. The interior designer of the class was the mediator between the two, and laid all the pieces of plastic out in a pattern on the classroom floor first. I don't want to generalize or overstate the differences in this approach, but their difference becomes significant when you replace the scraps of plastic with a community or a site. When you enter a neighborhood - specifically with the racial and economic divide that the University and the near west side represents - ideas of mapping and "not - touching" are exactly what I wanted the students to avoid. A kind of intimacy seems necessary – similar to what was developed in my project on the Bowery with the homeless men. But a plan is also a good idea. There was a necessary kind of messy.

JM: Anda, at 601 Tully I observed that to meet construction and completion schedules, you had to move the project pretty far along before the collaborative process generated clear directives about the activities this building was to house, or the principles that should guide its design. How did you shape your role as architect in response to these unusual parameters? Did you look to any specific precedents to help model this?

AF: Interesting issues came up immediately around the program. The work embodied both a denial of the still dominant modernist organization of the process/project and, at the same time, a loose embrace of the modernist free plan to welcome possible future use. It anticipates future use in certain strange ways based on the quirky details of the physical limitations of the structure, but this anticipation does not take a recognizable or branded form. Even when program has become a flexible concept in architecture, it still exists as a dictate before the design process, whether it is being responded to, denied, or projected as manifest in some formal or visual gesture. The process for 601 Tully often felt outside of this condition, or at least always resisted "program" in any of these senses.

MW: At the beginning of the first semester of the college class that designed 601 Tully, we organized a focus group in the driveway and asked the neighbors (future stakeholders) three simple questions: What was the history of the building? What was their personal relationship to the building? What would they like to see in the building? At that time, Syracuse University was engaged in a "neighborhood revitalization" strategy, purchasing properties on the Near West Side with Home Headquarters and a non-profit they created, and working to fix the city schools. I wanted 601 Tully to differentiate from this initiative in a key way. I did not want to propose that we were "improving upon" an existing condition - but rather to sit within in it or reveal its condition. Similarly, for the ground breaking ceremony, instead of putting a shovel into the soil or cutting a ribbon, I led everyone in a blind contour drawing exercise and asked them to see-anew the building and its surroundings. This included the local Senator, Deans, Chancellor, donors, college students, neighbors, and school children. My goal was to encourage an intimate mutual "seeing" of each other; and reveling in a new way of becoming.

At one of the community meetings, Yun-Pei Hsiung, an interior design student in the class, characterized this approach in his own way. He assertively asked, "in order to understand this neighborhood, I need to sleep in someone's house for a night, or a few nights. Who will let me stay over?" And a family volunteered, so he spent some time living with them and getting to understand their life. Unlike the other architects I interviewed, Anda understood that the social institution we wanted to create could not be designed outside of a deeply engaged process.

Suspending our engagement with function allowed our program to evolve. We were actors in this process. The objectives that students distilled from encounters with other artwork became the program. For instance, sculpture student Samantha Harmon drew upon the work of Tracey Emin, which includes the idea of collecting memory by writing on the walls. Rather than saying "we need 60 square feet of kitchen space," we said things like "we need places for memory to be inscribed on building surfaces."

The actuality of a location (as site) and the social conditions of the institutional frame (as site) are subordinate to a discursively determined site that is delineated as a field of knowledge, an intellectual exchange, or a cultural debate.[6]

As the architect of record, Anda was thrown into a different kind of design process, back and forth between the known conditions of the building shell and an unknown destination, with clues slowly emerging along the way. I think she was key to the project's success. We created a porous space that encouraged co-production between neighbors, artists, and the university. We were able to approach the building as a living sculpture, something provisional and not quite finished.

AF: When Marion and I met, I was in the midst of executing another non-traditional architectural project, the Sibylline TXT, which operated under a similar sense of play. Sibylline TXT is an urban text message-based storytelling project that replaced program with narrative, and sequential organization with nonlinear organization, based on participants' movement in the city. By superimposing a story that had to be collected at multiple locations over the city, I was trying to break down Grosz's notion of the "privilege of the present" to build out a virtual space that could be in a constant state of becoming.[7]

On a practical level, I was running around town for this project, meeting with every art and cultural community organization to build up the participatory network. The project only existed through community participation. Because of this, I was in just the right place to work with Marion in this alternative architectural mode.

With regards to this issue of 'program', it has gone in and out of fashion in architecture as a term, but it is always present in the room in contemporary architectural practice. There's *Praxis*, issue 8 on the program that I was using in my teaching, which compares Bernard Tschumi's designs for *Parc de la Villette* with those of Rem Koolhaas.

What do you solidify and materialize, and what don't you, to allow possibilities to emerge? Tschumi used program to generate these complex, particular objects that attempted to concretize "program" in crystallized forms. Koolhaas imagined these territories across which events could happen. Our approach was more like the latter, but we were working within an existing shell that was already a sort of crystallized form. The practical constraints of the existing form became a large focus in my professional work (how to build the building inwards from the edges of its skin). In the end, the goal of stabilizing the structure became an active player in keeping the architecture as neutral as possible; this allowed for changes in use to be absorbed in an alternative sequence.

JM: How did the collaboration begin and build?

MW: The collaboration for me and for my students, not to sound too academic, began with the rhetorical death of the author.

What is the status of traditional aesthetic values such as originality, authenticity, and uniqueness in site-specific art, which always begins with the particular, local, unrepeatable preconditions of a site, however it is defined? Is the artist's prevalent relegation of authorship to the conditions of the site, including collaborators and/or reader-viewers, a continuing Barthesian per-

formance of "death of the author" or a recasting of the centrality of the artist as a "silent" manager/director?[8]

Both projects began the same way - I asked each class member (always art, architecture, and design students) to describe what they perceived to be their skill sets. This process set the stage for incredible productivity on the students' part in both projects. MLAB used the collaborative model of "everyone does everything", and we made designs based on that model. 601 was based on our collective and divergent skills. For example, the high school student that joined our class became a neighborhood expert; a painting student had excellent social rapport; the architecture students could draw what was necessary for zoning meetings; and the English and journalism majors wrote our Manifesto.

MLAB inspired a heightened productivity in all nine of its participants. There was an incredibly intense level of engagement. Margaret Heffernan, a sociologist, talks about the productivity of chickens versus the Super Chicken in her TED talk. This theory suggests that we become more productive when we don't focus on the superstar, but rather cultivate an egalitarian team ethos. That resonates for me with the experience of MLAB. We developed what Heffernan called social capital or the John Nash theory: to supplant competition with building social capital. We built extraordinary trust and interde-

pendence that was the result of many, many hours spent together. Maybe there's something to the social science suggesting that we are instinctually social and cooperative, not competitive. We sat in a circle for weeks and talked for our three-hour class meeting. We blogged daily. This was back in 2007, when not everyone had a blog. Our blog tells our narrative, and we published a small book. Sometimes a student would fall out due to some other life circumstance, and I would let them go, because I knew they would come back. During the course of the one year project, there were two marital engagements, five senior thesis projects, one leave of absence, two bike accidents, one car accident, and one gallery fire.

AF: It sounds like a cult! In the best sense, of course. It was very satisfying to work with students in a similar fashion when I was invited to sessions with the 601 Tully Social Sculpture courses.

This model seems to question what expertise is. Each student brought an "expertise" related to his or her discipline, but I would think there were other non-disciplinary forms of expertise that went further and blurred some of the disciplinary lines.

MW: I heard of a company in Scandinavia that insisted

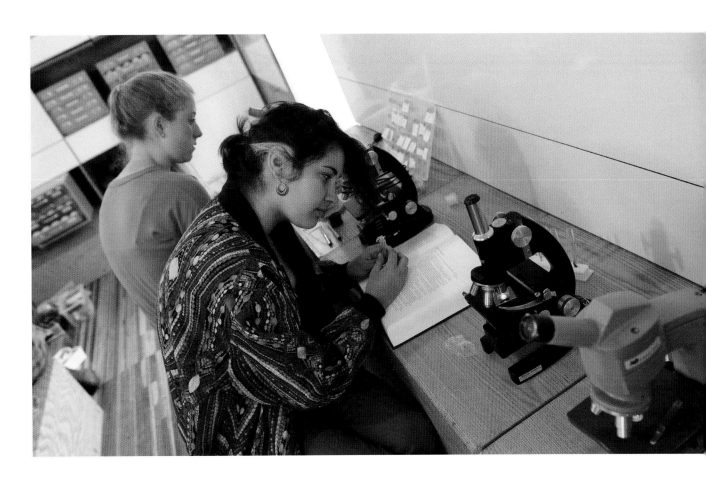

Students of SUNY/ESF drawing in Mobile Field Station, Syracuse, NY, 2015

Many of the artists were women sculptors. In this subtle yet important way, the building now becomes a living form - a living sculpture. The facade became a block of lard with a bite taken out of it; or a wall of striped mirrors; or a fabric wall with lovers' names stitched onto it. Architecture student Andrew Weigand's image of Daniel Buren's façade with mirrors was important, not only in its blurring of the boundary of interior and exterior, but in its framing of the institutional critique. This critique is inherent in the University as the power broker in the situation; or in the disciplinary straight jackets that kids were forced to wear in the public middle school next door; and in the critique of the building itself as permanent form or finished object rather than living sculpture. This assignment set up this entire discourse.

AF: I find this very interesting in contrast to a piece like Rachel Whiteread's *House*. Our "pragmatic" architectural goal was not to lift the history and expose it through its enshrinement in plaster, but rather to rebuild from the outside in, because 601 Tully had been completely stripped bare to the studs on the interior before we began working on it. As a result, it is only the exterior surface that remains. Everything else is reconstituted and reconfigured. If the project were seen as a palimpsest, the facade would be the scroll, and everything else would be washed away and rewritten. Then again, the architectural rewriting is also like a Madlib, with key pieces left to be written in later.

JM: Last night, I watched a great lecture by Andrés Jaque, the Catalan architect behind this year's MoMA PS1 Young Architects Program installation, "Cosmo." Jaque designs buildings, installations, and other objects aimed at revealing the networks of relationship among agents and things, and reconfiguring those relationships into new configurations. His work has elements of relational aesthetics, overlaid with ideas from the actor-network theory outlined by Bruno Latour and others. One thing that struck me today as I thought about his work and yours--they have some of the same goals--was that part of Jaque's practice is to foreground the distinctness of his objects, to de-familiarize them so that you look a second time and perhaps begin to puzzle at the implications they might have. "Cosmo," for instance, is a giant assemblage of pipes, tubes, cables, water basins, and planters suspended above the PS1 courtyard.

601 Tully has a similar aim of reassembling networks of people, places, and things into a preferred configuration. But its architecture is very low-key and unobtrusive. It doesn't stand out or call attention to its distinctiveness--apart from the big ramp out back. There's a part of me that wanted a more non-normative, non-standard architecture from 601 Tully. I'm sometimes disappointed that it isn't more visibly, formally, and materially differ-

that everyone in their company took the same "coffee break," or as they called it, "water-cooler" time – so that the employees would build social bonds beyond their work bond. They found that the productivity of the company increased by something like 10 percent once the social bond was increased.

People would ask me, why do you want to collaborate with your students? Or with homeless people? For me, I am my best self when I'm collaborating with other people. And this is true of many people, including the students who thrived in these projects.

JM: Any successful project like this depends in part on the unique talents of the participants and their chemistry with one another. But there are probably ways for other people pursuing similar projects to learn from your process and accomplishments. Could you say a bit about how you structured components of the work, course assignments, team projects, and the like?

MW: The facade assignment is an illustrative example of how I teach. Based on their skill sets, I paired students with well-known contemporary artists, whom they researched, presented, and designed a facade solution in relationship with or to. In this way, we added a dozen or so more voices to the room - that of Daniel Buren, Janine Antoni, Teddy Cruz, Tracey Emin, Rachel Whiteread, Tyree Guyton, and Rick Lowe, for example.

TOP
Student Façade Assignment, Andrew Weigand on Daniel Buren
BOTTOM
Student Façade Assignment, Wayne Tseng on Eva Hesse

ent from other buildings--to register and communicate its distinctive program, operations, and history. Some glitter and marble--or whatever the elements are that would convey this.

AF: I think it could bear that differentiation now that it is established. In this project, the collapse of time, the traces, are virtual rather than material. This is the aspect in which the architectural experiment on the structure itself is most successful but least visible-a fact that is both satisfying and terrifying to an architect!

Much of the initial architectural work exists in Grosz's notion of virtuality and time. She makes this great point that "Architecture has thought time, with notable exceptions, through history rather than through duration, as that to be preserved, as that which some-how or provisionally overcomes time by transcending or freezing it."[9] I would like to think that 601 Tully does not operate this way; instead, as Grosz then writes, it oper-ates in a different kind of time,

"A time bound up not only with the past and with history and historicity but also, perhaps primarily, with futurity, thus providing a mode of resistance to the privi-lege of the present and the stranglehold that the pres-ent and its correlatives, identity and intention, maintain on space and matter."[10]

MW: Yes, and part of that was the point-to "polish the familiar"-but then as a living sculpture-and to allow oth-er artists to continue the visual form. It can be read as a narrative and not as an object. All of my college classes are taught in this building, several miles from campus. Each semester, we invite and engage new artists to work in the space- linking neighbor with artist and university partner. For example, Dan Sieple, an artist from Berlin and founder of Skulpturenpark, created a bird line con-necting 30 properties along their fence lines – emanat-ing out from 601 Tully's front entrance. Sam Van Aken's *Tree of Forty Fruits* is planted in the garden. Tattfoo Tan, eco-artist from Staten Island, NY, created *Nature Match-ing System*, linking art and nutrition, and worked with the local grocer and a bilingual school in the neighbor-hood. Students in New Directions in Social Sculpture class were active co-initiators of the finished works. All along, the idea was to make the building structurally viable, which then allowed for hundreds of neighborhood kids to participate in after school art classes taught by the college kids. The structure of the building was also home to the creation of works by visiting artists.

But the real intent of the work is understood through the institutional critique of displaced site that is again framed in Miwon Kwon's essay- away from modernist discussion of form and beauty. All of my college classes are housed three miles from campus, way down the hill at the far western edge of the city in one of the poorest neighborhoods in the nation. That is the suggestion of

601 Tully – as opposed to whether it has a certain tilt to the roof or a laser cut façade. The power of the project is its site- and the very fact of its site in the context of the institution!

In the paradigmatic practice of Hans Haacke, for instance, the site shifted from the physical condition of the gallery (as in the *Condensation Cube)* to the system of socioeconomic relations within which art and its institutional programming find its possibility of being. Haacke's 1970s fact-based exposés, which spot-lighted art's inextricable ties to the ideologically suspect, if not morally corrupt, power elite, recast the site of art as an institutional frame in social, economic, and political terms, and enforced these terms as the very content of the art work. Exemplary of a different approach to the institutional frame are Michael Asher's surgically pre-cise displacement projects, which advanced a concept of site that was inclusive of historical and conceptual dimensions.[11]

AF: I would also think that if it had a frozen-in-time architectural expression from the beginning, it would not have succeeded in the way that it has. To remain "quiet" in terms of architectural expression was important here to the collaborative work that would proceed from this initial process. There is a Scandinavian idea of the "Law of Jante," which favors the collective over the individual, and is arguably lacking in notable architectural practice.

Funders of MLAB and 601 Tully: The Salt District of the Near Westside, E-nitiative, Kauffman Foundation, National Grid, Imagining America, Syracuse Univer-sity, School of Education and Office of the Chancellor, POMCO, State Senator Valesky, and Verizon Foundation.

ENDNOTES:
1 Miwon Kwon, "One Place after Another: Notes on Site Specific-ity", *October*, MIT Press Vol. 80. (Spring, 1997), pp. 85-110.

2 Rita Axelroth Hodges and Steven Dunn (2012). *The Road Half Traveled: University Engagement at a Crossroads.* East Lansing: Michigan State University Press

3 Joseph Beuys, *Public Dialogues* 1974

4 Kwon, One Place After Another, 89

5 Grosz, E. (2001). *Architecture from the Outside: Essays on Virtual and Real Space.* Cambridge, MA: Massachusetts Institute of Technology.

6 Kwon, "One Place After Another, Notes on Site Specificity", 103

7 Groz, "The Future of Space: Towards an Architecture of Inven-tion", 111

8 Kwon, "One Place After Another, Notes on Site Specificity", 103

9 Groz, "The Future of Space: Towards and Architecture of Inven-tion", 111

10 Ibid, 111

11 Kwon, "One Place After Another, Notes on Site Specificty", 91

SINGULARITIES OF PLACE

by ELIZABETH G. M. PARKER

Light slides across a wall through whites into faded yellow and eventually the memory of burnt orange, the sheetrock at its edges grey-white, grey-black, black-gray. The dents, scuffs, and squeaks of place reside with us; their peculiarities are reminders of place, like the scars that transport us to childhood scrapes.

It is, perhaps, from these skin scars and wall scuffs alike that nostalgia grows: moving away, we close the door on scratched floors and familiar smells just before opening the door to a space, new to us, that bears traces of prior residents. So, moving in, we clean these traces, checking, installing,[1] and gradually laboring our way into a familiar dwelling.

Mostly, the preservation or erasure of these small, discrete imperfections is concomitant. They are neither the significant traces of centuries John Ruskin described[2] nor original decorative flourishes, but rather the discrete, un-authored chips from walls and gaps between wallpaper, accumulated over a building's life and easily erased by the swipe of a putty-covered spatula.

It may be, however, that their small size and un-authored locations in the midst of walls or ceilings are what makes these peculiarities so compelling. If, as research suggests,[3] humans extend their self-identities most readily into the external objects they perceive most controllable, the mutability of these marks makes them ripe subjects for self-extension. And, because normal perception of surface relies on the presence of the edge conditions to which our neurons respond strongly,[4] these random scuffs activate interior surfaces for human eyes. Through them, perhaps, comes place attachment.[5]

And so an aesthetic practice is begun: it embraces the preservation, addition, and removal of small domestic peculiarities and their reframing into expressions. Its forms come from a building's existing drips, crooked boards, and shadows. Its canvas is the skin of the interior, drawing idle attention near the kitchen table or shaping evening shadows. Its intention is the increased possibility of a lingering, thickly[6] human encounter with the singularities of place.

ENDNOTES:

1 Georges Perec and John Sturrock, *Species of Spaces and Other Pieces* (London: Penguin, 1997), 35.

2 John Ruskin. *The Seven Lamps of Architecture* (New York: John Wiley, 1849), 161-163.

3 Russell W. Belk, "Possessions and the Extended Self," in *Journal of Consumer Research* 15.2 (Chicago: The University of Chicago Press, 1988), 140-141.

4 Evan Thompson, Alva Noë and Luiz Pessoa, "Perceptual Completion: A Case Study in Phenomenology and Cognitive Science" in *Naturalizing Phenomenology: Issues in Contemporary Phenomenology and Cognitive Science*, eds. Jean Petitot, Franscisco J. Varela, Barnard Pacoud and Jean-Michel Roy (Stanford: Stanford University Press, 1999), 163-164.

5 Leila Scannell and Robert Gifford, "Defining place attachment: A tripartite organizing framework," in *Journal of Environmental Psychology* 30 (Amsterdam: Journal of Environmental Psychology, 2010), 3.

6 Kent Kleinman, "Taste, After All," in *After Taste: Expanded Practice in Interior Design*, eds. Kent Kleinman, Joanna Merwood-Salisbury, and Lois Weinthal (New York: Princeton University Press, 2012), 30-34.

An existing peculiar gap between two widths of wallpaper that, when painted over, grew apart. Washington, D.C., 2014.

FIGURAL IDENTITY IN ADAPTIVE REUSE

PRESERVED, NEW, AND HYBRID

by MARIE S. A. SORENSEN

Experimental Ambitions and Legacy – Architecture as Art in the Modern Period

Why is it useful to explore the apparently semantic discussion of art and its categorical difference from architecture? Architecture's aspirations to achieve 'artistic' merit are endemic to the discipline – appearing in recorded history as early as Vitruvius' first century BCE platform of 'firmitas,' 'utilitas,' and 'venustas' (strength, utility, and beauty). However, the 'beauty' of early architecture was a classical and symmetrical undertaking, and a majority of the work of architects during and since Vitruvius' time fell within a mode of 'fabric' buildings, structures with height, bulk, proportions, and detailing based in the existing construction and stylistic traditions of a given city, town, or rural region.

Departing from the 'fabric' building tradition, formal inventiveness in architecture flourished at the turn of the twentieth century in the horizontal and vertical expansiveness, volumetric drama, and sculptural freedom of residences for professors by Bernard Maybeck in the Berkeley Hills of California and in Frank Lloyd Wright's Prairie School compositions for Chicago's elite. On the eve of the First World War, Henry van de Velde and Bruno Taut celebrated the excitement of the new spatial possibilities engendered by steel, reinforced concrete, and glass in temporary exposition buildings for the Werkbund Exhibition in Cologne. While regular in their symmetry, these buildings and Erich Mendelsohn's post-war Einstein Tower near Berlin are highly stylized, geometric formal departures from the metered vocabulary of the earlier regional and classical traditions. But in the post-

World War II building boom, the 'fabric' building returned, now taller. Chicago's first skyscrapers, quickly adopted in New York City and other dense cities, set the trend for the regular shape of urban buildings from the turn of the twentieth century.

In the past forty years, only the most virtuosic architects who created advertising value through formal distinctiveness – employing visually memorable silhouettes; dramatic use of sculptural relief and cladding color and texture; strongly contoured horizontals, verticals, and curves; and/or shapes with form references easily understood by reference to familiar objects (such as 'the washboard,' as the Boston Fed is known)[1] – managed to break the developers' pro-forma of maximum leasable space and achieve divergent artistic form in urban settings: Jorn Utzon with the Sydney Opera House (1973); Philip Johnson and John Burgee at Pennzoil Place in Houston (1975); Hugh Stubbins with the Boston Federal Reserve Bank (1977); Dominique Perrault at the National Library of France (1995); Frank Gehry with the Guggenheim Museum Bilbao (1997); OMA with the Beijing CCTV Headquarters (2012); and others – but few.

Building or Complex as *Object Trouvé* – 'Found Object'

Architects and artists seeking large-scale formal experimentation outside of this commercial setting looked to factory complexes as territory. Writing reflectively in 1990 on the prior two decades of industrial decline and prospectively on the continuing economic need to revitalize districts left vacant with offshoring, theorist Kevin Lynch envisioned vacant urban factories as places

An informal exterior composition in red, turquoise and white as a 'topographical artwork', 50 Moganshan Road, Shanghai.

of unbounded possibility.[2] The low economic value of these purpose-built structures and complexes at city edges made them ideal sites for low-risk experimentation within their large volumes. Upon their surfaces, and through additions, the architects or artists worked with the existing structure as a large-scale *object trouvé*. This term describes an artist incorporating a 'found' object with culturally-specific meaning into a new context wherein its meaning is transformed by the perception of the artist's work of art. Marcel Duchamp's *Fountain* (1917) – the display of a urinal as art – is the iconic example, though the descriptive term *object trouvé* came into use in 1937. Artists 'find' buildings designed for manufacturing, science, engineering, offices, and housing in districts that have been eclipsed by new developments fulfilling related needs. Upon securing access – through cooperative and/or governmentally-financed means, through direct arrangement with the owner, or, in unfortunate cases, illegally – artist occupants respond to the megalithic form with three overarching purposes: (1) to shelter themselves and their art-making; (2) to create at an unprecedented scale in terms of 'numerousness' or sheer size; and (3) to alter our understanding of the building's signification as a shelter. Developers and owners often encourage and facilitate artist occupancy and alteration of vacant industrial buildings and complexes, as their creative culture has been shown to precipitate district regeneration in cities around the world, including New York, Boston, San Francisco, Basel, and Copenhagen.

We look here at two spatial expressions of adaptive reuse within the *object trouvé* typology – *the complex as topographical artwork* and *the building as hybrid figure* – to describe those qualities that make them 'art.' Illustrating *the complex as topographical artwork* are two projects that create a morphological play between the existing complex and the new forms or surface treatments: Richard Meier's Westbeth Arts live-work housing in New York City and the informally-developed arts complex 50 Moganshan Road (M50) in Shanghai. Describing *the building as hybrid figure* are two projects separated by over nearly fifty years in time: a pair of Paris townhouses in Les Halles altered by artist Gordon Matta-Clark for the 1975 Biennale (now demolished) and Herzog & de Meuron's Elbphilharmonie in Hamburg. These are discreet singular structures changed by a significant addition or subtraction of form. Derelict or otherwise underutilized buildings have long been locations of expansive creativity for artists – and in fact, the four examples given are programs for artists and the arts.

Art's Critique of Architecture and the Built Environment

In the 1970s, art reacted to architecture, and the ensuing experiments in turn influenced architects. Sculptors Donald Judd, Robert Smithson, Richard Long, Gordon Matta-Clark, and others carried art practice into the built environment. Robert Rauschenberg criticized the archetypal sterile white gallery by breaking the edge of the frame in mixed-media collages he called 'combines.' Smithson created *Spiral Jetty*, a large rock formation in the landscape; Richard Long documented long lines walked across desert territory and allowed only recordings of the ephemeral actions to be curated; and Donald Judd made geometric vertical and horizontal forms with deep voids breaking masses. The architecture world almost claims Judd – and he confirmed the presumed affinity with his purchase of a former army base in Marfa, Texas as *object trouvé*. These experiments, briefly mentioned here, have detailed histories beyond the scope of this analysis and impacted art in additional ways.

As Smithson and Long drew the art world's attention to the environment, historians JB Jackson and Dolores Hayden contemporaneously penned critiques of the new look of the American landscape: the sprawling cities, redeveloped downtowns, proliferating highway interchanges, and increasingly abandoned factories. Landscape photographers Robert Adams and Lewis Baltz – members of a group of large-format photographers referred to as *New Topographics* – photographed the dystopia of residential and industrial sprawl. In their images, clusters of dwellings read as topographical aberrations on scraped sites.

Complex as Topographical Artwork

This 'topographic' trend in art surely influenced architects such as Richard Meier, also based in New York City, a major center of the 1970s art world. Today, we know Meier as an architect of major commercial works of new construction – luxury apartment buildings, academic centers, and government offices with clean lines and bold white humanistically-scaled facades. But Meier's first large commission, completed in 1970s, was a renovation project for the J.D. Kaplan Fund and the National Council on the Arts: Westbeth Arts. This 384-unit complex in New York City's Greenwich Village was the first publicly-funded live-work housing project in the United States. The existing buildings, Bell Telephone Laboratories' late nineteenth and early twentieth-century office and research and development complex, were an agglomeration of robust brick structures assembled to utilitarian ends. The multiple structures on the large block had diverse footprints and heights, though several strong rectilinear axes brought drama and coherence to the assemblage.

Subtracting two existing timber-framed structures, selectively painting facades, and adding geometric elements like fire escapes, concrete park benches, and a fountain, Meier developed a new language of form to be read at an urban scale simultaneously with the existing historic volumes. The resulting Escher-esque composi-

tion of white on brick showcased new geometrically-defined gathering spaces while allowing the formal identity of the existing office and lab building complex to remain visually whole.

Today, the website of the architect, to whom Ada Louise Huxtable referred in 1969 as "...one of the city's more conspicuously talented and stylish younger architects,"[3] lands on a sizable life sciences research building at Cornell University, clad in white. Headlines move along the website with the text of Meier's 1984 Pritzker Prize acceptance speech:

"White is the most wonderful color because within it you can see all the colors of the rainbow. The whiteness of white is never just white; it is almost always transformed by light and that which is changing; the sky, the clouds, the sun and the moon."[4]

Meier's use of white paint to alter the urban presence of the former Bell Labs complex is elemental to its resonance as a large-scale work of art. It brings the former office and test facility buildings into the modern spatial idiom of solid and void by amplifying the presence of certain facades. This use of white on such a large scale is the earliest expression of Meier's later oeuvre.

Westbeth's Executive Director, Steven Neil, understands the importance of the white paint to the historic significance of the modern period of this complex and the work of Meier. He is currently supervising the restoration of the complex as part of a $7 million renovation project that includes deferred maintenance left off the project in 1970, like fixing roofs and other envelope issues. The New York City Landmarks Preservation Commission, which designated the complex in 2011, men-

Complex as Topographical Artwork – Richard Meier's 1970 topography of white paint on brick exteriors at New York City's Westbeth Arts can be understood as a megalithic artwork at the scale of an urban block.

Westbeth Arts, the first publicly-funded live-work artist loft project in the United States, is an Escher-esque composition of white on brick by Richard Meier, showcasing geometric additions like these park benches.

tions Meier's alteration work but attributes Westbeth's contemporary significance primarily to the building's social history as a community of significant artists.[5] As early work by Meier and other members of the New York Five – an avant-garde group of architects featured in a 1969 exposition at the Museum of Modern Art – increasingly requires substantial renovation, preservation tides will surely shift. Docomomo, the international preservation organization for modern movement heritage, and *Metropolis Magazine*[6] are at the head of this trend, building the case for the significance of noteworthy works of architecture built since 1970.

As at Westbeth, exterior paint is the primary element of change in the adaptive reuse of 50 Moganshan Road (M50), a studio, dwelling, and gallery complex developed in the late 1990s in a multi-structure 1930s-era former textile mill complex owned by Shangtex, the state textile company, in the Putuo District of Shanghai, China. Over 100 artists' studios are located here and merge with the adjacent residential and industrial neighborhoods. The underutilized factory buildings in this area are quickly being converted to residential, office, and artist studios such as the nearby Creek Art Center. Located near the downtown of the Jing'an District, the area is a part of Shanghai's Suzhou Creek Renewal District and has been improved through public park amenities and infrastructure replacement over the last decade.

The M50 buildings are an assortment of tile-roofed one to four-story concrete, brick, and stucco structures with dark gray, white, and red brick weathered exteriors, alternately advancing and receding at irregular intervals. The varied topography of façades and roofs is connected on the ground plane by broken asphalt access drives from which furniture-scale water, sewage, and fire protection piping access points protrude and cluster, and large pipes occasionally pass overhead from building to building, making informal thresholds.

Within this discordant setting – reminiscent of the dystopic 1979 Russian film *Stalker* by Andrei Tarkovsky that initiated the 'landscape urbanism' trend, in which abandoned industrial landscapes are reclaimed as parks – the artists have built empathy with their surroundings by framing doorways, installing studio signs, and graphically altering entire sections of the exterior as informal site-specific artworks. One of these works, in red, white, and iridescent blue paint, colonizes a metal stairwell, a grouping of human-scale pipes, and the adjoining two building exterior walls.

Art enacted on the existing structures is an empathy-generating design mode, setting in play a new formal way of looking at the building forms and the experience of the space within. While the episodic alterations of M50's exteriors are small-scale topographic interventions, the interiors are claimed and altered in their entirety by the artists whose gear, workbenches, and framed works occupy the lower third to half of the

fifteen to thirty-foot high spaces. The upper two-thirds of the walls, the figurally-expressive rectangular columns with four-sided trapezoid-faced capitals, and the flat and saw-tooth ceilings are a topographic artwork of whitewashed planes. Within one of these radiant white volumes stands a twenty-foot high plaster figure of Mao Tse-tung with sculptures of children prostrate at his feet. As at Westbeth, the *complex as topographical artwork* is created through the amplification of latent spatial geometries.

Building as Hybrid Figure
In the 1970s, art reacted to architecture not only at the scale of the complex, but also in disputing the culturally prescribed meanings of individual structures. Artist Gordon Matta-Clark is arguably the initiator of *the building as hybrid figure* mode of adaptive re-use within the *object trouvé* typology – in which existing buildings are dramatically transformed through the addition or subtraction of large-scale elements with distinct figural identities.

Splitting (1974) and *Conical Intersect* (1975), two of Gordon Matta-Clark's works of 'anarchitecture,' exemplify the alteration of a 'found' building whose signification as a sheltering structure is dramatically ruptured by a counter-posing figural gesture. Bruce Jenkins, biographer of Matta-Clark, chronicles the emotional impact of Matta-Clark's first building-scale works. He describes the New Jersey tract house that Matta-Clark split by making two vertical cuts one inch apart with power hand tools and by chiseling the foundation to cause its settlement to one side of the house. Matta-Clark had invited a group of friends to come see the work, but even right before the intended exhibit, Matta-Clark told interviewer Liza Bear, "there was a terrific suspense, not really knowing what would hold or shift." In the end, the cut building's two halves settled outwardly, creating a wedge of light that destabilized the solidity of the structure and carried the social commentary of that rupture with it.[7]

The geometric play of *Splitting* relies partly on an equivalency between the rectangular proportions of the original house and that of the two halves, which are proportionally identical to the house. *Conical Intersect* is a temporary work that Matta-Clark constructed in two Les Halles townhouses on the edge of the Pompidou Center construction site during the 1974 Paris Biennale. Matta-Clark's geometric dialogue with the existing structures similarly destabilizes their original meaning, in this case through the cutting away of a telescope-shaped form on the third, fourth, and fifth floors of the structure, its roughly 10-15-foot diameter opening, and several additional circular cuts beyond visible to passers-by below. The drama of *Conical Section* is clear in Marc Petitjean's photographs taken inside the structure during the construction of the artwork, in which the brick, timber, and

plaster of the floor and wall construction make a rough contour for the conical volume of intersecting circular cuts.

Equally dramatic is Herzog and De Meuron's alteration of Werner Kallmorgen's 1966 Kaispeicher A in Hamburg into a hybrid form with a brick base and soaring glass crown for the Elbphilharmonie symphony, hotel, and condominium complex (completion expected in 2017). As in *Splitting* and *Conical Intersect*, the historic form, the new form, and the compositional whole are uniquely identifiable. The distinctiveness of the historic form within the architects' hybrid composition stems from both its unique appearance and the geometric parity set up by the adaptation.

Kaispeicher A, rising 98 feet above a 25-foot high pier in the Elbe River, appears like a fortification, with three roughly 80-foot wide brick piers interspersed with the dark slots of vertical loading bays.[8] Small, square, regularly-spaced openings evoke gun emplacements in a castle wall and have a similar aspect to the now classic postmodern façade of Michael Graves' 1980 Portland Building.

Above the brick base, trapezoidal in plan and used now for parking, a one-story high recess, perhaps fifteen feet in height, separates the brick volume from a soaring glass crown above that the architects refer to as a 'crystal.' This joint is the structure's main circulation node, the arrival point from the sweeping grand escalator and the entrance lobby to the two symphony halls. With the exception of the sky-reaching fore and aft portions of the 'crystal,' the heights of the brick volume and the glass volume are identical. The proportional balance strengthens the identity of the historic structure.

Herzog and de Meuron intended the glass addition to look like "…an immense crystal, whose appearance keeps changing as it captures and combines reflections from the sky, the water and the city…" and also "like a tent," bringing a vertical "accent" to the formerly planar pier.[9] The operable apertures in the building's skin – precision-formed and coated slumped-glass panels of variable profile roughly eleven feet high and sixteen feet wide on standard floors[10] – might be interpreted as a riff on the small regular openings of the warehouse façade, whose "abstract" beauty the architects admired.[11]

The Elbphilharmonie's *hybrid figure* resonates as a compositional whole through proportional equivalency, the language of its apertures, and through the dramatic and abstract deployment of classical forms. In the glass crown, these forms resonate with the traditional language of the brick base: both the vaulted openings at lobby level and the arced forms of the 'crystal' play on the Gothic arch.

Experimental Ambitions – Formal Distinctiveness in Urban Settings

The successful and coherent transformation of complexes and buildings into *topographical artworks* and *hybrid figures* argues for acceptance of the progressive approach outlined here, in which added elements have voice, historic works maintain material and formal integrity, and the resulting hybrid building or complex is itself a new work of art. These strategies are not simple or proscriptive, and any proposed development aspiring to artistic merit should be held to strict standards of review. But formal distinctiveness is a value we have neglected in the design of urban buildings, and we can and should use adaptive reuse as a vehicle of experimental ambitions.

ENDNOTES:

1 Katherine Solomonson. *Design for Advertising* from *The Chicago Tribune Tower Competition*. University of Chicago Press, 2003.

2 Kevin Lynch. *Wasting Away*. Sierra Club Books, 1990.

3 These words were included in the National Register of Historic Places Nomination for the former Bell Laboratories complex, penned shortly after the alteration work in 1975 (though, unfortunately, perhaps due to the stigmatization of modernism in some preservation circles, not in its *Statement of Significance*).

James Sheire. *National Register of Historic Places Inventory – Nomination Form for Bell Telephone Laboratories (common name Westbeth)*. March 5, 1975.

4 Richard Meier & Partners Architects LLP, www.richardmeier.com, accessed October 16, 2015.

5 Jay Schockley. Landmarks Preservation Commission, Designation List 449 LP-2391. October 25, 2011.

6 Paul Makovsky and Michael Gotkin. *The Postmodern Watchlist*. November 2014.

7 Bruce Jenkins. *Gordon Matta-Clark Conical Intersect*. MIT Press, Cambridge MA, 2011. 54, 59, 63.

8 "A Crystal in the Harbour – The Glass Façade of the Elbphilharmonie." *Detail*. 2010-5. 498-508.

9 Herzog & de Meuron, www.herzogdemeuron.com/index/projects/complete-works/226-250/230-elbphilharmonie-hamburg.html, accessed October 16, 2015.

10 Detail. 498-508.

11 Herzog & de Meuron, www.herzogdemeuron.com/index/projects/complete-works/226-250/230-elbphilharmonie-hamburg.html, accessed October 16, 2015.

FROM RUST TO REUSE

FROM BUILDING TO COMMUNITY THROUGH INSTRUMENT MAKING

by ZEKE LEONARD

"One day I was introduced to Oscar Fischinger, who made abstract films quite precisely articulated on pieces of traditional music. When I was introduced to him, he began to talk with me about the spirit which is inside each of the objects of this world. So, he told me, all we need to do to liberate that spirit is to brush past that object, and to draw forth its sound."
-John Cage, interview with David Charles, 1968[1]

"In our contemporary world in which railroad stations become museums, and churches are turned into night clubs, the old, stable coordinates cease to apply."[2] This is increasingly true with regard to materials and materiality. It is now routine to salvage and reclaim, to find new use and life for what would have been formerly treated as waste.

On Otisco Street in the historic Near West Side neighborhood of Syracuse, NY, there is a four-story brick building, built in 1911 as a storehouse for a hardware company. By the 1950s, it housed the Lincoln Plumbing Supply Company until it fell out of use and into dereliction.

When the building was gutted in 2009 to be reborn as a LEED Platinum mixed-use building, the resultant pile of discarded material was rich with promise and (like many similar piles of material in similar situations) set aside with an assumed use as lumber for architectural finishes or furniture objects. It was well suited to this fate: the floor joists are five inches thick and twenty inches wide, and the box-heart columns are twelve inches square.

The sheer size of these components and the work they had done for more than a century held unusual potential beyond the typical impulse to simply mill them into lumber. They had a tectonic past; it seemed only fitting that at least some of them should have a tectonic future. Bernard Tschumi wrote repeatedly that there is "no architecture without program, without action, without event."[3] If these massive timbers were to have such a future, an event needed to be formed.

Musical Instrument as Structure

A half-mile from Otisco Street is a brownfield that has been appropriated by a local non-profit group as Lipe Art Park. This unusable expanse has been slowly re-worked into a sculpture park on what was a railroad siding. The stewards of this park put out a call for a sculpture show celebrating the history and possible future of Syracuse as a Rust Belt city. This was the kind of chance that Bronwen Gray refers to as "cultural activism,"[4] and it provided the "event" that would crystalize an architectural structure. It could be an event that, as Tschumi wrote, "might change society - that could have a political or social effect."[5]

An installed sculpture in an environment like that of the park faces a particular problem: the context is so large that even very large objects seem diminutive by comparison. If the installation were to have the kind of presence that it needed to seem relevant, it would need to be more than an object; it would have to have the scale of a built environment. It must be a *space/object*, that is, something that stands alone and creates

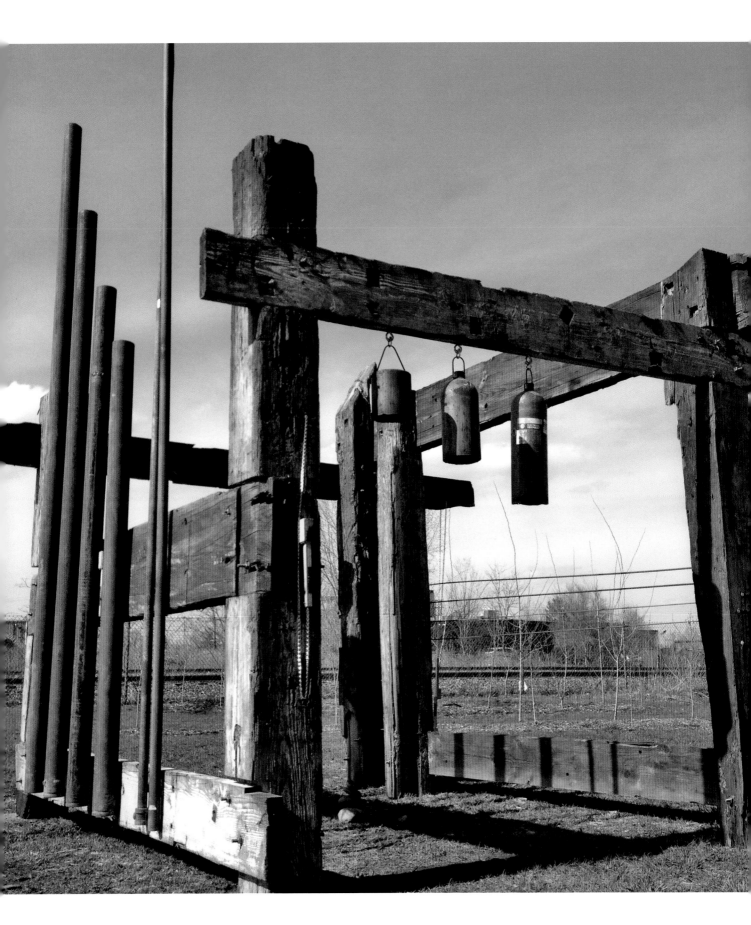

The completed RustOPhone in situ.

a human scale space, but that in itself has some of the qualities of an object.

An installed sculpture can be static and alienating; it sits silently in the landscape, made and installed by unknown people for unknown purposes. As Gray points out, "one effect of modernism is that ordinary citizens may feel disconnected from art and view it as 'special and heightened, not everyday and ordinary.'"[6] The question in this case became "how many people can I involve in the making and use of this space/object?" In addition, "how can I continue to make plain to viewers that they are invited to engage with the object?"

Experiments that I had been making in assembling found-object instruments (e.g. pie tin banjos and cigar box guitars) provided the clues to a way forward. There is a semiotic identity of many instruments that encourages interaction. When presented with a string to be plucked, or a gong and a hammer, many viewers find the urge to touch them irresistible.

A previous installation in another location had involved the making of found-object instruments that were "instrument sized" (that is, of a scale to be held by and played by people) and affixed to the wall of a local community center.[7] The sculpture created is popular and has turned out to be successful at engaging many of the viewers as they walk up and down the stairway. However, these are *objects* installed in a *space*; they constitute an entirely different proposition from the creation of a *space/object* and would disappear in the ex-railroad yard that is Lipe Art Park. On the other hand, the monumental size of the raw materials (as well as their history) suggested a completely different approach, as did their capacity to be played or inhabited by a collective ensemble.

History as Enabler: Impetus and Process
An interest in rock gongs as place-based community musical instruments became the inspiration. These Paleolithic found-object instruments require a community to gather around them due to their sheer size. As the instrument cannot be moved by the musicians and listeners, the musicians and listeners must come to it.[8] Instead of moving the object into a space, a human scale space is created around the object. This space/object identifies and defines the listening space. The intention became one of using this project as a way to bring people to this reclaimed brownfield, to excite them to gather, and to make music and enjoy time together.

A particularly compelling component of many Nigerian rock gongs is that they can engage several musicians at once: striking the rock in different places can produce different tones. As such, the availability of various instrument typologies would be desirable for musicians to make different types of tones. It was also important to let the materiality itself have a voice, as a rock gong does. It is because a rock gong is a rock and

because it is that *type of rock* that makes sound. In the same way, it was obviously necessary to find musical components that would have similar material-specific voicing, in order to make music *out of* the history of the place, not just *for* the history of the place.

As sketches became drawings, and drawings became realities, another possibility for building community evolved. The massive timbers would of course be too large for me to move by myself, and clearly a team of people would be needed when the time came to stand them in place. They could only be moved by the works of a "gang" in concert. This material reality evokes images of work gangs on the railroads in the early part of the 20th century in America, and the songs they sang to coordinate movement and effort; or of barn raisings and the celebration that comes with the completion of a large community endeavor.[9] In this way, the built environment can be a coming-together of a community, creating a sense of place.

The reference to barn-raisings provided the last piece of the puzzle. The columns and beams had stood for more than a century, bolted together tectonically to hold up the Lincoln building. The purpose-built hangers and brackets had been made for that configuration and would not work for the new one. What was needed was a different joinery, one that honored the material and referenced a construction methodology that was appropriate to the material. In this way, the *material* and its *history* become the co-architects of the installation; they provide as much generative information as an external vision. This understanding easily led to a post-and-beam tectonic construction that references the original structure and simultaneously evokes wooden structures that have been built in Syracuse since the first wooden mill in 1805.

Fabrication: The Rise and Voice of the RustOPhone
As fabrication began, and the beams and columns were moved into place, marked, and cut, the community formed and dissolved as needed. Rather than drawing on employees, this particular installation garnered help from supportive individuals and groups on an "as-needed" basis. This process allowed awareness of the project to ripple outward and to permeate a diverse population: not just people interested in the Art Park, but also community groups, student groups, and even passers-by.

In conjunction with the structure of the space/object, the tonal components were taking shape. Many of the instruments that I had previously assembled or constructed were stringed, either as zithers or as lute descendants: guitars, ukuleles, and banjos. This project provided an opportunity to make a very large-scale stringed instrument (subsequently dubbed the "Mega-Bass"). As with any extremely experimental instrument, lessons were quickly learned about the suitability of

materials and the possibilities within those materials. The strings of the Mega-Bass were made of steel rod, which does not vibrate when plucked in a way that produces a discernable tone. The strings became a percussion instrument, which, though initially disappointing, did create a more accessible instrument to viewers: though experience has shown that many novices are reluctant to engage a stringed instrument, most feel comfortable engaging percussive instruments.

Other tonal components were the Uncymbal, the Xylo-Pipe, and the Gongs, all of which were fabricated from repossessed and repurposed refuse. For these instruments, other detritus from the Lincoln Building (and other buildings) was brought to the site. The base objects for the Uncymbal were the brackets that had once topped the columns in the Lincoln Building. When suspended and struck with ball peen hammers, they resonated with a dull pinging thud, the sound that one could imagine they had last made over a hundred years earlier as the floor joists were dropped into place upon them. The Xylo-Pipe was conceived of as a load of rust-covered salvaged Schedule 80 pipe dropped off of a truck at a salvage yard. The resultant cacophony of steel ringing on steel had music at its core, and the pipes provided a fourteen foot tall xylophone when mounted vertically. The gongs were simpler and derived from the experience of many musicians and sculptors around the world who have taken advantage of the tonal qualities of fire extinguisher bodies when the bottoms are removed and the tanks are suspended and struck. There was yet another instrument that had escaped notice: the wooden frame of the space/object itself. At the celebratory opening performance, one of the musicians stood on a cross brace and played the frame with drumsticks, evoking the Paleolithic players of the rock gongs, miles and millennia removed from the park where we stood.

In this way, all of the material used was allowed its own voice, with its materiality celebrated visually and tonally, as a product of the history of the material, the place, and the fabrication methodologies. Some of these voices were obvious from the outset, others were found through experimentation, and the group of five musicians began working together to make a celebratory composition on the instrument. The massive size of the instrument made a solo presentation impossible: in order to present all of the tonalities in concert, there must be an ensemble present. The resultant musical community was as diverse as the components of the instrument: it included a composer, a guitar player, and two musical novices, as well as the maker of the instrument.

The resultant piece, "Rust Elegy," recorded the assorted voices of the materials and forms. It evoked the industrial history of Syracuse by building through a quiet cacophony from a single gong to a rhythmic chorus that reached a crescendo, and then it was silenced, leaving only the gong ringing in the end, to mark the passage of industry and prosperity from the city. "Rust Elegy" was presented on a sunny early summer evening, after which members of the audience were invited to participate in improvisational music making, expanding the community of musicians in an inclusive and participatory way. Though Tschumi points out that "politically, the socially conscious have been suspicious of the slightest trace of hedonism in architecture,"[10] in this case, a purely hedonic structure was raised and embraced by a diverse group of makers, users, players, and occupants. It was a moment of ultimate pleasure: "that moment when an architectural act, brought to excess, reveals both traces of reason and the immediate experience of space."[11]

Epilogue: Continued Adaptive Reuse

The RustOPhone stood in the park for more than two years and was interacted with regularly by passers-by, by other artists, and by musicians (including a 2012 visit by Kronos Quartet). Its inception as a temporary installation, however, was inescapable. In June of 2015, the space/object was dismantled, and as of this writing, the materials are being processed to become components of a semi-permanent shade structure/gathering space to be installed less than one hundred feet from where the RustOPhone stood.

ENDNOTES:

1 John Cage, *For the Birds: John Cage in Conversation with Daniel Charles*, trans. Richard Gardner, ed. Tom Gora and John Cage (Boston: Marion Boyars, 1981), 68

2 Bernard Tschumi, *Event Cities (Praxis)* MIT Press, Cambridge, 1994, 13

3 Bernard Tschumi, *Architecture and Disjunction*, MIT press, Cambridge, 1996, 3

4 Bronwen, Lucie Gray (2012) "The Babushka Project: Mediating Between the Margins and Wider Community Through Public Art Creation", *Art Therapy*, 29:3, 115

5 Tschumi, *Architecture and Disjunction*, 5

6 Gray, 114

7 Zeke Leonard *Staircase in the Key of D*, 601 Tully Gallery, Syracuse, NY

8 Jeremy Montagu, *Origins and Development of Musical Instruments*, Scarecrow Press, Lanham, Maryland, 2007, 8

9 Alan Lomax, *The Land Where the Blues Began*, Pantheon Books, New York, 1993, 27

10 Tschumi, *Architecture and Disjunction*, 81

11 Ibid, 89

CONVERGING IN SPACE

ART, ARCHITECTURE, AND URBANISM IN P.S. 1's *ROOMS* EXHIBITION

by CECILIA THORNTON-ALSON

*Between the sub-systems and the structures con-
solidated by various means (compulsion, terror, and
ideological persuasion), there are holes and chasms.
These voids are not there due to chance. They are the
places of the possible.*
— Henri Lefebvre, "The Right to the City"

Now an iconic destination for those interested in con-
temporary art, MoMA PS1 opened its doors in June of
1976 as Project Studios One, a derelict school building
occupied, excavated, and (in some cases) rehabilitated
by artists as part of a large group show, *Rooms*. The
show featured original artwork built for and of the
edifice—peeling paint, crumbling brick, and old floor-
boards became media alongside the traditional canvas
and oil paint. *Rooms* spurred landmark art historical
discussions on site specificity, medium, and the ideol-
ogy of display in Rosalind Krauss' famous essay, *Notes
on the Index*, but what of the architecture? What was at
stake in the re-use of this abandoned building? Con-
sidering the *Rooms* exhibition within the framework not
simply of artistic but of *architectural* display prompts
a renewed examination of the role of adaptive reuse
within the show: not only were the artworks indexical,
but the *building* was also a trace of its environment: an
index of New York City's urban blight in the midst of an
economic recession. The *Rooms* exhibition offers a lens
into P.S. 1's role in a changing city-wide debate on space,
re-use, and urban planning.

Note: the Index

Rooms was a large group show held in an abandoned
public school building in Long Island City, Queens, and
it featured seventy-nine contemporary artists from all
around the world.[1] Curator Alanna Heiss, the founder
and chairwoman of the Institute for Art and Urban Re-
sources, gave each artist 100 dollars and invited them to
execute installations in the building—*anywhere* in the
building. Artists not only occupied the former class-
rooms, but also created works in the hallways, boiler
rooms, bathrooms, and even on the roof. Though the
works varied widely in medium, form, and scale, all bore
a direct relationship to their site. From occupancy to
opening, the show was three short weeks in the making.
Artists also helped to rehabilitate the structure, amend-
ing it as needed to accommodate their work. Former
Public School One thus became Project Studios One, an
artist workshop and an exhibition space.

 Rooms occurred at a time when the boundaries of
the art object, medium, and art institution had all been
called into question.[2] In *Notes on the Index: Art of the
Seventies in America*, Rosalind Krauss describes an op-
erational shift endemic to the art production in the sev-
enties. Writing a year after *Rooms*, in 1977, she argues
that traditional artistic media, from dance to painting
to sculpture, have begun to employ the logic of the pho-
tograph: no longer bound to a self-reflexive dialectic of
immanence, artworks take on indexical qualities.[3] The
index, as opposed to the icon, is an empty sign, one that

becomes inextricably linked to its referent as a trace.[4] Krauss elaborates, "by index I mean that type of sign which arises as the material manifestation of a cause, of which traces, imprints, and clues are examples."[5] The index, too, employs the gestural quality of an index finger—pointing to its referent.

Notes on the Index draws many of its examples from P.S. 1's *Rooms* exhibition, which Krauss notes as offering a critical survey of contemporary artistic production.[6] She highlights the paintings of Lucio Pozzi, the rubbings of Michelle Stuart, and the building cuts of Gordon Matta-Clark, and remarks that, "the ambition of the works is to gather the presence of the building, to force it to the surface of the work."[7] If an indexical sign continually points to its referent, these indexical artworks continu-

ally underscored the material presence of the building, Public School One.

There were no spaces *concealed*, only those negated or removed, as in Matta-Clark's work, *Doors, Floors, Doors*. In his piece, Matta-Clark demolished the same rectangular area of the floorboards and the ceiling lath and plaster on three floors. Beginning at the threshold of his dedicated classroom-turned-studio space, the cuts extended back ninety-six inches and were all uniformly forty-two inches wide. As with his other building cuts, Matta-Clark's piece for the *Rooms* exhibition heightens the sense of insecurity of this derelict space—viewers were cautioned not to step into the void by nothing more than a thin cord.

In addition to works like *Doors, Floors, Doors*, artists

Installation View, Gordon Matta-Clark, *Doors, Floors, Doors*, May 1976.
Rooms P. S. 1., Exhibition catalog
New York: Institute for Art and Urban Resources, 1977, page 18, Digital Image
© The Museum of Modern Art/Licensed by SCALA / Art Resource, NY

also commented on P.S. 1's former program as a school.[8] Vito Acconci installed abandoned stools (once used in P.S. 1's classrooms) in the excavated basement near the furnace, with an audio-recording of his voice slowly saying, "Let's be suckers All: we—are—suckers" in a taunting didactic loop. The seats were placed in a pit in the same arrangement of a typical classroom, creating an evocative mise-en-scene. The relocation of a classroom to the boiler room illustrates the way that institutional processes (such as education) repress—or literally bury—alternate histories. This work bears an indexical relationship not only to the building itself, but also to its architectural program, and it evoked the haunted quality of the space—disembodied voices and chairs without students stress the connection between derelict space and a type of societal invisibility.

Rooms was a huge success. Reviewers commented on both the sheer size of the exhibition and the architectural qualities of the building. In the New York Times, John Russell remarked, "Daniel Buren has put stripes on some of the windows, and Marjorie Strider has devised red, white and blue sculptures that pour down out of some other windows, but fundamentally, P.S. 1 is still the same minor masterpiece of institutional architec-

ture...."[9] The exhibition even graced the October 1976 cover of Artforum under the pithy title, "The Apotheosis of the Crummy Space." In her review of the show, Nancy Foote noted that, "at least 50 of the 80 artists hacked, gouged, stripped, dug, poured, and picked away at [the school's] rotting hulk—to their art's content."[10] According to the reviews, Rooms was as much about the experience of touring the edifice as it was about seeing the artwork within. The building operated on many levels within this show: as the literal site of experience, as an edifice reclaimed through the exhibition, and as materia prima for the artists. Even within the downtown art scene, P.S. 1 existed in a borough apart. Exhibition goers had to leave the institutional stronghold of Manhattan on an expedition to the city's periphery, and to see each artwork, viewers had to visit every space in the building, from the boiler room (for Vito Acconci's "Under History Lessons") to the roof (for Richard Serra's untitled piece). Rooms was both a group show and a ruin on display.[11] The indexical nature of the artworks within the Rooms exhibition prompts a discussion of the show beyond purely art historical terms: if the art works pointed to the building, the building itself pointed to the widespread problem of abandoned space in Manhattan.

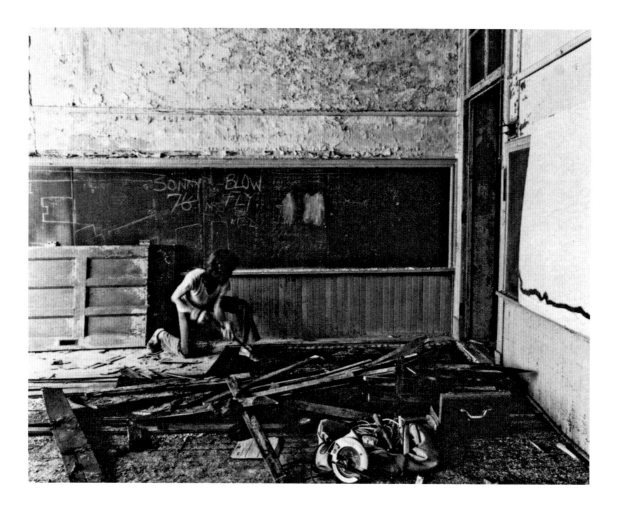

Installation View, Gordon Matta-Clark, *Doors, Floors, Doors*, May 1976.
Rooms P. S. 1., Exhibition catalog
New York: Institute for Art and Urban Resources, 1977, page 18, Digital Image
© The Museum of Modern Art/Licensed by SCALA / Art Resource, NY

Manhattan, Moses, and the Downtown Scene

In New York in the seventies, so many streets were dark, and so many buildings were empty...the one thing you had most of in the seventies was you had space and buildings.
— Alanna Heiss, interview with the author

P.S. 1's founder and curator Alanna Heiss returned to New York from London in 1970 and immediately became immersed in the burgeoning downtown art scene.[12] Of the era, she remarked, "New York was at that time in the belly of the beast. It was a very dark time for New York City and a very light time for me."[13] Indeed, the abandoned streets of the city provided omnipresent signs of an economic recession, urban blight, and white flight. Deindustrialization and depopulation of the city resulted in part from earlier municipal policies of urban redevelopment in post World War II Manhattan. Federal funds from Title I of the Housing Act of 1949, along with local subsidies, instantiated a process of city-wide urban renewal that made it more profitable for landlords to demolish or vacate aging buildings than to restore them.[14] Later, the city's Slum Clearance Committee, chaired by now-infamous city planner Robert Moses, initiated the relocation of over 100,000 New York City residents in order to begin the construction of large-scale public housing.[15] While the intent of these projects was ultimately to improve the city, the evacuation of both industry and population only crippled New York's urban fabric. By the early sixties, a lack of students led to chronic abandonment of school spaces, yet another symptom of New York's urban crisis. Public School One, the first school building in Long Island City, closed its doors in 1963.

In his analysis of the relationship between New York City's neoliberal government and city planner Robert Moses, Joel Schwartz describes that city planners, working from the ideology of the City Beautiful movement, viewed aesthetics as integral to well planned urban spaces.[16] Accordingly, the redevelopment of Manhattan prioritized the zoning and construction of large-scale social housing and buildings for commercial use rather than less-aesthetically pleasing industrial zones. While ostensibly serving the greater good, Schwartz argues, this type of development thinly masked a program of urban gentrification while effectively dislocating thousands of blue-collar jobs.[17]

Moses' method of redevelopment employed a multi-step procedure of population removal, demolition, and finally, urban rebuilding and "renewal". First, the Slum Clearance Committee mobilized the forcible evacuation of low-income, high-density neighborhoods, condemning and demolishing them with the future promise of returning residents to "modern" high-rise housing. However, the city's fiscal crisis and growing popular unrest with racist and classist relocation policies in the late 1960s arrested this process midway. Moses resigned from his position in 1968, but the continued lack of funding and loss of industry promulgated by earlier policies left swaths of the city's landscape a pitted ghost town awaiting judgment.

The availability of empty and abandoned spaces coincided with (and abetted) new developments in New York City's art scene: the coalescence of artists around alternative centers of production and display, and the changing nature of the art object itself. In an interview, Gordon Matta-Clark reflected:

Here as in many urban centers the availability of empty and neglected structures was a prime textural reminder of the ongoing fallacy of renewal through modernization. The omnipresence of emptiness, of abandoned housing and imminent demolition gave me the freedom to experiment with the multiple alternatives to one's life in a box as well as popular attitudes about the need for enclosure.

Matta-Clark touches on the pervasive questioning of modern "projects" on multiple fronts. The re-population of Manhattan's downtown with large-scale, site-specific installations confronted the failure of the purity of the artistic medium, just as artists' reclamation of abandoned industrial buildings called attention to the miscarriage of the modernist project to rebuild Manhattan. The occupation of abandoned space implied not only an alternative stance in art-making, but also an alternative to the modernist dream of relocation away from the urban core.

The *Rooms* exhibition on the cover of *Artforum*.
© Artforum, October 1976, Cover

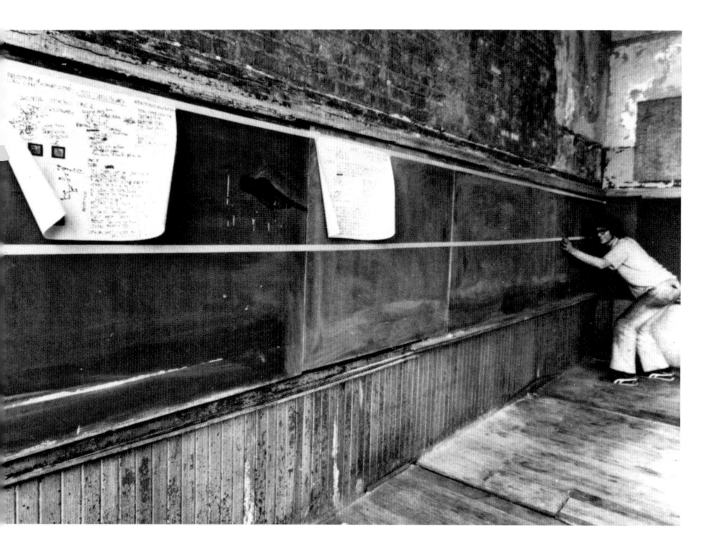

On the Institute for Art and Urban Resources

The Institute for Art and Urban Resources (IAUR) emerged in 1971 as a collaboration between Alanna Heiss and writer Brendan Gill.[18] Unlike the individual opening alternative venues in downtown Manhattan, Heiss wanted to form an *organization* that could handle the task of finding abandoned spaces for contemporary art: "I was searching for interesting kinds of space for art that I had in mind, but I was also searching for space in different parts of the city...not just Manhattan...I was interested in trying to...build a kind of vocabulary of spaces that would be useful for art."[19] Other models at the time were primarily artist-run ventures based entirely in one location, like Jeffrey Lew's converted warehouse on 112 Greene Street. By contrast, the Institute for Art and Urban Resources was an organization grounded in the concept of spatial nomadism. Heiss recalls:

I saw myself as trying to set up a kind of dictionary or workbook about how one could take spaces on for temporary periods of time, use them for the arts, and then give them back. A primary problem of the use of space—by anyone—is that everyone is afraid you're going to squat there and they can't get you out....I tried to create a trustable entity which ...[people] who had a lot of control over space would really be able to trust.[20]

Her last comment proves particularly telling. Space, in the urban context—even vacated or abandoned buildings—is never simply empty; there always exists an owner or a landlord, whether public or private. The Institute for Art and Urban Resources established a mediating agency to advocate the creative re-occupation and adaptation of space, providing a bridge between contemporary artists and municipal agencies.[21]

An early document from MoMA PS1's archive labels this nascent project, "Workspace," elaborating, "Workspace is a plan to utilize vacant buildings to provide temporary working space for artists. In most cities, there are large empty buildings waiting for extensive renovation or demolition that could be turned into

Installation View, *Rooms* Exhibition, May, 1976.
Rooms P. S. 1., Exhibition catalog.
New York: Institute for Art and Urban Resources, 1977, page 16. Digital Image
© The Museum of Modern Art/Licensed by SCALA / Art Resource, NY

studio space for artists at little cost."[22] Heiss' first space was a burned-out building at 10 Bleeker Street, followed rapidly by the Clocktower, the Idea Warehouse, the Coney Island Sculpture Factory (also known as the Coney Island Sculpture Warehouse), and the Ferris Police Station.[23] These spaces were both publicly and privately owned, and, as Heiss had envisioned, the Institute for Art and Urban Resources developed tactical strategies to temporarily capture these buildings through art, and then release them once again.[24] By 1976, the Institute was coordinating exhibitions and leasing studios across multiple abandoned and underutilized structures, and Heiss had become, in her words, "the darling of the liberal world of urban planning."[25]

Shifting Priorities and Shifting Policies
In the early seventies, New York City's municipal government was embroiled in a huge debate over the question of "decentralization"—that is, diverting political power away from New York City Hall and into local borough-based leadership.[26] This debate, as one between a unified, central authority and local, relational governance, bears important ideological parallels to the critique of modern city planning.[27] Urban decentralization was also part of a larger political debate on the development of land-use strategies as a means of addressing continuing economic problems. By 1975, the city was reeling from over five sustained years of recession; forecasts for the future changed from hopeful to increasingly weary.[28] New approaches to addressing urban blight began to stress *neighborhood* revivification rather than new housing as a solution. Rather than looking to new construction as a utopic means of producing the ideal city, city officials and urban planning advocates were beginning to acknowledge the critical importance of the reoccupation of abandoned neighborhoods, and by extension, abandoned buildings. In New York's *City Almanac* from February of 1978, the recommended action from city officials includes, "A comprehensive land management plan to encourage redevelopment of some areas and revitalization on a more human scale."[29]

Henri Lefebvre famously argues that rational city planning subsumes the diversity of urban life through the segregation of functional zones within the city.[30] By separating industry from commerce and residence, the planned city negates the creative potential of spontaneous encounters that arise from organic municipal growth. Lefebvre even goes so far as to argue that, "A particular kind of planning projects on the ideological terrain a practice whose aim is the death of the city."[31] Zoning policies, emblematic of rationalist planning, thus offer a means of enforcing (or combatting) a given urban ideology. Beginning in 1971 with the passage of Loft Law, the New York City government began to expand the constraints of existing land use, and to incorporate more flexibility for spatial conversion, largely in response to

artist occupation of abandoned space.[32] The *Rooms* exhibition, as a large, well-publicized event, provided a poster child for the changing tide of New York City urban policy.

From Public School One to Project Space One

This is a happy story about New York, whose heroes are some dedicated patrons of the arts, a number of farsighted leaders in federal, state, city, and local government, and a public spirited bank.
— Brendan Gill, press release for the *Rooms* exhibition, 1976

Notably, P.S. 1 was the first building the Institute for Art and Urban Resources (IAUR) occupied that Heiss did not scout on her own; rather, each borough President was asked to present her with a proposed abandoned building to occupy. The city was looking to re-populate its spaces, and Heiss was also envisioning a new project for the Institute for Art and Urban Resources: "No longer nomadic. No longer being an alternative space, buta substantial large space which was an experimental museum."[33] Archival documentation supports Heiss' account: a draft dated December 31, 1975 outlines the goals and future projects for "The Institute," and cautions:

If, for example, proposed plans to acquire New York City Public School No. 1 as a major expansion in the Workspace program reach fruition, no further workspace additions should be undertaken during the next three to five years. The need to ingest the P.S. 1 facility into the operations of the Institute will require a tremendous amount of energy and commitment on the part of the staff. Any substantive new extensions of the Workspace program should therefore be held off so that other important services of the Institute do not suffer.

The size of the space, the shift from nomadism to permanence (or at least semi-permanence), and the prospect of building renovation required a moment of institutional pause so that the IAUR could refine its mission. Further, the acquisition of P.S. 1 formally acknowledged the pre-existing relationship between the City of New York, municipal planners, and the Institute for Art and Urban Resources. Heiss' earlier "trustable entity" had become, in several short years, credible enough to take on an entire building.

The Institute for Art and Urban Resource's grant application to repay its loan for the repairs on P.S. 1 describe it as, "a lovely, red-brick, Romanesque Revival building," but Heiss said that most people described the old school as something akin to the hotel in *The Shining*. Large portions of the roof had fallen off, and the building had no plumbing or electricity. While the IAUR initially planned to rehabilitate Public School One in its entirety, prohibitive cost forced a more ad hoc solution—the school's "renovation" became incorporated into the show

itself. The earliest estimates to renovate in full were up-
wards of a million dollars; however, Heiss and Gill scaled
back to the bare minimum of upgrades and secured a
loan for $150,000 to complete only the most necessary
changes.[34]

This dereliction was both an opportunity and a
badge of honor. Culturally, it aligned P.S. 1 with the
contemporary use of "raw space," heightening the sense
that the *Rooms* exhibition showcased critical, cutting-
edge, artistic practices. In her curatorial statement for
the exhibition, Heiss framed the exhibition relative to the
material differences between neutral and raw spaces.
She wrote that the show:

> ... represents an attempt to deal with a problem.
> Most museums and galleries are designed to show
> masterpieces; objects made and planned elsewhere
> for exhibition in relatively neutral spaces. But many
> artists today do not make self-contained master-
> pieces...nor are they, for the most part, interested
> in neutral spaces. Rather, their work includes the
> space its in; embraces it, uses it. Viewing space
> becomes not frame but material. And that makes it
> hard to exhibit.[35]

Indeed, the space occupied during the *Rooms*
exhibition was anything but neutral: the side-by-side
renovation and installation offered a cultural and politi-
cal coup for both the IAUR and the borough of Queens.
The show's press release, far from highlighting artwork,
emphasizes P.S.1's emergence from a collaboration
involving "a minimum of expense and a maximum of
cooperation," further noting, "The result is that today, for
the first time anywhere in the country, three floors of an
old-fashioned public school will now be reused to pro-
vide studios for 35 artists..."[36] The Institute for Art and
Urban Resources had long functioned as an established
organization emblematic of alternative space; this his-
tory enabled the exhibition to effectively bridge the insti-
tutionalized sphere of urban planning with the renegade
world of contemporary art.

A publication of New York City in 1976, shortly after
the opening, attests to the project's political success.
Entitled, "Surplus School Space: Some Facts About Re-
Use," it is a practical guide for the re-population of aban-
doned school buildings and features P.S. 1 as its first
example.[37] This publication further stresses the give-
and-take between the political and the cultural at this
time—as culture became understood as a politically
valuable tool to reinvigorate a derelict urban landscape.
Project Studio One continued to undergo piecemeal res-
toration hand-in-hand with exhibition until the building
underwent a major remodel in 1997, in conjunction with
its institutional affiliation with the Museum of Modern
Art. However, even during this final "official" renovation,
P.S.1 retained traces of its past, indices of *Rooms*.

ENDNOTES:

1 The number varies from account to account. The catalog says
78, Foote's article says 80 and Heiss claimed 100 in our interview,
however, the show's checklist numbers 79 artists. See: MoMA
PS1 Archives, I.A.48. The Museum of Modern Art Archives, New
York.

2 Greenberg's essay, "Modernist Painting" (first published in
1961) has become virtually synonymous with modernist ideals
of painting, both by virtue of its rhetoric, and because of its
generative power in the field of art production. Artists working
in the 1960s (primarily in and around New York City) immediately
rebelled against Greenberg's essentialist theorization of paint-
ing, and became affiliated with a number of different art move-
ments, many of which were highlights of the *Rooms* exhibition.
See Clement Greenberg, "Modernist Painting," in *Art in Theory
1900-1990: An Anthology of Changing Ideas.* ed. Charles Harrison
and Paul Wood. (Oxford UK and Cambridge, USA: Backwell, 1993).
754-760.

3 Here I am referencing the Greenberg's essentialist claims
in"Modernist Painting," in which he describes works of painting
to be oriented in a linear trajectory toward the quality of flatness,
"It was the stressing, however, of the ineluctable flatness of the
support that remained most fundamental in the processes by
which pictorial art criticized and defined itself under Modern-
ism. Flatness was alone unique and exclusive to that art. The
enclosing shape of the support was a limiting condition, or norm,
that was shared with the art of the theatre; color was a norm or
means shared with sculpture as well as the theater. Flatness,
two-dimensionality, was the only condition painting shared with
no other art, and so Modernist painting oriented itself to flatness
as it did notion else." From Greenberg,"Modernist Painting" in *Art
in Theory, 1900-1990.* 775. To his terms, the logic and language
of painting is to convey the quality of flatness, whereas the logic
of photography, for example, employs the quality of serial and the
referential quality of the index.

4 In constructing this connection to photography, Krauss draws
from the essay by C.S. Pierce, "Logic as Semiotic: The Theory of
Signs," in which Pierce describes the difference between the icon
and the index, the former which establishes meaning with its
referent through representation (as in a painting) and the latter
which have a physical correspondence to a given site.

5 *Ibid.*, 59.

6 *Ibid.*, 60.

7 *Ibid.*, 66.

8 Nancy Foote, "The Apotheosis of the Crummy Space," *ArtForum.*
(October 1976)

9 John Russell, "Gallery View: An Unwanted School in Queens Be-
comes and Ideal Art Center," *The New York Times.* June 20, 1976.

10 Foote, "The Apotheosis of the Crummy Space."

11 John Russell's review in the *New York Times* notes two prec-
edents for the *Rooms* exhibition, St. Katharine's Dock in London
(Which Heiss also mentioned in our interview) and *Documenta*,
famously situated in ruins from World War II. See Russell, "Gal-
lery View: An Unwanted School in Queens Becomes and Ideal Art
Center."

12 For an extensive overview of the downtown art scene of Lower
Manhattan, see Lynne Cooke, Douglas Crimp, and Kristin Poor, ed.
Mixed use, Manhattan: photography and related practices, 1970s

to the present. (Madrid: Museo Nacional Centro de Arte Reina Sofía, 2010).

13 Alanna Heiss, interview with the author, April 12, 2012.

14 Juan A. Suárez, "Styles of Occupation: Manhattan in Experimental Film and Video from 1970s to the Present," in *Mixed Use Manhattan,* 134.

15 Joel Schwartz. *The New York approach: Robert Moses, urban liberals, and redevelopment of the inner city*. (Columbus: Ohio State University Press,1993) xv. Moses, ever a controversial figure, also came under attack in the press at the time. For one example, see Paul Crowell, "Mayor 'Irons Out' Moses Grievance" *The New York Times*, August 30, 1956.

16 *Ibid.,* 229.

17 *Ibid*, xv.

18 At the time of their initial collaboration, Gill was a theater critic for *The New Yorker*. Heiss credits Gill for thinking of the name of the organization, one he said was good because, "by the time you get to the end of it, you can't remember the beginning of it." At the time of the Institute's founding, Heiss already had artistic and civic ties to the city as the program director for the Municipal Art Society, an organization devoted to "bringing the voice of public conscience to debates about the design of the city's municipal buildings, parks and monuments, the public responsibilities of private developers." In our interview, Heiss noted that her work with the Municipal Art Society not only introduced her to important local figures within the municipal government, it helped clarify her emerging curatorial aims. Heiss, interview with the author, April 12, 2012.

19 Heiss, interview with the author, April 12, 2012.

20 *Ibid.*

21 While there were other examples of organizations acting as interlocutors between New York City and the downtown contemporary arts scene, the Institute for Art and Urban Resources was unique in its approach to gathering a conglomerate of different locations—from the Idea Warehouse to its space on Coney Island to 10 Bleeker Street and the Clocktower.

22 MoMA PS1 Archives, VIII.D. 7. The Museum of Modern Art Archives, New York City.

23 Heiss also occupied a small space on John Street, where the IAUR offices were located.

24 For example, Heiss often used film permits to provide catch-all documentation and legitimation for the plethora of artistic practices—dance, sculpture, and installation—speaking through the IAUR's "vocabulary of spaces." Heiss, interview with the author, April 12, 2012.

25 *Ibid.*

26 A *New York Times* article from November of 1970 reports a study and symposium on decentralization at the Association of the Bar of the City of New York. The article claims a nation-wide trend "away from centralization," calling out both the questions this raises, "Which services should be decentralized?...What claim, precisely, should these districts have on the city budget? Should they have a budget revenue of their own?"Anonymous, "Decentralizing the City," *The New York Times*. November 27, 1970.

27 One of the most ardent critics, especially in New York City, was Jane Jacobs, whose book, *the Death and Life of Great American Cities* argued fervently in favor of the local neighborhood. See Jane Jacobs. *The death and life of great American cities*. (New York: Random House, 1961). In addition to Jacobs, New York Times architecture critic was a resounding advocate against the capitalist instrumentalization of urban planning. See, for example, her "Architecture View" from April 6, 1975 in the *New York Times*. In an article entitled, "What's Best for Business can Ravage Cities," she writes, "And so the ultimate shaper of cities turns out to be, for better or for worse, so-called sound business practice, or economic viability. That this often distorts or destroys more than it contributes is becoming perilously clear in these troubled economic times. If there were no other way than to let sound business practice take its course, there would be little hope for the urban environment."

28 A *New York Times* article August 9, 1976, notes, "Explanations of urban troubles have become more tentative now, and proposals put forth these days are more modest than the programs launched with such high expectations in the 1960s.'"Ernest Holsendolph, "Economy Called Key to Urban Plight," *The New York Times*. August 9, 1976.

29 Gail Garfield Schwartz, "New York City in Transition: Economic Development," *City Almanac* vol 12, no. 5 (Feb 1978). 2.

30 Henri Lefebvre, "Spectral Analysis," in *The Right to the City* (Oxford, UK: Blackwell Publishers, 1996).

31 *Ibid.*, 145.

32 This was widely noted in the press at the time, and has since been further validated. See, for example, *Mixed Use Manhattan* and Sharon Zukin, "In Defense of Benign Neglect and Diversity," *The New York Times*. February 13, 1977.

33 Heiss, interview with the author, April 12, 2012.

34 Heiss, interview with the author, April 12, 2012.

35 Alanna Heiss, Untitled document [*Rooms* Curatorial Statement]. MoMA PS1 Archive. I.A.48. The Museum of Modern Art Archives, New York City.

36 Press Release page 2, MoMA PS1 Archive I.A. 48

37 City of New York, Department of City Planning. *Surplus School Space: some facts about re-use.* (New York: The Department of City Planning, 1977)

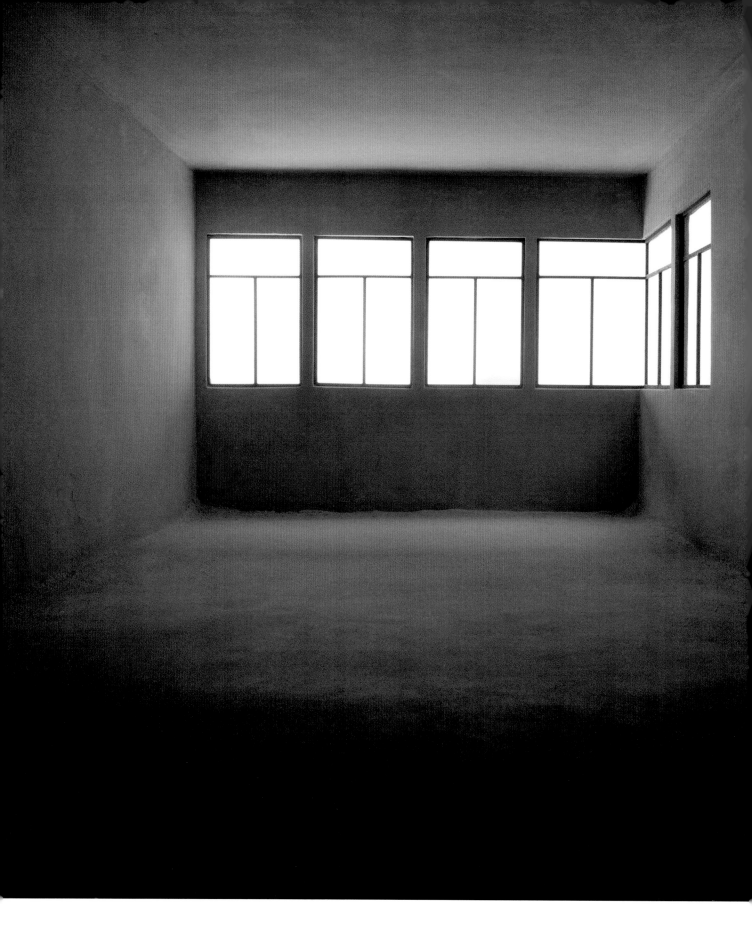

PICTURING SPACE

THE MANIPULATION OF ARCHITECTURAL IMAGERY

by JEFFREY KATZ

In 2009, as I was wandering around Chelsea, in New York City, I walked into an exhibition of Andreas Gefeller's work in the Halsted Kraeutler Gallery. In a series called *Supervisions*, Gefeller displayed large images of buildings that had been created by taking hundreds of overhead shots with a camera mounted to a harness strapped to his shoulders. For the process of recording, Gefeller took a few steps, snapped a picture, took a few steps more, and repeated that process until he had documented the entire area of interest. Then, using digital software, he "stitched" the pictures together to create one continuous image.

By meticulously creating detailed images that mimic a plan, an abstract architectural drawing convention, Gefeller made a new perception of an existing building. A plan drawing—a scaled orthographic projection of a space—is considered a true representation of a building. Here, however, it is upstaged by photography that inherently confers the notion of accuracy and truth

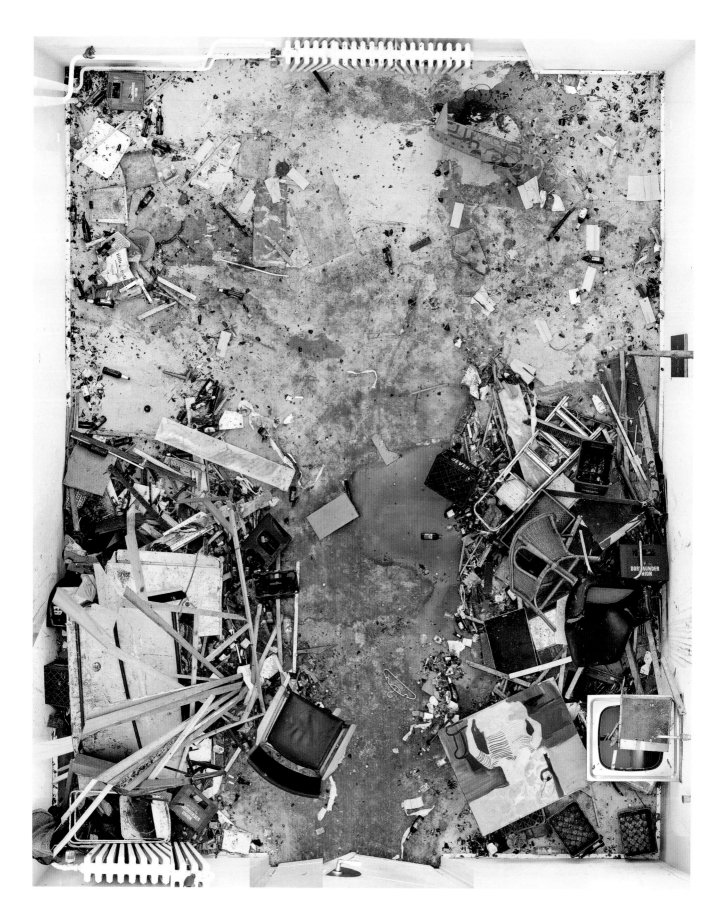

Andreas Gefeller, *Untitled (Academy of Arts, R209)*
Düsseldorf, 2009, 110 cm x 89 cm
From the Series *Supervisions*
Courtesy Thomas Rehbein Gallery Cologne

in the documentation of its subject. Gefeller's method confounds the reading that plans are typically used to represent. His images are true to the idea of a plan; however, there is now life, character, use, and inhabitation (or desertion) embedded in the representation of the building. By applying architectural conventions to photography, Gefeller created a radical new way of understanding architecture.

As I stood in the gallery, transfixed by these images, it occurred to me that this artist was engaged in work that has a strong corollary to what is taught in the Interior Architecture Department at RISD. We ask students to consider a whole range of modifications to existing buildings in order to revise and imbue them with new function, aesthetics, and meaning. Similarly, this artist creates new readings of existing buildings, but he does so through the manipulation of *imagery*. He re-imagined an existing building in the same way that we ask our students to think about the built environment. The medium is different, but the message is the same.

There is much to learn from these pictures about adaptive reuse. Just as there is a broad range of categories that describe ways of modifying structures—replication, restoration, renovation, remodeling—there is an equally broad array of ways to modify *images* of structures in order to make art: framing, cropping, blurring, digital manipulation.

Barbara Kasten does not manipulate images once they are created; instead, she manipulates the subject. For a series called *Studio Constructs*, Kasten used planes of materials and light to create "space." These planes are elaborate sets that she builds in her studio. The images have an ambiguous scale, but the spaces are somehow familiar. Are these photographs of details of a Zaha Hadid project? Are they cleverly framed reflections of glassy storefronts in Tokyo? A Preston Scott Cohen building? The images are constructed, but their architectural character, the idea that we could walk around in these spaces, relies on the viewer's memory of places that they have visited. With Kasten's prodding, we reconstruct a place from an image in our mind's eye.

Kasten's series from the 1980s, *Architectural Sites*, is just the opposite—she creates dreamlike images by photographing real spaces. Reflections, color, light, shadow, and confluence of indoor and outdoor spaces all conspire to dematerialize and decontextualize the actual space, creating a completely new rendition of it. Through Kasten's deft process of thoroughly transforming an existing space, the severe, concrete sunken courtyard of Marcel Breuer's Whitney Museum on Madison Avenue, now called the Met Breuer, becomes a dizzying kaleidoscope of colors and shapes.

Aaron Siskind taught photography at RISD from 1971 to 1976. (There is a Siskind Center at the RISD Museum.) His methods of making art from architecture were framing and cropping. His extraordinary eye found beauty in the most unlikely places. Focused on cracked stucco, repetitive windows, and peeling surfaces, Siskind used his camera to discover connections between seemingly mundane subjects and high art. An elegant example is his 1975 portfolio, called *An Homage to Franz Kline*.

If Siskind's work, created by simply using the camera lens to isolate and transform a part of a building, is at one end of the spectrum of images in this portfolio, Beate Gütschow's work is at the opposite end. In her series called *S*, she uses somewhere between thirty and a hundred photographic "samples" of buildings and recombines them to create new images. In one remarkable picture, titled *S#17*, the Maritime Hotel in New York City, a happy, strange building designed by Albert Ledner in 1966, becomes a stark dystopian place. Gütschow uses radical digital manipulation so seamlessly that it is difficult to believe that the images are not "real." The reuse of each fragment in the completed composition is no longer evident.

James Casabere builds architectural models, photographs them, and then destroys them. He makes representations (photographs) of representations (architectural models) in order to create new images. The result is the representation of a space that strikes an emotional cord. It may be a space that is destroyed by water or made reflective by the presence of water, or it may be a space made holy by its resemblance to a mosque. The "realness" of the authority that photography confers on its subjects is held in check. Although we are not entirely certain of what we are looking at, we are certain that it is intriguing and beautiful.

Like Gütschow, Filip Dujardin uses digital software to create astonishing images of buildings and spaces that he calls *Fictions*. Thomas Ruff blurs images of iconic buildings in order to reread them.

Similar to our engagement in the adaptive reuse of existing buildings, each of these artists encourages us to look at architecture in a way that was perhaps never intended by the original designer. This new look at existing architecture allows us to make richer interventions, either subtle or radical in approach.

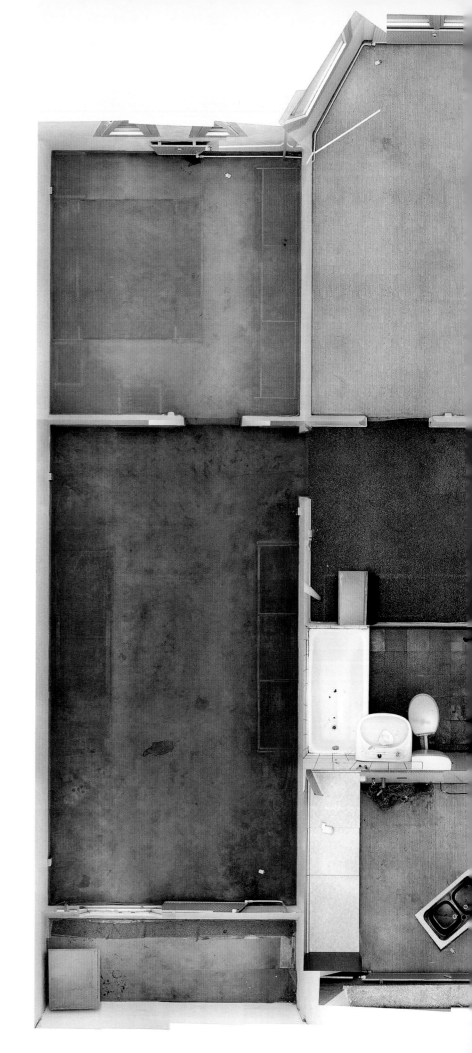

Andreas Gefeller, *Untitled (Panel Building 5)*
Berlin, 2004, 110 cm x 131 cm
From the Series *Supervisions*
Courtesy Thomas Rehbein Gallery Cologne

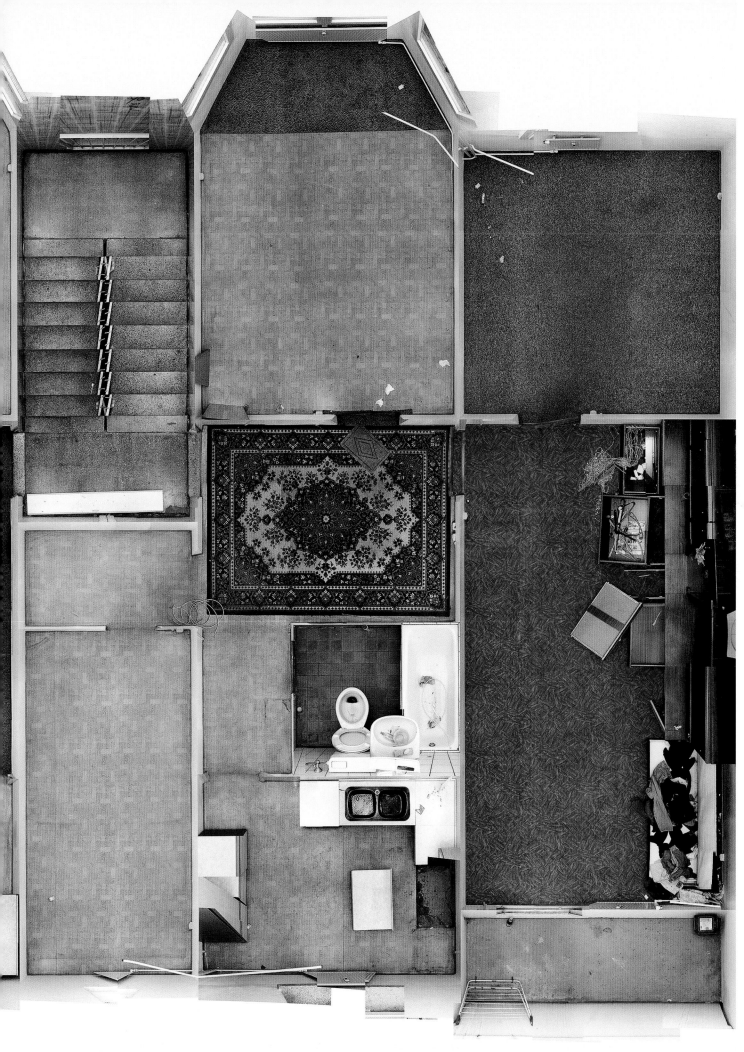

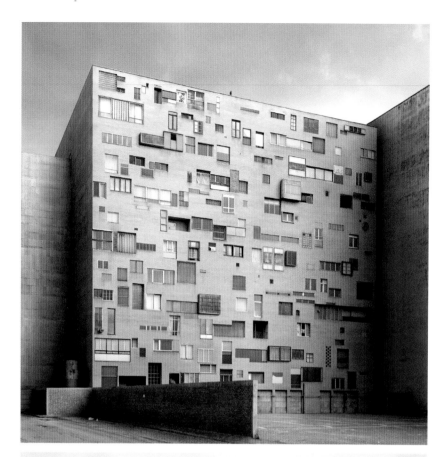

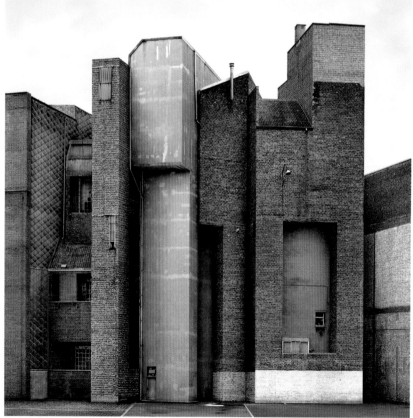

TOP AND BOTTOM
Filip Dujardin, *Untitled from series 'Fictions'*
Courtesy Van der Mieden Gallery

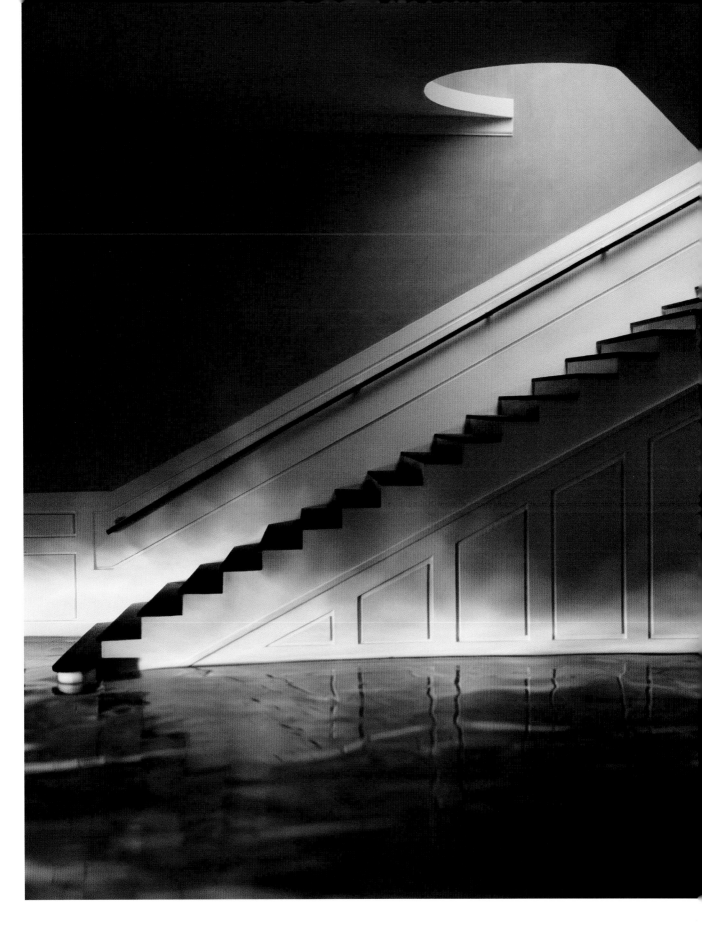

Green Staircase #3, 2002
© James Casebere. Courtesy of the artist and Sean Kelly, New York

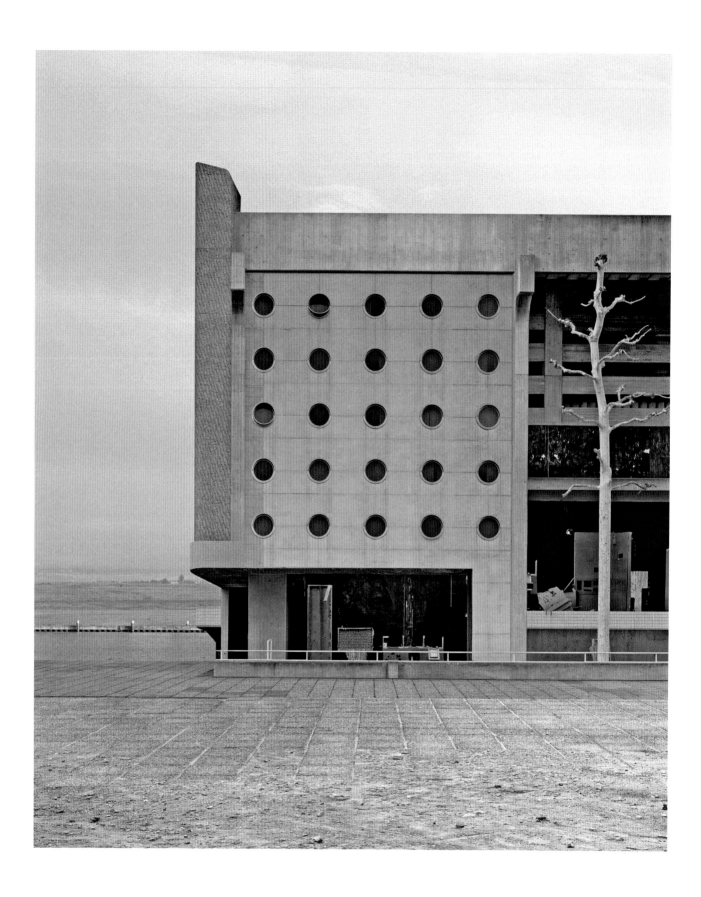

LEFT
Beate Gütschow, *S#31,* 2009, LightJet print, 142 cm x 122 cm
RIGHT
Beate Gütschow, *S#2,* 2005, LightJet print, 212 cm x 177 cm
Courtesy: Sonnabend Gallery, New York.
© Beate Gütschow, VG Bild-Kunst, Bonn 2015

PROJECT CREDITS, INFORMATION AND BIBLIOGRAPHIES

INTERSECTION OF ART, SCIENCE, AND ARCHITECTURE

Project name 01_Apartment renovation in Piazza Lecce, Rome; Project location_Stochastic floor in apartment renovation in Rome; Name of design firm _Studio Cadmio, Rome; Key architects _Claudio Greco; Design team _Daniele Sansoni, Belardinelli Viviana; Project artist_Sergio Lombardo; Material manufacturer_Corafa factory, Terracina, Italy, www.corafa.it; Project completed_2005; Project name 02_S.Felice church in Avignonesi, Italy; Name of project_restoration of S.Felice church in Avignonesi Italy; Project Design_2015; Project Completed_2016; Project Supervisor_Soprintendente of Molise Region, arch Carlo Birrozzi; Architectural consultant_Claudio Greco; Tile design_Sergio Lombardo; Tile manufacturing coordinator_Rita Rivelli, Studio Forme, Rome, www.studioformeroma.it; Rendering_arch. Sebastian Di Guardo; Project name 03_Restoration and renovation of law office in via Mercalli, Rome; Project completed_2005; Key architect_Claudio Greco; Design team_Carlo Santoro, Daniele Sansoni.

Image Credits_ Figure 01_Stochastic wall in law firm, Rome © Claudio Greco; Figure 02_Sergio Lombardo, Pittura stocastica TAN, (Stochastic Painting), 1983 © Sergio Lombardo; Figure 03_Stochastic floor in apartment renovation, Rome_Photographer_Lorenzo De Masi, © Studio Cadmio; Figure 04_One of the 24 floors, Residential Complex in Tufello, Rome_Image courtesy of Claudio Greco; Figure 05_ View of the new entrance hall and stochastic floor, Residential Complex in Tufello, Rome, Photographer_Vincenzo Labellarte © Vincenzo Labellarte; Figure 06_External view of one of the entrances, Residential Complex in Tufello, Rome, Photographer_Claudio Greco © Claudio Greco; Figure 07_Internal view, S.Felice church, Avignonesi, Italy, Rendering_Sebastian Di Guardo; Figure 08_Floorplan, S.Felice church, Avignonesi, Italy_ Image courtesy of Claudio Greco; Figure 09_A single tile, S.Felice church, Avignonesi, Italy_ Image courtesy of Claudio Greco; Figure 10_ Internal detail, S.Felice church in Avignonesi, Italy_ Image courtesy of Claudio Greco; Figure 11_Before and after floor plans, Rome, © Claudio Greco; Figure 12_View of ceiling, law firm, Rome, Photographer_Claudio Greco © Claudio Greco.

BIBLIOGRAPHY:

-Greco, C. - Santoro, C. "Applicazioni di architettura Eventualista", RPA Nuova Serie, anno XXVI, 16. (2005).
-Greco, C. "Verso un Architettura Eventualista", RPA Nuova Serie, Anno XXIV, 14. (2003).
- Greco C. "Le teorie dei razionalisti russi e il laboratorio di psicotecnica al Vuthemas (1919-1927) -alle origine dell'approccio eventuali sta all'architettura". RPA anno XXXIII n.23. (2012).
-Greco, C. - Santoro, C. "Metodi avanzati di composizione architettonica stocastica", RPA Nuova Serie, Anno XXV, 15. (2004).
-Greco, C. "Modular Tessellation and architecture. Sergio Lombardo's stochastic tiles and their -application in real architecture". RPA Nuova Serie, Anno XXXV, 25. (2014).
-Lombardo, S. "Approssimazione alla struttura casuale assoluta", RPA anno V, 8/9. (1983).
-Lombardo, S. "Estetica della colorazione di mappe", RPA Nuova serie, XX, 10. (1999).
-Lombardo, S. "La teoria Eventualista", RPA (Rivista di Psicologia dell'Arte) Anno VIII 14/15. (1987).
-Lombardo, S. "Primitivismo e avanguardia nell'arte degli anni '60 a Roma", RPA Nuova Serie, anno XI, 1. (1990).
-Lombardo, S. "Pittura stocastica, introduzione al metodo TAN e al metodo SAT", RPA anno VII, 12/13. (1985 – 1986).
-Lombardo, S. "Pittura stocastica, tassellature modulari che creano disegni aperti", RPA Nuova Serie, Anno XV, 3/ 4/5. (1994).

A SACRED TRANSLATION

Project name_Holy Trinity Church to Jesus Son of Mary Mosque; Project location_Syracuse, N.Y.; Key architect_Dennis Earle; Project completed_Ongoing as of summer 2014.

Image Credits_All images courtesy of Dennis Earle; Figure 01_ Prayer hall, Masjid Isa Ibn Maryam, Syracuse, NY; Figure 02_ Original nave windows shown early in the renovation; Figure 03_Temporary coverings for cherub heads; Figure 04_Plaster cherub head ornament before covering; Figure 05_Decorative screen at rear of main prayer area.

BIBLIOGRAPHY:

-Grabar, Oleg. The Mediation of Ornament; Princeton, 1992.
-Singer, Lynette. The Minbar of Saladin; New York, 2008.

SAMPLING SECULARIZATION

Project name 01_ Fontevraud L'Abbaye Royale_Project location_Anjou, France; Project name 02_Fontevraud L'Abbaye Royale, Julien Salaud_Project location_Fontevraud-l'Abbaye, France; Project name 03_Church of Sant Pere; Project location_Corbera, D'Ebre, Spain; Project 04_ Oude Kerk; Project location_Amsterdam, The Netherlands.

Image credits_Opening image grid of 08_ Conceptual models of additive and subtractive operations for the church typology; Photographer, Lea Hershkowitz; Figure 01-05 Courtesy of the authors, Kirby Benjamin and Katherine Porter_Figure 01-02_ Fontevraud L'Abbaye, Anjou, France; Figure 03_ Fontevraud L'Abbaye Royale, Julien Salaud_Fontevraud-l'Abbaye, France; Figure 04-05_Church of Sant Pere_Corbera, D'Ebre, Spain; Figure 06-07 Courtesy of Markus Berger_Figure 06-07_Oude Kerk, Amsterdam, The Netherlands.

BIBLIOGRAPHY:

Bindley, Katherine. "Religion Among Americans Hits Low Point." The Huffington Post. March 13, 2013. Accessed February 1, 2015.

CONSTRUCTING "documenta"

Project name_"documenta" exhibition in the Museum Fridericianum; Project location_Kassel, Germany; Key designer_Arnold Bode; Project completed_1955

Image credits_Figure 01_Milky white galleries on the first floor of the Museum Fridericianum, Kassel, Germany, Göppinger plastics and homasote boards shape the gallery space and blur interior/exterior. Photograph: Gunther Becker © documenta Archiv; Figure 02_Wilhelm Lehmbruck's Kneeler (1911) in the Museum Fridericianum Rotunda, Paintings by Oskar Schlemmer were hung along the stairway, Photograph: Gunther Becker © documenta Archive; Figure 03_Museum Fridericianum Große Halle, 1955, With Fritz Winter's Composi-

tion on the far wall, Photograph: Gunther Becker © documenta Archive.

BIBLIOGRAPHY:

-Bode, Arnold and Heiner Georgsdorf. *Arnold Bode: Schriften Und Gespräche* (Berlin: B & S Siebenhaar, 2007).
-Bode, Arnold. documenta Archiv, *documenta* 1 Collection, Kassel.
-Bosmon, Jos. "The Tale of Kassel: From a Unique and Intact 1000 Years of Urban Heritage to a Cityscape Saturated with Modernist Buildings, Crowned by a Copy of Hercules from the Palazzo Farnese in Rome." *Urban Heritage: Research, Interpretation, Education* (n.d.): 129-35. Web.
-Buergel, Roger M. "The Origins" in *50 Jahre Documenta: 1955-2005*, edited by Michael Glasmeier and Karin Stengel (Göttingen: Steidl, 2005), 177.
-Christov-Bakargiev, Carolyn. *DOCUMENTA (13): Catalog = Katalog*. Ostfildern: Hatje Cantz, 2012.
-Dewey, John. *Art as Experience* (New York: Minton, Balch, 1934).
-documenta Archiv, Kassel. documenta 1 (Mappen 6a, 6b, 7b, 8, 9, 10, 16, 17, 18, 20, 21); documenta 2 (Mappen 23b, 24, 31, 45, 52, 65, 68), and documenta 3 (Mappen 96, 99, 100).
-Floyd, Kathryn Mae. "Between Change and Continuity: Documenta 1955-2005", *Dissertation*, University of Iowa, December 2006. Chapter 2: Structuring Documenta: Architecture, Space, Design (94-135).
-"Frei Otto," The Pritzker Architecture Prize/Hyatt Foundation, last modified September 8, 2015, http://www.pritzkerprize.com/sites/default/files/file_fields/field_files_inline/2015-PP-Photo-Booklet.pdf. 28-30.
-Glaser, Hermann. *The Rubble Years: The Cultural Roots of Postwar Germany*. New York: Paragon House, 1986.
-Grasskamp, Walter. "'Degenerate Art' and Documenta I." In *Museum Culture: Histories, Discourses, Spectacles*, by, Sherman, Daniel J. and Irit Rogoff. 163-96. Minneapolis: University of Minnesota Press, 1994.
-Haacke, Hans. "Lessons Learned," *Tate Papers: Landmark Exhibitions Issue* 12 (2009): http://www.tate.org.uk/research/publications/tate-papers/12/lessons-learned.
-Haftmann, Werner *Malerei im 20. Jahrhundert* (English: *Painting in the Twentieth Century*) (Munich: Prestel-Verlag, 1954).
-Kimpel, Harald. *Documenta: Mythos und Wirklichkeit* (Cologne, 1997).
-Klonk, Charlotte. *Spaces of Experience: Art Gallery Interiors from 1800 to 2000* (New Haven: Yale University Press, 2009).
-Lange, Christoph. "The Spirit of *Documenta*," in *Archive in Motion: 50 Jahre documenta 1995-2005*, edited by Glasmeier, Michael and Karin Stengel (Göttingen: Steidl, 2005), 14.
-Mattern, Hermann and Vroni Hampf-Heinrich. *Hermann Mattern: 1902-1971; Gärten, Gartenlandschaften, Häuser ; Ausstellung D. Akad. D. Künste U. D. Techn. Univ. Berlin Vom 17. Oktober Bis 17. November 1982*. Berlin: Akad. D. Künste, 1982.
-"Museum Fridericianum als Ausstellungsbau," *Kasseler Lokalausgabe*, HN Nummer 31, 6. February 1954. Retrieved from the Stadt Archiv, Kassel.
-O'Doherty, Brian. *Inside the White Cube: The Ideology of the Gallery Space* (Berkeley: University of California Press, 1999).
-Stadt Archiv. Bundesgartenschau, Bode and documenta files, Kassel.

-Tietenberg, Annette. "An Imaginary *Documenta* or The Art Historian Werner Haftmann as an Image Producer", *Archive in Motion: 50 Jahre documenta 1995-2005*, edited by Glasmeier, Michael and Karin Stengel (Göttingen: Steidl, 2005), 35-45.
-Wallace, Ian. *The First Documenta, 1955 = Die Erste Documenta, 1955* (Ostfildern: Hatje Cantz, 2011).
-Weiner, Andrew Stefan. "Memory Under Reconstruction: Politics and Events in Wirtschaftswunder West Germany." *Grey Room* 37 (Fall 2009): 94-124.

"WORN HALF AN INCH DOWN"

Project location_Newcastle Upon Tyne, England, U.K.; Key architect_Christopher Brown.

Image Credits_Figures 01-06 are courtesy of the author, Christopher Brown_Figure 01_Extract Of Point Cloud Data, 3D View; Figure 02_Point Cloud Elevation; Figure 03-05_Milling Experiments In Low Density Modeling Board Point Cloud Extract and Meshed 3D Print At 1-20 Scale; Figure 06_Visualization Of Proposed Installation.

BIBLIOGRAPHY:

-De Carlo, Giancarlo. "Reading and Tentative Design." *Places: Forum of Design for the Public Realm* 12, no. 3 (Spring 1999): 51–51.
-Edensor, Tim. "Entangled Agencies, Material Networks and Repair in a Building Assemblage: The Mutable Stone of St Ann's Church, Manchester." *Transactions of the Institute of British Geographers* 36, no. 2 (April 1, 2011): 238–52.
-Edensor, Tim. *Industrial Ruins: Space, Aesthetics and Materiality*. Berg Publishers, 2005.
-Holtorf, Cornelius. "On Pastness: A Reconsideration of Materiality in Archaeological Object Authenticity." *Anthropological Quarterly* 86, no. 2 (2013): 427–43.
-Littlefield, David, and Saskia Lewis. *Architectural Voices: Listening to Old Buildings*. Chichester: Wiley-Academy, 2007.
-Norberg-Schulz, Christian. *Genius Loci: Towards a Phenomenology of Architecture*. New York: Rizzoli, 1980.
-Pallasmaa, Juhani. *The Eyes of the Skin: Architecture and the Senses*. Chichester; Hoboken, NJ: Wiley-Academy ; John Wiley & Sons, 2005.
-Pearson, Mike, and Julian Thomas. "Theatre/Archaeology." *TDR (1988-)* 38, no. 4 (December 1, 1994): 133–61.

WHAT ONCE WAS

Image Credits_ Figure 01_Rachel Whiteread, *Ghost*, 1990 Plaster on steel frame; 106 x 140 x 125 inches (269 x 356 x 318 cm) ©Rachel Whiteread; Courtesy of the artist, Luhring Augustine, New York, Lorcan O'Neill, Rome, and Gagosian Gallery; Figure 02_Rachel Whiteread, *House*, 1993 Concrete; Commissioned by Artangel Photo credit: Sue Omerod ©Rachel Whiteread; Courtesy of the artist, Luhring Augustine, New York, Lorcan O'Neill, Rome, and Gagosian Gallery.

BIBLIOGRAPHY:

-Morris, William & Founding Members. "Manifesto". The Society for the Protection of Ancient Building, 1877. http://www.spab.org.uk/what-is-spab-/the-manifesto/, accessed 04.16.16
-Mullins, Charlotte, and Rachel Whiteread. RW: *Rachel Whiteread*. London: Tate Pub., 2004.
-Myzelev, Alla. "The Uncanny Memories of Architecture:

Architectural Works by Rebecca Horn and Rachel Whiteread." *Athanor* 19 (May 2001): 59-65.

-Riegl, Alois. "The Modern Cult of Monuments: Its Essence and Its Development" in *Historical and Philosophical Issues in the Conservation of Cultural Heritage*. Getty Publications, 1996.

-Ruskin, John. "Book 6: The Lamp of Memory" in *The Seven Lamps of Architecture*. New York: J. Wiley, 1849.

-Viollet-le-Duc, Eugène and Charles Wethered. *On Restoration*. London: Sampson Low, Marston Low, and Searle, 1875. [translated from an article in his *Dictionnaire raisonée de l'architecture francais*]

-Whiteread, Rachel, James Lingwood, and Jon Bird. *House*. London: Phaidon, 1995.

-Whiteread, Rachel, Fiona Bradley, and Rosalind E. Krauss. *Rachel Whiteread - Shedding Life*:. Liverpool: Tate Gallery Publishing, 1996.

COMING HOME

Image Credits_ All images courtesy of the artist, Do Ho Suh. Figure 01_*348 West 22nd Street, New York, NY 10011, USA – Apartment A, Corridors and Staircases (Kanazawa version) 2011-2012*, polyester fabric and stainless steel. Apartment A 690 x 430 x 245 cm / Corridors and Staircases 1328 x 179 x 1175 cm. © Do Ho Suh; Figure 02_*Rubbing/Loving Project: Kitchen, Apartment A, 348 West 22nd Street, New York, NY 10011, USA 2014*. Colored pencil on vellum pinned on board. Dimensions, overall 363.9 x 843.6 cm (143.25 x 332.125 inches). © Do Ho Suh; Figure 03_*Specimen Series: Stove, Apartment A, 348 West 22nd Street, New York, NY 10011, USA 2013*. Polyester fabric, stainless steel wire, and display case with LED lighting. Framed dimensions 74 1/8 x 36 1/8 x 35 inches. © Do Ho Suh. Figure 04_*Fallen Star 1/5, 2008-2009*. ABS, basswood, beech, ceramic, enamel paint, glass, honeycomb board, lacquer paint, latex paint, LED lights, pinewood, plywood, resin, spruce, styrene, polycarbonate sheets, and PVC sheets. Approximately 332.7 x 368.3 x 762 cm (131 x 145 x 300 inches). © Do Ho Suh; Figure 05_*Home Within Home Within Home Within Home 2013*, polyester fabric, metal frame 1530 x 1283 x 1297 cm. © Do Ho Suh; Figure 06_*Apartment A, 348 West 22nd Street, New York, NY 10011, USA 2011-2014*, polyester fabric, stainless steel tubes. Dimensions 271.65 x 169.29 x 96.49 inches / 690 x 430 x 245 cm. © Do Ho Suh; Figure 07_*Wienlandstr. 18, 12159 Berlin, Germany – 3 Corridors 2011*, polyester fabric and stainless steel tubes 655 x 209 x 351 cm. © Do Ho Suh; Figure 08_*Apartment A, 348 West 22nd Street, New York, NY 10011, USA 2011-2014*, polyester fabric and stainless steel tubes. Dimensions 271.65 x 169.29 x 96.49 inches / 690 x 430 x 245 cm. © Do Ho Suh.

BIBLIOGRAPHY:

-"Architecture Biennale - Do Ho Suh + Suh Architects (NOW Interviews)." *YouTube*. Accessed February 03, 2016. https://www.youtube.com/watch?v=oiXNVoitp8g.

-"Artist Do Ho Suh Explores the Meaning of Home." *WSJ*. Accessed February 03, 2016. http://www.wsj.com/articles/SB10001424052702303376904579137672335638830.

-"Do Ho Suh - Exhibitions - Lehmann Maupin." Accessed March 07, 2016. http://www.lehmannmaupin.com/exhibitions/2011-09-08_do-ho-suh/press/1181/video.

-"Do Ho Suh at Lehmann Maupin Galleries." *YouTube*. Accessed February 03, 2016. https://www.youtube.com/watch?v=0DiCJT7j8TI.

-"Do Ho Suh at Lehmann Maupin, New York (Jan 2008)." *YouTube*. Accessed February 03, 2016. https://www.youtube.com/watch?v=Npb1UkNIZmQ.

-"Do Ho Suh Discusses "Gate" at Seattle Art Museum." *YouTube*. Accessed February 01, 2016. https://www.youtube.com/watch?v=_R03tUqKVuw.

-"Do Ho Suh: *Home within Home* at Leeum Samsung Museum of Art." *Designboom*. April 04, 2012. Accessed February 01, 2016. http://www.designboom.com/art/do-ho-suh-home-within-home-at-leeum-samsung-museum-of-art/.

-"DO HO SUH in between - Hiroshima MOCA." *YouTube*. Accessed February 01, 2016. https://www.youtube.com/watch?v=Pgo2zW6YEcA.

-"Do Ho Suh Interview." *Designboom*. January 03, 2008. Accessed February 01, 2016. http://www.designboom.com/interviews/designboom-interview-do-ho-suh-3/.

-"Do Ho Suh: New Works 2015." *YouTube*. Accessed February 03, 2016. https://www.youtube.com/watch?v=qWHtYM4saMg.

-"Do Ho Suh." *PBS*. Accessed February 03, 2016. http://www.pbs.org/art21/artists/do-ho-suh.

-"Do Ho Suh: "Seoul Home/L.A. Home"-Korea and Displacement, *ART21*. Accessed February 01, 2016. http://www.art21.org/texts/do-ho-suh/interview-do-ho-suh-seoul-home-la-home-korea-and-displacement.

-"Do Ho Suh: The Drawings of Do Ho Suh - Curiator Featured Artist." *Curiator*. Accessed February 03, 2016. http://curiator.com/curatorials/lfkv.

-"Do Ho Suh's Interview for TATE Modern." *YouTube*. Accessed February 01, 2016. https://www.youtube.com/watch?v=S1EOlpX4tlc.

-"Do-ho Suh (subs Esp)." *YouTube*. Accessed February 01, 2016. https://www.youtube.com/watch?v=lXgg2ACBF2o.

-"*Fallen Star: Wind of Destiny* (Herald Tribune Version) by Do Ho Suh." *Curiator*. Accessed February 03, 2016. http://curiator.com/art/do-ho-suh/fallen-star-wind-of-destiny-herald-tribune-version.

-"Installing Do Ho Suh's Staircase." *YouTube*. Accessed February 01, 2016. https://www.youtube.com/watch?v=3ee_b4G5L-DI.

-"TateShots: Do Ho Suh – Staircase-III." *YouTube*. Accessed February 01, 2016. https://www.youtube.com/watch?v=xYEF_GXilu8.

DESIGN, SUBJECTIVITY, AND CULTURE

Image Credits_All images courtesy of the author, Clay Odom; Figure 01_Installation 'Tesseract 4.0' at Salvage Vanguard Theater, Austin, Texas; Figure 02_Rendering of proposal for installation at Boston Society of Architects

BIBLIOGRAPHY:

-Benjamin, Walter. *The Work of Art in the Age of Mechanical Reproduction* (London: Penguin, 2008).

-Bishop, Claire. *Installation Art: A Critical History* (London: Tate Publishing, 2005,2008), 82.

-Bohme, Gernot. "Atmosphere as the Fundamental Concept of a New Aesthetics," *Thesis 11* 36 (1993).

-Branzi, Andrea. "The Visceral Revolution," *Domus* 897 (Nov 2006): 43.

-Carpo, Mario. *The Alphabet and The Algorithm* (Cambridge: The MIT Press, 2011).

-Clear, Nic. "Drawing Time," *Architectural Design* 83 Issue 3 (2013): 74.

-Furuto, Allison. "'On Space Time Foam' Exhibition / Studio Tomas Saraceno," *ArchDaily* (November, 2012). http://www.archdaily.com/292447/on-space-time-foam-exhibition-studio-tomas-saraceno

-Jensen, Michael K. *Mapping the Global Architect of Alterity* (New York: Routledge, 2014).

-Gibson, William. *Pattern Recognition* (New York: Berkley Books, 2003).

-Koolhaas, Rem. Interview with Charlie Rose, October 19,

2011, http://www.archdaily.com/182642/rem-koolhaas-on-charlie-rose/.
-Lynn, Gregg. *Animate Form* (New York: Princeton Architectural Press, 1999).
-Lynn, Gregg. *Intricacy: Exhibition Catalog.* (Philadelphia: University of Pennsylvania / Institute of Contemporary Art, 2003).
- Morton, Timothy. *Realist Magic: Objects, Ontology, Causality* (Ann Arbor : Open Humanities Press, an imprint of MPublishing - University of Michigan Library, 2013).
-Odom, Clay. "Mobile Processes Transient Productions: Nomadic Spatial Practices", (presented at the IFW Nomadic Interiors, Politecnico di Milano, May 2015).
-*Room.* http://www.cooperhewitt.org/events/current-exhibitions/immersion-room/.
-Schumacher, Patrik. "Parametricism as Style," http://www.patrikschumacher.com/Texts/Parametricism%20as%20Style.htm.
-*Serial Classic,* Prada Foundation Milan, curated by Salvatore Settis and Anna Anguissola, (9 May – 24 August 2015), http://www.fondazioneprada.org/exibition/serial-classic/?lang=en .
-Snooks, Roland. "Observations on the Algorithmic Emergence of Character," in *Models: 306090 Books,* Vol 11. Ed Emily Abruzzo, Eric Ellingsen, and Jonathan D. Solomon, (New York, 306090 Inc., 2007), 96.

THE BUTTERFLY EFFECT

Project 01 name_Center for Engaged Art and Research_Project location_601 Tully, Syracuse, NY; Project 02 name_M Lab, Mobile Literacy Arts Bus, Syracuse, NY.

Image Credits_Figure 01_Pre-Renovation Exterior View, 601 Tully, Syracuse, NY, 2010, Photograph, John Cardone; Figure 02_Renovated First Floor, 601 Tully, 2013, Photograph, Charles Wainwright; Figure 03_Students of SUNY/ESF drawing in Mobile Field Station, Syracuse, NY, 2015, Photograph, Steve Sartori; Figure 04_Student Façade Assignment, Andrew Weigand on Daniel Buren, Photograph, Marion Wilson; Figure 05_Student Façade Assignment, Wayne Tseng on Eva Hesse, Photograph, Marion Wilson.

BIBLIOGRAPHY:

-Axelroth Hodges, Rita and Steven Dunn. *The Road Half Traveled: University Engagement at a Crossroads.* East Lansing: Michigan State University Press, 2012.
-Beuys, Joseph. *Public Dialogues,* 1974.
-Grosz, E. *Architecture from the Outside: Essays on Virtual and Real Space.* Cambridge, MA: Massachusetts Institute of Technology, 2001.
-Kwon, Miwon. "One Place after Another: Notes on Site Specificity", *October,* MIT Press Vol. 80. (Spring, 1997).

SINGULARITIES OF PLACE

Image Credits_All images courtesy of the author, Elizabeth Parker; Figure 01_An existing peculiar gap between two widths of wallpaper that, when painted over, grew apart. Washington, D.C., 2014.

BIBLIOGRAPHY:

-Belk, Russell W. "Possessions and the Extended Self." In *Journal of Consumer Research* 15.2, 139-168. Chicago: The University of Chicago Press, 1988. http://www.jstor.org/stable/2489522.
-Kleinman, Kent. "Taste, After All." In *After Taste: Expanded Practice in Interior Design,* 28-41. Edited by Kent Kleinman, Joanna Merwood-Salisbury, and Lois Weinthal. New York:

Princeton University Press, 2012.
-Perec, Georges and John Sturrock, *Species of Spaces and Other Pieces.* London: Penguin, 1997.
-Ruskin, John. *The Seven Lamps of Architecture.* New York: John Wiley, 1849.
-Scannell, Leila and Robert Gifford, "Defining place attachment: A tripartite organizing framework." In *Journal of Environmental Psychology* 30. Amsterdam, 2010, 1-10.
-Thompson, Evan, Alva Noë and Luiz Pessoa, "Perceptual Completion: A Case Study in Phenomenology and Cognitive Science." In *Naturalizing Phenomenology: Issues in Contemporary Phenomenology and Cognitive Science.* Edited by Jean Petitot, Francisco J. Varela, Barnard Pacoud and Jean-Michel Roy. Stanford: Stanford University Press, 1999, 161-195.

FIGURAL IDENTITY IN ADAPTIVE REUSE

Project location 01_50 Moganshan Road (M50), Shanghai, China; Project location 02_Les Halles townhouses, Paris, France_Project artist_Gordon Matta Clark_Project completed_1975 Biennale, now demolished; Project location 03_Westbeth Arts live-work housing, New York City_Project architect_Richard Meier; Project location 04_Hamburg, Germany_Project name_Elbphilharmonie_Project architects_ Herzog & de Meuron.

Image Credits_Figure 01_An informal exterior composition in red, turquoise and white as a 'topographical artwork', 50 Moganshan Road, Shanghai_Image Credit_Marie S. A. Sorensen, 2006; Figure 02_Complex as Topographical Artwork – Richard Meier's 1970 topography of white paint on brick exteriors at New York City's Westbeth Arts can be understood as a megalithic artwork at the scale of an urban block_Image credit_Marie S. A. Sorensen, 2015; Figure 03_Westbeth Arts, the first publicly-funded live-work artist loft project in the United States, is an Escher-esque composition of white on brick by Richard Meier, showcasing geometric additions like these park benches_Image credit_Marie S. A. Sorensen, 2015.

BIBLIOGRAPHY:

- "A Crystal in the Harbour – The Glass Façade of the Elbphilharmonie". *Detail.* 2010-5. 498-508.
-Herzog & de Meuron, www.herzogdemeuron.com/index/projects/complete-works/226-250/230-elbphilharmonie-hamburg.html, accessed October 16, 2015.
-Jenkins, Bruce. *Gordon Matta-Clark Conical Intersect.* MIT Press, Cambridge MA, 2011.
-Lynch, Kevin. *Wasting Away.* Sierra Club Books, 1990.
-Makovsky, Paul and Michael Gotkin. *The Postmodern Watchlist.* November 2014.
-Richard Meier & Partners Architects LLP, www.richardmeier.com, accessed October 16, 2015.
-Schockley, Jay. Landmarks Preservation Commission, Designation List 449 LP-2391. October 25, 2011.
-Sheire, James. *National Register of Historic Places Inventory – Nomination Form for Bell Telephone Laboratories (common name Westbeth).* March 5, 1975.
-Solomonson, Katherine. *Design for Advertising* from *The Chicago Tribune Tower Competition.* University of Chicago Press, 2003.

FROM RUST TO REUSE

Project location_Otisco Street historic New West Side neighborhood, Syracuse, N.Y.; Project completed_2009

Image Credits_Image courtesy of the author, Zeke Leonard_ Figure 01_The completed RustOPhone in situ.

BIBLIOGRAPHY:

-Bronwen, Lucie Gray. "The Babushka Project: Mediating Between the Margins and Wider Community Through Public Art Creation", *Art Therapy*, (2012) 29:3, 113-119
-Lomax, Alan. *The Land Where the Blues Began*, Pantheon Books, New York, 1993.
-Montagu, Jeremy. *Origins and Developmnt of Musical Instruments,* Scarecrow Press, Lanham, Maryland, 2007.
-Tschumi, Bernard. *Event Cities (Praxis)* MIT Press, Cambridge, 1994.
-Tschumi, Bernard. *Architecture and Disjunction*, MIT press, Cambridge, 1996.

CONVERGING IN SPACE

Project name_P.S. 1's *Rooms* exhibition; Exhibition opened_ June 9 - 26, 1976; Museum founded_1971; Founder_Alanna Heiss; Affiliation with MoMA: 2000

Image credits_All images courtesy of Digital Image © The Museum of Modern Art/Licensed by SCALA/Art Resource, NY. Rooms P.S. 1 (New York: Institute for Art and Urban Resources, 1977), pages 10, 11, 16, 18. The Museum of Modern Art, New York, NY, U.S.A. _Figure 01_Installation View, Gordon Matta-Clark, *Doors, Floors, Doors*, May, 1976; Figure 02_ Installation View, Gordon Matta-Clark, *Doors, Floors, Doors*, May, 1976; Figure 03_The *Rooms* exhibition on the cover of *Artforum*; Figure 04_ Installation View, *Rooms* Exhibition, May, 1976.

BIBLIOGRAPHY:

-Alden, Robert. "Lindsay Rejects Moses' Proposal for 30th St. Road," *The New York Times.* December 24, 1965.
-Apple, Jacki. *Alternatives in Retrospect: An Historical Overview, 1969-1975*. exh. Cat. New York: The New Museum, 1980.
-Ault, Julie, ed. *Alternative Art New York 1965-1985: A Cultural Politics Book for the Social Text Collective.* Minneapolis and London: University of Minnesota Press, 2002.
-Blumberg, Linda. Untitled document [P.S. 1 Mission Statement]. MoMA PS1 Archive. I.A.48.The Museum of Modern Art Archives, New York City.
-City of New York, Department of City Planning. *Surplus School Space: some facts about re-use.* New York: The Department of City Planning, 1977.
-Cooke, Lynne, and Douglas Crimp, eds. *Mixed Use, Manhattan: Photography and Related Practices, 1970s to the Present*, exh. Cat. Cambridge: MIT, 2010.
-Crowell, Paul. "Mayor 'Irons Out' Moses Grievance" *The New York Times.* August 30,1956.
-"Excerpts from Beame's Address on State of the City." *The New York Times.* January 23, 1976.
-Foote, Nancy. "The Apotheosis of the Crummy Space," *Artforum.* (October 1976)
-Glueck, Grace. "Montezuma and the P.S. 1 Kids," *The New York Times.* April 15, 1977.
-Glueck, Grace. "Abandoned School in Queens Lives Again as Arts Complex" *The New York Times.* June 10, 1976.
-Glueck, Grace. "Study Urges Big Increase in National Arts Fund" *The New York Times.* October 3, 1975.
-Greenberg, Clement. "Modernist Painting," in *Art in Theory 1900-1990: An Anthology of Changing Ideas.* ed. Charles Harrison and Paul Wood. (Oxford UK and Cambridge, USA: Backwell, 1993). 754-760.
-Heiss, Alanna. Interview with the author. April 12, 2012.
-Heiss, Alanna. Untitled document [*Rooms* Curatorial Statement]. MoMA PS1 Archive. I.A.48. The Museum of Modern Art Archives, New York City.
-"History of the Municipal Art Society of New York," The Municipal Art Society of New York, accessed April 5, 2012. http://mas.org/aboutmas/history/
-Holsendolph, Ernest. "Economy Called Key to Urban Plight," *The New York Times.* August 9, 1975
-"The Housing Issue," *The New York Times.* October 21, 1976.
-Huxtable, Ada Louise. "Anyone Dig the Art of Building?" *The New York Times.* April 11, 1971.
-Huxtable, Ada Louise. "What's Best for Business Can Ravage Cities" *The New York Times.* April 11, 1971.
-Huxtable, Ada Louise. "Lessons in How to Heal the City's Scars" *The New York Times.* May 27, 1973.
-Huxtable, Ada Louise. "A Happy Turn for Urban Design" *The New York Times.* September 14, 1975.
-Institute for Art and Urban Resources. Untitled Document. [P.S. 1 Project Description]. MoMA PS1 Archive. I.A.48. The Museum of Modern Art Archives, New York City.
-Institute for Art and Urban Resources. Untitled document [*Rooms* Exhibition Checklist]. MoMA PS1 Archive. I.A.48. The Museum of Modern Art Archives, New York City.
-Institute for Art and Urban Resources. "Recommendations of the Advisory Committee on Goals and Objectives." MoMA PS1 Archive. VIII.D.11. The Museum of Modern Art Archives, New York City.
-Institute for Art and Urban Resources. "Revised, Detailed Queens/P.S. 1 Budget: January 1, 1976-August 31, 1976." MoMA PS1 Archive. VIII.D.11. The Museum of Modern Art Archives, New York City.
-Institute for Art and Urban Resources Inc. *Rooms P.S. 1.*, [exhibition catalog]. S.l.: Institute for Art and Urban resources, 1976.
-Institute for Art and Urban Resources. "Workspace." MoMA PS1 Archive. VIII.D.7. The Museum of Modern Art Archives, New York City.
-Institute for Art and Urban Resources. "Press Release—June 9, 1976." MoMA PS1 Archive. I.A.48. The Museum of Modern Art Archives, New York City.
-"Issues '76: Cities," *The New York Times.* April 5, 1976.
-Jacobs, Jane. *The Death and Life of Great American Cities.* New York: Random House, 1961.
-Krauss, Rosalind. "Notes on the Index: Seventies Art in America, Part 2" *October* 4 (Autumn 1977). 58-67.
-Lefebvre, Henri. *The Right to the City.* Oxford, UK: Blackwell Publishers, 1996.
-New York City Planning Commission & Municipal Art Society of New York. *Long Island City Study.* New York: The Municipal Art Society, 1976.
-Rose, Barbara. "More About the Care and Feeding of Artists." MoMA PS1 Archive. VIII.D.7. The Museum of Modern Art Archives, New York City.
-Russell, John. "An Unwanted School in Queens Becomes An Ideal Art Center," *The New York Times.* June 20, 1976.
-Schwartz, Gail Garfield. "New York City in Transition: Economic Development," *City Almanac* 12, no. 5 (Feb 1978).
-Schwartz, Joel. *The New York approach: Robert Moses, urban liberals, and redevelopment of the inner city.* Columbus: Ohio State University Press, 1993.
-Shapiro, Babs. "Architectural References: The Consequence of the Post-Modern in Art and Architecture." *Vanguard*, 9 (May 1980) 6-13.
-Shipler, David K. "Decentralizing the City," *The New York Times.* February 22, 1972.
-"State of the City," *The New York Times.* May 11, 1975.
-"State of the City: Industry and Labor," *The New York Times.* May 13, 1975.
-"State of the City: Planning the Future," *The New York Times.* May 15, 1975.
-"State of the City: A Fit Place to Live?" *The New York Times.*

May 16, 1975.
-"State of the City: Linking the Region," *The New York Times.*
May 24, 1975.
-Stern, Michael. "City Offers Ambitious Plan For an Economic Revival," *The New York Times.* February 16, 1975.
-Zukin, Sharon. "In Defense of Benign Neglect and Diversity," *The New York Times.* February 13, 1977.

PICTURING SPACE

Image Credits_Figure 01_*Wrap Around Window, 2003* © *James Casebere. Courtesy of the artist and Sean Kelly, New York*; Figure 02_Andreas Gefeller, *Untitled* (Academy of Arts, R209), Düsseldorf, 2009;110 cm x 89 cm; Figure 03_Andreas Gefeller, *Untitled* (Panel Building 5); Berlin, 2004; 110 cm x 131 cm; All works from the series Supervisions, Courtesy Thomas Rehbein Gallery Cologne; Figure 04_Filip Dujardin, *Untitled* from series 'Fictions' (courtesy Van der Mieden Gallery), Figure 05_Filip Dujardin, *Untitled* from series 'Fictions' (courtesy Van der Mieden Gallery); Figure 06_*Green Staircase #3*, 2002, © James Casebere, Courtesy of the artist and Sean Kelly, New York; Figure 07_Beate Gütschow, *S#31*, 2009, LightJet print, 142 cm x 122 cm (55 7/8 x 48 in.), Courtesy: Sonnabend Gallery, New York, © Beate Gütschow, VG Bild-Kunst, Bonn 2015; Figure 08_Beate Gütschow, *S#2*, 2005, LightJet print, 212 cm x 177 cm (83-1/2 x 69-5/88 in.), Courtesy: Sonnabend Gallery, New York, © Beate Gütschow, VG Bild-Kunst, Bonn 2015.

COLOPHON

Jenna Balute is a Masters candidate in the Department of Interior Architecture at RISD. Before attending RISD, Balute graduated from the American University of Beirut with a Bachelor of Architecture. A licensed architect in Lebanon, Balute has lived most of her life in Beirut, an ever changing and hybrid city that has inspired her to pursue the field of adaptive reuse. Balute's work focuses on the reuse of materials, transformative interventions, and the preservation of memory.

Kirby Benjamin, a recent graduate of the Department of Interior Architecture at RISD, is currently a designer at the NYC architecture firm, The Fractal Group. Benjamin's Masters thesis focused on the current decline of Christian religious practice, the subsequent religious building typologies left underutilized or vacant, and the difficulty of adapting such iconic structures. Following graduation, Benjamin helped to teach the foundational semester for the incoming class of Interior Architecture Masters students, alongside Katherine Porter, before traveling through Africa and Europe building, studying, and continuing her thesis research.

Christopher Brown is currently a PhD candidate and part time design tutor at Northumbria University in England. In addition to his studies, Brown works part time as a RIBA part 2 architectural assistant. He received his BA and MArch in Architecture from Northumbria University in 2010 and 2014, respectively. Brown's research interests include: ruins, aesthetics, archaeology, forensic architecture, and evidence based design.

Dennis Earle, originally from upstate New York, teaches at Syracuse University's School of Design in Syracuse, New York. Earle focuses on cultural readings of form in design, especially in the context of traditional cultures and cultural conceptions of "green" design. He studied the History of Art and Architecture at Yale University prior to studying architecture as a graduate student at the University of Pennsylvania.

Claudio Greco is an architect and civil engineer practicing in Rome, where he was born in 1955. Greco is a researcher and professor of Architecture and Architectural Composition at the Tor Vergata University of Rome. Active in various fields of design, Greco focuses on the relationship between form and construction, and new and pre-existing architecture. Greco's research spans a multitude of topics, such as: the Italian modern movement; the renovation and reuse of historic, modern, and urban architecture; elements of past and present Chinese architecture; and new methods in the field of architectural composition.

Lea Hershkowitz, a Masters candidate in the Department of Interior Architecture at RISD, graduated with a BA from Bennington College, as well as a position on the College's Board of Trustees. Hershkowitz's Masters thesis seeks to remediate recidivism through the design of healthy architecture in prisons. She has received multiple fellowships and grants, including one that looked to patent and commercialize her work adaptively reusing existing mechanical air systems in hospital ICUs. In addition to her graduate work, Hershkowitz is the editorial and communications assistant for the Int|Ar Journal and a consultant for Delos, a wellness real estate firm in NYC.

Jeffrey Katz has a Bachelor of Architecture from Carnegie Mellon University and a Master of Architecture from the Graduate School of Design at Harvard University. Upon completing his graduate degree, Katz joined the faculty of the Architecture Department at RISD. Katz and his wife, Cheryl, started C&J Katz Studio in 1984. The studio's work includes retail, workspace, residential, exhibition, and furniture design. As his practice evolved, Katz transitioned to the Department of Interior Architecture, where he is currently a Senior Critic. The focus of his design studios at RISD has been retail and hospitality design.

Zeke Leonard is an assistant professor at Syracuse University's School of Design and a member of the Environmental and Interior Design faculty. Writing about research-based design practices in his forthcoming book, and presenting at the Mackintosh School of Art in Glasgow, Leonard focuses his research on the role social responsibility and ecological stewardship have in design and fabrication; and how partnering with community organizations can put local resources to better use. Leonard has taught at NYU and his alma mater, RISD, where he received an MFA in Furniture Design, after completing a BFA at the University of North Carolina School of the Arts.

Clay Odom, a NCIDQ certified Interior Designer, graduated from Texas Tech University's College of Architecture and Columbia University's Graduate School of Architecture Planning and Preservation. Odom has worked on numerous design projects throughout the world for firms such as SHoP Architects and Studio Sofield. Odom's current design practice, StudioModo, as well as his research as Assistant Professor at the University of Texas School of Architecture, has been the subject of numerous publications and lectures in the US, Canada, and Australia. Odom lives in Austin with his wife Amy, son Gaines, and daughter Lola.

Elizabeth Parker is a professor of Interior Design at her alma mater, the Parsons School of Design, in NYC. Her practice, ParkerWorks, explores building interiors as sites of memory, decay, identity, and attachment through the crafting of furniture and objects. Parker received her BA in English from Rice University before completing her MFA in Interior Design at Parsons in 2012. Her thesis, "Sub/Surface: Encounter and Domustalgia", was awarded the iCrave Thesis Award for "exceptional advancement to the field of Interior Design." Previously, Parker served as a Political Risk Analyst and West Africa Specialist at the World Bank Group.

Katherine Porter, a recent graduate of the Department of Interior Architecture at RISD, received her BFA in Sculpture from the University of Victoria, as well as an MA in Architectural History from the University of Toronto. Following graduation, Porter helped to teach the foundational semester for the incoming class of Interior Architecture Masters students, alongside Kirby Benjamin. Porter's experiences range from working in publishing and education, to architecture and design. A Toronto native, she currently works as a designer in Gensler's Toronto office and hopes to become involved with the development of a cohesive approach to adaptive reuse projects within the city.

Marie S. A. Sorensen is head of Sorensen Partners|Architects + Planners in Cambridge, MA and teaches Architectural History and Theory at Norwich University. She earned her MArch and MCP from UC Berkeley and received the John K. Branner Fellowship in 2006 for Transformations: Urban Memory and the Re-Making of Marginal Industrial, Military, and Leisure Space – a global investigation of adaptive reuse sites and strategies across twelve countries. Sorensen holds a B.A. in Anthropology and Art, with honors, from Yale University, and was nominated in 2015 for the AIA Young Architects Award.

Cecelia Thornton-Alson, currently a designer and curator in the Bay Area of California, holds an MA in Modern Art from Columbia University and a BArch with a minor in Art History from the University of Pennsylvania. Thornton-Alson's research focuses on the intersection of art, social change, and spatial politics in urban fabrics, such as those of New York, Europe, and Latin America. Thornton-Alson is in the process of renovating a 1906 Edwardian building, as well as undertaking the re-programming of the traveling fellowship: the Curatorial Program for Research.

Mariel Villeré researches, writes, and organizes exhibits and cultural programming at the intersection of architecture, art, landscape, and the city. As the Manager for Programs, Arts, and Grants for Freshkills Park, the largest landfill-to-park project in the world, Villeré works with artists to create opportunities for the public to experience the park. Mariel earned her BA in Architecture from Barnard College and her Masters of Architecture Studies in the History, Theory & Criticism of Architecture and Art at MIT, where she also developed exhibitions and publications for the Department of Architecture. Villeré lives in Brooklyn, New York.

Marion Wilson is an artist and Associate Professor at Syracuse University. Wilson institutionalized an art curriculum called New Directions in Social Sculpture as a result of her belief in the revitalization of urban spaces through the arts. Wilson has built collaborative partnerships with students, the homeless, and neighbors, accessing individual expertise and working non-hierarchically. Her studio work uses drawing, painting, and photography to research endangered landscapes as well as useful and stress tolerant botanies. Wilson recently drove MossLab from Syracuse to Miami as a special project for PULSE ART Fair 2015.

EDITORS

Ernesto Aparicio is a Senior Critic in the Department of Graphic Design at RISD. Aparicio earned his BA at the Escuela de Bellas Artes, La Plata, Buenos Aires and completed his Post Graduate Studies at the Ecole des Art Decoratifs, Paris. Prior to moving to the US, he served as Art Director for Editions du Seuil in Paris, while maintaining his own graphic design practice, Aparicio Design Inc. Best known for his work in the world of publishing, Aparicio has worked on corporate identities, publications, and way-finding for corporations and institutions in France, Japan, and the US. Recently, Aparicio was named Creative Director for the New York firm DFA.

Markus Berger is Associate Professor and Graduate Program Director in the Department of Interior Architecture at RISD. Berger holds a Diplomingenieur für Architektur from the Technische Universität Wien, Austria and is a registered architect (SBA) in the Netherlands. Prior to coming to the US, Berger practiced and taught in the Netherlands, Austria, India, and Pakistan, and currently heads his own art and design studio in Providence. His work, research, writing, and teaching focus on art and design interventions in the built environment, including issues of historic preservation, sensory experience and alteration. He is a co-founder and co-editor of the Int|AR Journal.

Patricia C. Phillips, the current Dean of Graduate Studies at RISD and guest editor of the Int|Ar Journal, is an author and curator. Phillips was Editor-in-Chief of the Art Journal, a peer-reviewed quarterly on modern and contemporary art, and curator of numerous shows including: Disney Animators and Animation, Whitney Museum of Art, 1981; The POP Project, Institute for Contemporary Art/P.S. 1, 1988; and Retail Value, Dorsky Curatorial Projects, 2008. Phillips is co-curator of a forthcoming exhibition at the Queens Museum and author of *Mierle Laderman Ukeles: Maintenance and Art*. She has held positions at Parsons: The New School of Design, SUNY New Paltz, and Cornell University.

Liliane Wong is Professor and Head of the Department of Interior Architecture at RISD. Wong received her Masters of Architecture from Harvard University, Graduate School of Design and a Bachelor of Art in Mathematics from Vassar College. She is a registered Architect in Massachusetts and has practiced in the Boston area, including in her firm, MWA, where she focused on the design of libraries. Wong is a co-designer of the library furniture system, Kore. A long time volunteer at soup kitchens, she emphasizes the importance of public engagement in architecture and design in her teaching. Wong is a co-founder and co-editor of the Int|AR Journal.

Int|AR

Department of Interior Architecture
Rhode Island School of Design

NEW TRACK, STARTING 2017

MDES Interior Studies [2+ year program]
[Exhibition & Narrative Environments]

The study of Exhibition and Narrative Environments has been a part of our departmental studio offerings for many years. Our department has hosted annual studios specific to the design of the narrative environment that featured collaborations with the key members of the RISD Museum, the RISD Department of Graphic Design and Brown University, in particular, the Haffenreffer Museum and the John Nicholas Brown Center. The new track on Exhibition and Narrative Environments consists of an MDes curriculum supported by courses offered in these other disciplines, formalizing the existing relationships with these departments.